PENGUIN BOOKS

MEMOIR OF A MODERNIST'S DAUGHTER

Eleanor Munro's books include *An Encyclopedia of Art, Through the Vermilion Gates, Originals: American Women Artists,* and *On Glory Roads: A Pilgrim's Book About Pilgrimage,* and her articles have been widely published in the art and national press. She lives in Manhattan and Cape Cod with her husband and is the mother of two sons.

MEMOIR

OF A

MODERNIST'S

DAUGHTER

ELEANOR
MUNRO

PENGUIN BOOKS

PENGUIN BOOKS
Published by the Penguin Group
Viking Penguin Inc., 40 West 23rd Street,
New York, New York 10010, U.S.A.
Penguin Books Ltd, 27 Wrights Lane,
London W8 5TZ, England
Penguin Books Australia Ltd, Ringwood,
Victoria, Australia
Penguin Books Canada Ltd, 2801 John Street,
Markham, Ontario, Canada L3R 1B4
Penguin Books (N.Z.) Ltd, 182–190 Wairau Road,
Auckland 10, New Zealand

Penguin Books Ltd, Registered Offices:
Harmondsworth, Middlesex, England

First published in the United States of America by Viking Penguin Inc. 1988
Published in Penguin Books 1989

1 3 5 7 9 10 8 6 4 2

Copyright © Eleanor Munro, 1988
All rights reserved

Grateful acknowledgment is made for permission to reprint excerpts
from the following copyrighted works:

"September 1, 1939" by W. H. Auden. Copyright 1940 by W. H. Auden. Reprinted
from *The English Auden: Poems, Essays and Dramatic Writings 1927–1939* by
W. H. Auden, edited by Edward Mendelson, by permission of Random House, Inc.

"The Lost Son" by Theodore Roethke. Copyright 1947 by Theodore Roethke.
From *The Collected Poems of Theodore Roethke*, reprinted by permission of Doubleday,
a division of Bantam, Doubleday, Dell Publishing Group, Inc.

LIBRARY OF CONGRESS CATALOGING IN PUBLICATION DATA
Munro, Eleanor C.
Memoir of a modernist's daughter.
1. Munro, Eleanor C. 2. Art critics—United States—
Biography. I. Title.
[N7483.M86A3 1989] 709'.2'4 [B] 88–28933
ISBN 0 14 00.9944 1 (pbk.)

Printed in the United States of America
Set in Bodoni Book

Except in the United States of America, this
book is sold subject to the condition that it
shall not, by way of trade or otherwise, be lent,
re-sold, hired out, or otherwise circulated
without the publisher's prior consent in any form
of binding or cover other than that in which it
is published and without a similar condition
including this condition being imposed on the
subsequent purchaser.

For Jack, who kept telling me to go on with it

For Donald, Cynthia, Elisabeth, Ruth, David and
Alexander, who gave me permission to do so

And for my mother, who said, "Do what you must,
be what you must. It makes the difference
between life and nothing."

"... undo the folded lie."

W. H. AUDEN,
"September 1, 1939"

CONTENTS

PREFACE

My father was a philosopher and an atheist, and the fact that that he died on Easter struck me even that day as an irony. It was a religious holiday he'd especially scorned for its commercialism. However, when I began to write about him, it occurred to me his trouble with Easter was more fundamental: he preferred not to dwell on the idea that, to become an Immortal, one must first die.

"There is no God," he announced from time to time in the days of his jaunty young-fatherhood, when my brother and I were apprentices in wisdom at his side. "Man is the measure.

"People who spend their time trying to prove the existence of God are superstitious fools or charlatans. Obsession with mysticism destroyed the inventive genius of the great artists. Beethoven with his Ninth, so boring and repetitious. Titian the master colorist with his dismal late Christs. Too bad we have to celebrate Christmas. We could get so much more for our money on the twenty-sixth. Naturally," he would wind up, grinning like a slightly wicked kid, "we will not observe Easter, a silly holiday celebrated by sentimental pseudo-believers, an excuse for gift buying and all that hysteria about hats and bunnies."

Lightly that atheism of which he boyishly boasted rode on his shoulders in the old days. But as he aged and the world changed, it seemed to me his principles held him back from constellations of solace most human beings seek. Finally on his deathbed, he expressed desolation that his labors would

be forgotten. All his creative work, and it was considerable
and respected, was as nothing to him before the absoluteness
of the coming end. Painfully to those of us who were with him
then, he misquoted Longfellow,

> The lives of great men teach us
> How to make our lives sublime,
> And in retreating leave us
> Footprints in the sands of time . . .

and inserted between the last two lines the word "only,"
revealing his thought that he had no ongoing form of connec-
tion with the world he was leaving behind.

After the sorrow of his death, my own thinking took a new
turn. Until then, I'd often felt my own mind was set against
itself. For example, at the time I was bollixed by a research
and writing project I couldn't carry off in the way I'd con-
tracted. The subject was the American Protestant missionary
movement in China, an odd one for me—to that point an art
critic and sometime-poet—but one I'd taken up with a will,
as if it held private meaning for me. I still felt there was a
theme—though not the obvious one—in my notebooks, but
I couldn't draw it out. Every night, lying face down into the
sheets of my bed, I suffered the pressure of an unknown story
wanting to be told.

Some months after my father's death, I abandoned that
project—left China to the Chinese as it were—and sought
what I then considered to be my theme directly, in the life
of my family. At first, I took for mentor the greatest of
memoirists, who explained that "all these materials for liter-
ary work were nothing else than my past life . . . I had stored
them up without foreseeing their final purpose . . . living for
this seedling without knowing it." But eventually I had to
confess my intention wasn't the same as Proust's—to cele-
brate his age and ancestors by rendering them into finished

art. My need then was more like Edmund Gosse's in writing *Father and Son,* the painful record of his sonhood to an anachronistic Victorian father. Nothing the son says can shake the father's faith in the rectitude of his ideas nor pry him from his goal of shaping his offspring to his mold. But to live, the son must burrow into that monumental machine and the ground it stands on, sabotage it by exposing it, showing the elder to be a helpless, foolish product of his own past—a sorry destiny for both unless a larger landscape can be revealed in the writing.

I don't know of a woman's memoir that equals in frankness and also embarrassment that by Gosse: one feels so acutely the aspirant to adulthood turning on the pin of the patriarchal tradition. Yet for certain women, the problem and the need are of a related kind. For a female child to grow up in the shadow of an intellectually confident father rooted in ideology can be baffling in ways hard to come to grips with. For then she may be so alternately seduced and repelled by his ideas— all arising from some unknown theoretical nexus—that there is little room left for thought not focused on him.

In my case, my father had a clear notion of what a "modern" person was, and if a female person, how she should think and act so as to be free of the old imprisoning hang-ups of her sex. He willed me liberated according to his pragmatic Modernist model, not remembering how much it derived from Christian sources. He trained his wife and raised me, my brother and sisters to be useful people of the world, cosmopolitan, not limited by provincial or parochial identifications. From my childhood, he laid down principles by which I should conduct myself so as to get the best out of life while also—it has to be said—not upsetting the equilibrium of our family centered on himself. For though he was to the world a mild man known for his remarkable clarity of mind and deferential manners, in the bosom of his family he was domi-

nance itself. Indeed, I once heard a colleague affectionately tease him for being "the last of the patriarchal fathers."

Inevitably, considering the person I became, I first married a man who was in ways his opposite but who also had authoritarian ideas about a woman's role in life. He, too, preached me many a sermon on how I might achieve freedom by willingly exercising the arts of what he liked to call "womanliness." In the mid-twentieth century I was in every literal sense free to challenge or ignore these men's authority. But in not simply walking away from either of them, I suspected I was caught in a larger net than I could get the dimensions of—as were in fact both men.

However, my first husband died, the Women's Movement began, and between my father's maturity and my own came two breaks in the continuum that had bound us. One was personal to our family and signaled to me by my arrival at the end of an ideological thread that had trailed through our lives. The other was a historic and cultural transition like the one that separated Edmund Gosse from his father, in our case from Modernism, with its powerful esthetic, political and ethical aspects, to Post-Modernism. Modernist philosophy was a product of the scientific spirit grounded in empiricism, but it yearned toward ideal forms of art and society. The wars and social breakdowns of this century made a mockery of some of those ideals, and the contradiction in the Modernist approach was exposed. Post-Modernism is no "ism" but a stage of cultural laissez-faire in which the forms of a more equitable world society may be germinating.

Thus as the years passed, I, like the younger Gosse, took a more objective view of my father's life and attitudes. However, observing him and also the father of my two sons across a chasm, I felt removed from the generative sources of my life and for a while could only write, as Gosse did, in a driven way expressive of confusion and pain. I had to find a way back,

not directly but as a circumnavigator ends up back by having persevered forward. On that long trip home, so to speak, I passed through a more fundamental continuum of feeling and awareness than the one I'd earlier felt prisoned in, deeper than cultural idiom, more universal than family. And then, by one of those natural miracles of conception the imagination sometimes provides, I found I was able to draw this long engagement to a close.

WRITING
ANCIENT
HISTORY

There is always a beginning, not known as such at the time but marked off by the imagination from what memory holds in store. So I'll say that, in the beginning, there was sunlight on a meadow. The meadow lay halfway up one of the minor Catskill peaks, a few hundred yards by overgrown path uphill from the farmhouse to which my father's parents had retired. For some years of my childhood, our family of four drove in our tin lizzie from Cleveland, Ohio, to spend the summers with the old folks. Each year after we'd settled in and our father had helped his father clear the upper orchard of winter debris, we would make a ritual hike to the High Rocks where, according to my grandfather, Rip van Winkle played bowling balls with the little men of the sky, then fell asleep for half a hundred years.

On a certain early morning, then, our father, who was standing by the barn with his father and had hung up his scythe and rake, took a deep breath, looked up to the rocks that showed above the treetops on the mountain and said, "Come along. Today we go."

So we said good-bye to my grandfather, leaning on his cane, watching us through heavy glasses that turned his eyes into rings of water, and good-bye to my grandmother, squeezing her hands together under her apron lest she burst out and beg us to take her along, and set off single file with our father leading, then my little brother, me next, lastly, Mother. We walked out along the back path that skirted the barn and led between raspberry bushes till we were out of sight of the house, and there we stripped naked according to the principles of Havelock Ellis.

Such a mix of intentions, he was already in those days, our father! He returned to his modest, churchgoing parents in their rustic retirement and there flaunted the freedoms he had

acquired in New York, Berlin and Paris. Granted, he didn't undress in the backyard itself. Yet did he think they didn't suspect to what extremes he went both here and in his own house in Ohio?

Dutifully, I plodded behind the proud torsos of the males. I noted their swinging members, great and small. I watched them stop, once each, to pee into the bushes. When I squatted to do the same, I doused my feet by mistake. Was this the body beautiful, the *corps* divine? I made as if to hide my blunder. "Hike up, daughter," our father said, "we don't believe in shame."

However, when we got to the meadow, it was delightful, as it had been the year before and the year before that and would be forever.

Mist rose in spindles from the long grass, creased this way and that by feet of deer and rabbits. Last season's sumac let loose its acrid, bronzy dust. Here and there in the furrows of what had once been a cultivated field stood dogwood trees, their blossoms fallen, given way to pale young leaves. Gnats skimmed our heads, my brother's golden curls, our mother's frizzy red tresses and my own hair straight like my father's.

His eyes were sky blue. His lips, chin and nose were clean-cut as paper. He wasn't tall, but he was neat and lordly. Also, he was so friendly that when I found myself near the object whose separate identity apart from the rest of his torso I hadn't knowingly noticed before that day, I asked, "May I touch that . . . ?" to which he, with a smile over my head at Mother, said, "Yes . . ." So I did, gingerly with one finger, and then in a fit of discomfiture that surprised me, turned and ran away down the length of a furrow.

From a distance, I could see my parents' bodies in full light. Mother was walking around without a trace of either modesty or display, brightly illumined and open to view. The

hair of her body was lightly curled with only a suggestion of dusky color. It barely concealed, rather framed in a hazy nimbus, the cleft between her long legs. There were other points of interest, nipples, bellybutton, knees. When she turned lazily around, held out her arms, took a deep breath and said in a blissful voice, "Smell the air!" I saw a bruise on her buttock and ran back asking, "Did it hurt?" But she only pushed me off, saying, "You know I bruise easy as an apple if you drop me on the floor," at which our father laughed and said, "And I'm the only one who knows how you got dropped," making her bend her head down and blush, a behavior I'd never seen before.

Then my brother and I began racing between the trees shouting, "Where is it, Daddy, Mommy, where?"

"What do you mean, Donald, Eleanor? Where is what?"

"Oh, the tree, the tree!"

"Which tree, in god's name?"

"Why, the tree you were married under!"

"Oh, *that* one. It used to be right here. No, over there. Well, it could be that, or that. What do you say, Lucile?" He was never as sentimental as we would have liked.

"Well, I think it's this one. I choose this one," I said, vehemently willing the others to come stand in its shadow with me. I was thinking of the snapshot on Mother's dressing table at home, showing the bride and groom sitting cross-legged in this very grass. Our mother looked down at a spray of dogwood in her lap. A light breeze lifted the edge of her white skirt. The young man in a suit grinned, laid his hand on her knee. Dogwood was in his buttonhole.

But that one of us, this morning, wasn't in a mood for reminiscing. He went off to climb a little knoll and strike a pose. "I am Kosmos, of Mighty Manhattan the son!" He sent Walt Whitman's words sounding across the meadow:

Turbulent, fleshy and sensual, eating, drinking and breeding!
No sentimentalist . . . no more modest than immodest . . .
Unscrew the locks from the doors!

"My stars and little fishes," said Mother, dragging out one of
her old Alabama sayings. "Is that what you want to teach the
children?" So he stepped down, I remember so well, and
spoke quietly but earnestly, facing off toward the meadow's
edge,

> I shot an arrow into the air!
> It fell to earth I know not where . . .
> Long, long afterward in an oak,
> I found the arrow . . . still unbroke.

Even so young, I found such thoughts intriguing: time fallen
in on itself, beginnings and endings linked. I knew the sto-
ries, the woodsman's ax forgotten by a tree, the hunter's horn
left hanging on a branch, the bride's ring dangling on a twig.
One day we are together in the meadow, our father was
saying. Another day, each one will be old and come back
looking. And who can tell what forgotten thing each one will
find? There is something here in the meadow, he seemed to
be saying. Come back when you will, it will be waiting.

But "Farewell to you mountain goats," Mother would have
said at that point, though I don't really remember this part,
only what followed. "I'm going back down and take a
snooze." And so she must have done, though we would have
begged her to stay, but she kept walking while someone
called, "We'll be home for lunch, hungry as saber-toothed
tigers!"

So the three of us set off across the meadow toward the
trees that marked the beginning of the real climb. "Shoulders
back, Eleanor," chided our father, and "Hike up, Donald!,"

and then in his marching voice he began enumerating heroes in whose footsteps we walked, "U . . . lys . . . ses . . . Sir Robert . . . the Bruce . . . Pro . . . metheus . . . We walk in their tracks . . . climb behind them to the peak . . . persevere . . . brave men! . . . Women, too, don't forget!"

But the forest lay ahead, a gully of gloom. Suddenly, I was afraid. The ground rolled away from the pitch of the slope. The trees rose up brown and dun. On the ground, the leaves were scattered, red-brown. A chill wind blew from above. The tiger thudded our way on soft paws.

In the years' spin of memory, I long sought the reason for my fear. Then, once, it came with a jolt, as if I'd fallen through space on the line of two blue eyes coolly measuring me from above. Hadn't I turned and sent my hand flashing out to my father's body to grab the projecting part of him and hold on hard and twist? And in amazement and pain, hadn't he reared back and shouted, "Don't do that!"? And then as if his wrath built in a micro-second to ungovernable heights, had he not shouted again, "Goddammit! Don't *ever* do that again!"?

Smoke curled up from the grass where we stood. People, trees, meadow were wiped off the earth by my deed.

Or did I dream the whole thing? Or was it true that seeing before me the token of rank as that object seemed to be considered, I turned criminal thief and struck out to have it for my own?

The scene recomposes itself.

My little brother marches along quietly enough, a curly-haired miniature of the philosopher, who seems unperturbed.

The sky is blue again. The clouds glide on. Possibly our father even seems pleased with himself. So witty a young Freudian, was he even puffed up by the event, if happen it did—as it did?

I have only one token of its truth, a coin in the hand of a dreamer who wakes. When I see myself again on the path through the trees, my mother is gone and I am there with my father alone for guidance.

At the trees' edge, we stopped to dress again. Now our path doubled away from the slope and entered the shadows. Our father broke a branch, used it as a stick to hold back a vine, to beat down a bramble. He lifted a mat of brown leaves and showed us the buried wintergreen.

A wall cut us off, overgrown and falling down. We climbed it, pushed through thickets, met it again. It marked property once cleared, gone to wild. "The owner lives on the other side of the mountain," said our father, uneasily. "We don't know him," he said. "If we meet him, we'll say we were just hiking and took the wrong trail."

A patter sounded in the leaves. It began to rain. By the time we neared the crest, a storm boiled overhead. We huddled together under the split and rumble of Rip's bowling ball.

Then we came out from the trees, followed the soaking path as it turned around boulders, pushed aside a last stand of sassafras, showering rainwater all over ourselves, and broke into the clear.

Before us lay the plains, widespread, with field running into field toward the grey-green mountains. Over the Ashokan Reservoir far below, white mist trembled, a star field at our feet. The sun, blown free of clouds, blasted the High Rocks. Steam rose from the treetops all the way down.

"Halloo! Halloo!" we shouted. Little figures appeared on a tiny patch of green. There was our grandfather! There our grandmother and mother! He waved his gnarled stick. The women waved aprons, bonnets. Wildly we waved, leapt up

and down. Cautiously, then, we inched forward to sit in a row on the edge of the cliff swinging our legs in space, marking it all in our minds, the little house with its fringe of tigerlilies, the tiny car, the cornfield, the winding dirt road that turned by the little white church, met the highway and ran on beyond Hurley to Kingston and the antipodes.

A bee hummed. A gnat skimmed my ear. Thyme and lavender around about us released their fragrance. Somewhere below, an ax fell. A dog barked.

Now our father grew serious, pointed with his stick, subdued us with talk of long roads ahead, goals we must bear in mind, to live up to the faith of our elders.

I see his image still, hear words I place in his mouth.

"Let it be always like this," he says, standing on the mountain. "I've brought you to the top. I'll lead you safely down.

"We will all come back here together.

"Believe what I say. I know the way."

Then the climb was over. We came scrambling back down the mountain in no order, falling over stumps, muddying our behinds, scratching our legs. But for me, the distance between the heights and the house had a shape, a face, but hidden. It was the stranger, the beyond. Sleeping in thickets, the tiger, the bear covered their eyes with their paws and breathed in and out.

In long years before I remembered the meadow, I remembered the forest without wishing to, bare trees rising up, the earth in shards, red-brown, loose and springy. Even in daylight I could evoke the fear when I invoked the image. I was lost in deep woods. In my dreams, hopeless for help I knew would never come, I plunged alone along the path that would lead me deeper into, before out of, its tangles.

* * *

For the rest of those early summers, however, we belonged to the safe slopes, bottling insects, scouting for arrowheads, swimming in the cold pond, watching Mr. Zog's cows plod steamily home at dusk, when supper was laid out and soon, to our joy, the stories began.

The great storyteller of those days was my grandfather, Alexander Allan Munro, born in 1856 in the Scottish diaspora, transported ever westward by ship and new-laid rails as far as the Nebraska frontier, along with his seven siblings and his mother, Sarah, in the wake of his father, Thomas.

That great-grandfather of mine, Thomas, was born in Skye and worked as a Free Church schoolmaster until he read *The Origin of Species,* fell out of orthodox grace and sank to the lot of a poor farmer. His son, my grandfather, worked the Nebraska fields till he was twenty-five, a lanky, big-jawed rustic with mystical eyes and a brain full of Milton as well as Tennyson, Emerson and Longfellow, and Whittier for sheer enjoyment. Then at last, he took off for the brand new university in Lincoln. There he joined some hundred or so other farmers' sons, sitting on hard benches, all driven by the Christian lesson they got from their first readers: Become learned and virtuous and you will be great. Love God and serve Him and you will be happy.

At the university, "Sandy" broke up a couple of dry-goods crates and made himself a table, a bookshelf and a coal box. He laid in oatmeal, potatoes, eggs and bread. Having not enough left to buy a dictionary, he wrote home to borrow one from the doctor who lived next door. But his mind was being fed. He was memorizing half a chapter of Caesar a day and reading Xenophon as well as economics and social theory. And when the striped Chautauqua tent was set up outside town, there were lecturers and theatrical presentations. Of all the acts he saw in those days, the one

he remembered best was Joseph Jefferson as Rip van Win-
kle. When the bearded actor raised his arms to the sky and
cried, "Oh, what is this . . . it was only a moment I slept
and now I am changed . . . ," tears were in the eyes of many
in the audience, born at other ends of the earth and driven
by the fates to Nebraska.

My grandfather made great strides as a student, later as a
teacher and finally superintendent of schools in Lincoln,
when he began thinking about taking his place in the Great
Chain of Being that was the descent of the patriarchy. Then
it was his luck or fate to fall under the spell of a beautiful,
high-born and ambitious young teacher, Mary Spaulding, a
granddaughter of the Revolution and descendant of the
founding family of her birthplace, Crown Point, New York.

By the time her own father had been born, Spaulding pride
of family ran so high its newest member was christened
Americus Vespucius. True to his name, in mid-life he
uprooted his family, including Mary, who had just won two
merit scholarships to college in the East, and led them to
Nebraska. There he labored as a kind of capitalist Johnny
Appleseed, distributing the fruits of evolution until, even in
his lifetime, the prairies began to flower and fruit. Four
decades later, his seed catalogues advertising scarlet
tomatoes, purple-streaked petunias, blueberries and pear and
apple trees, printed on paper that kept something of the smell
of sod, lay among the magazines in the Catskill house to be
cut apart for scrapbooks. And so Americus's seedlings found
their place also in the minds of my brother and me.

When he died in 1909 at the age of 77, the *South Omaha
Presbyterian* wrote of him,

Up under the shadows of the Adirondack mountains is a good
place in which to be born, for from those grand old hills

started the springs of political power in Colonial days flowing like rivulets from the north at Ticonderoga, until the meeting of liberty's streams made possible Bunker Hill and Lexington. It is a great thing to be born right. Mr. Spaulding was so born. From his mother's breasts he drank in a love of liberty, and out of that primitive mountain home came a character founded on the unshaken rock of God's word.

His daughter Mary in her youth had the cut-ivory features my father would inherit. She had a sharp mind and New England manners, and along with her education in economics and politics, she had fallen in love with "all the arts" from painting to elocution. Like her husband-to-be, she had been brushed as well by the outspreading winds of evolution theory, in her case the new science of eugenics.

Applied eugenics, an outgrowth of Social Darwinism, was a technology purporting to hold promise for improving the human species. If an Americus Vespucius Spaulding, by pruning his seed stock of genetic anomalies, could grow wondrous fruits as a result, it seemed science might do the same with human seed. From the 1880s until after the First World War, the supposed technology was applied to the problems of a nation in rapid enlargement and flux. The aim was to protect the Anglo-Saxon stock, which had settled the nation, from unknown degenerate strains from foreign parts, especially China, Jewish Eastern Europe, the Balkans and Italy. To that end, prospective immigrants were examined and often rejected as genetically damaged, i.e., tubercular, feebleminded, of criminal character, physically disabled and so on. But a collective fear remained, directed toward the future, and many progressive-minded women of the time, who considered themselves advanced Christian liberals, took seriously the question of wedlock—specifically, the avoidance of "race mingling"—to the end of raising good child stock.

Like other ethically neutral theories, eugenics could be

applied for good or evil. It has proved its value in modern genetic counseling. But in pathological form it at least helped provide rationale for the concentration camps of World War II and supports racial enmities that still threaten the world. Its influence on my family would be subtle but long-lasting.

My grandmother's mother was a Christian Scientist not much given to enjoy the generative process or to pass on to her children a wish to experience it. Only one of her three, Mary, bore a child, and she may have been concerned that there was an anomalous gene in her own line of descent, for in spite of noble names in the family tree—Hickses and Carrolls in addition to Spaulding—there was also inscribed, on two separate lines within half a century, the nameless phrase "wild girl." Possibly to the end of genetic balance, therefore, she chose as her breeder a mild Scot with Highland ancestry, a historic castle in his clan's past, and even a battle cry: "Dread God." That his closer forebears had been poverty-stricken and scattered mattered not so much to Mary, I suppose, as that Sandy had book-learning and adaptability, proven by his place in the educational bureaucracy. Their firstborn son, named Thomas after the old Darwinist, died of a winter's croup. Their next and only surviving child, also named Thomas, would be my father.

As soon as his conception took place, Mary set to work on the fetus. During her pregnancy, she spent evenings sorting through reproductions of great paintings and sculpture, imagining by some process unknown yet valid her own "love of all the arts" filtering into her child's bloodstream. Thus, it occurs to me now that my father, who arrived in life with a dead brother's name to attach him to the past, may also have arrived with the theme of his eventual book, *Scientific Method in Aesthetics.*

After a couple of years, to ensure the lone survivor an education to meet his mother's ambitions for him, the trio

moved back to her native New England and settled in New York City. Mary was already set on a career as an elocutionist-lecturer and would soon make her way onto the Chautauqua circuit. After that time, my father believed, his parents' sexual life ended. Whether that was true or only sometimes true, then and thereafter Mary Munro's will shaped their lives, as it would indirectly shape mine. For she made her son as closely as she could in her image, though she lost him in the doing, as he would later both make and lose his own children.

In the East, Sandy took up elementary school teaching with promise of advancement when he should have earned his master's degree. Mary rented a Carnegie Hall studio and ordered flyers with a picture of herself in profile with her nose raised, her red tresses coiled and a silk rose on her breast. She offered recitations of Byron, Pope, Whittier and Lord Dunsany. She knew whole scenes of Shakespeare by heart, nearly all of *A Midsummer Night's Dream,* and was skilled in "Southern and Negro dialect." She also offered lectures on progressive issues like thrift, world citizenship and hard work. Sandy, however, kept shuffling the pages of his thesis, turning over an idea in the wind in those days: that from a merger of Christian morality and free-market economics, a workable social system might come. He followed his Darwinist father's lead and read with conviction the British philosopher Herbert Spencer, apostle of evolutionary progress in human culture. But to apply Spencer's sweeping observations to his small corner of the social picture was beyond him. So he plodded along and never got the better job.

Instead, he detached himself from the world somewhat and immersed himself in an idea also in the wind at that time: that if one sought carefully enough between the axioms of modern science, faint but certain evidence of human immortality might be found. Therefore, he read voluminously in astron-

omy, looking for clues to what he longed to believe. He became an elder of the church and his social life ended there. He was loving to his little son. He would get down on the floor and pretend he was a bear so the boy could capture him. But he laughed little, and his conversation was abstract and sometimes gloomy.

Mary found him sadly wanting in initiative. Diminished in patriarchy, he aged prematurely and his expression grew vaporous. Looking back and forth between her husband and her precocious son, Mary must have been filled with urgency to see the boy achieve great things.

My father, as he later gave me to understand, watched the light dying in his father's eyes with confusion and possibly also some shame, and may have felt again, as in the case of his dead brother, that he was taking his life from another's waning energy. If he failed to keep up the pace set for him by his mother, he may have imagined he too would join the ghosts.

In fact, his mother worried greatly about his health, and in spite of her allegiance to the public school system taught him herself at a little desk in the corner of their Brooklyn house. He left the nest only for one year of college preparatory at Erasmus Hall High School, then went off to Amherst, at which time the elders retired to the little homestead they had purchased in the Catskills.

There it was that our grandfather, by then a knobby, sour-faced Scot with the deferential manners of some country people, would take me and my brother on his knee when we begged him to tell us a story.

"Bappa, tell us about Rip van Winkle!"

"What? That one again?" He would settle into his rocker covered with old scarves and a crocheted afghan. He would raise his head, lean back against the chair and close his eyes

while he called up the lines. I looked up into the long deep pleats of his throat. I jabbed my brother as we settled ourselves in his lap. My brother jabbed me.

"Soo, soo," our grandfather would say, stroking our arms and our hair. "Settle down and listen. There was a man a long time ago . . ."

(Our eyes were closing, my brown head leaning on my brother's curly gold one.)

". . . and he lifted his hand to his face and felt a long beard. 'Oh, what is this?' he cried. 'What has happened? I just lay down for an hour, and now I am changed . . . and where is my home, and my wife and my son? . . .'

"Then came a lady . . .

" 'I remember a Rip, a long time ago,' said she, 'but he went away into the woods and his family is gone to the ends of the world. But come into my house, old man, and I'll care for you till you die.' "

Thus did our grandfather weave for us the first intimation we had of the exile's lament, the pain of separation and the impossibility of finding one's way back to the place of beginning. So much had been lost out of his own life by then, a whole clan vanished on the winds, his sisters Flora and Ferny, his mother and dad, and behind them in memory, the patriarch, Big Alexander of the Prayers, an evangelical preacher-teacher born on Skye after the catastrophe of Culloden.

On us, our grandfather shed the love those clansmen shed on their children and the lore he had learned by the sea and on the prairie. He taught us the Indian walk and how to lift birch bark with a penknife, bend it and seal it with candlewax for a toy canoe. He gave me my name, Hiawatha Painted-feather, and ordered me moccasins and a bow and arrow from the Sears, Roebuck catalogue. One day when the rain was blowing in sheets, he strode out into the storm to cut me Indian grass for a basket.

"Because he loves you," said Mary, biting off a thread. I watched through the window as he leaned against the wind. He came back stamping, shaking rain all over the kitchen, his eyes grave behind spotted glasses, speaking in a brogue full of tenderness, "It rains on the housetops and all through the land . . ."

When I dropped my doll, old and floppy, down the outhouse, he raked it up and washed it. "Because he loves you," said Mary tightly, watching it blow on the line. It must have hurt her to see how such small acts touched us while her demanding labors left us unaware.

He seemed very wise and knew all the tales, and even those he may not have known I attribute today to his telling, for they all come out of the same well. "Pison, Giheon, Hiddekel and Phrath," he would begin, "four are the rivers that run toward the sea." He would reach over to the enormous black teacher's desk that stood by his chair, pull out from among his Testaments and Psalms, his Homer, his Tennyson and Longfellow, his Emerson, Darwin and Spencer, a yellow tin box of licorice. His hands would move like rusty farm machinery to work off the lid. With slow farmer's hands, he would grope out two tiny black squares for us and go on playing on the strings of our imagination.

The old names lay soft on his tongue——Gilgamesh and Abraham, Theseus and Odysseus, Mowgli and Ab, and the one who went into the pit and whose coat was dipped in blood.

"Man was born in a cave and lived in a tree. Man sailed in a boat dug out with fire, curved like the moon. Man wrote on a stone in letters called runes.

"What is man?" he would ask us children, looking away over our heads into the distance through his heavy glasses. Then he would answer. "He struggles upward. He pushes on. He reaches his level. He will live on that spiritual height forever."

"You are so wise, Bappa," I said more than once, standing by his knee, looking up into his face. And he would correct me gently, "Remember the man who walked by the sea and picked up a stone.

" 'This stone,' he said, 'is what I know,' and he threw it into the waves.

" 'The ocean is what I do not know.' "

There came a time, after Mary died, when he came down from the mountain to live with us in Ohio. I was then an adolescent, and he seemed to me pulled out from the roots, an aged melancholic in black clothes and ill-fitting false teeth. For a while, he wanted to chop wood for exercise, as he had once done for necessity. So my father ordered cords of it, and every afternoon he would take his stance in the backyard, fix the log with solemn gaze, lift the ax and let it fall. All afternoon, *chop chop* would echo down the backyards of our suburban block, *chop chop* like the sounds of country lanes. So he would chop while the hours went by, and it came to me, young as I was, that he was holding time at bay.

Then his mind began to go. "The Overflowing Fountain bathes us all," he would intone. "The spirit lives on. We can communicate beyond the grave. I often feel the presence of my beloved Mary." At parties in our house, he would lift a finger to a circle of guests. His impassioned brogue brought them to a halt. "What is man? A wind that passeth away and cometh not again . . ."

Witness to such scenes, my brother and sisters and I stood helpless in pity and shame. "He is old, he is sad, he is mystical," our father instructed us children, four in number by then. "He believes in things people no longer do. Don't hurt him by arguing, but remember there's no truth to them." I saw our father had no way to approach his father or to alleviate his own pain. It was then our mother, usually so

diffident and self-involved, who would reach out to the old man, quiet him and lead him off to his room at the back of the house. So that finally we children, busy in any case with our schoolwork, our sports, parties and friends, were uncertain how to behave and drew away, leaving our grandfather in his loneliness.

During my first winter at college, he died. He left me a little black notebook in which year by year he'd copied out poems he loved. In it, I found again William Carruth's once-famous, swelling lines I had first heard spoken in his Gaelic accent:

> A fire-mist and a planet, a crystal and a cell,
> A saurian and a jellyfish, and a cave where the cave-men dwell.
> Then a sense of law and order, and a face turned from the sod.
> Some call it Evolution. Others call it God . . .

and so also of Autumn, and Longing, and Consecration, all of which some others "call God."

Then I put the book away in guilt and sorrow and also in silence, for my father's resistance to talking about death or the dead spread an anesthesia throughout our household. For him, it would never wear off. After he carried his father's ashes back to the mountain in a box, he would never return or mention the place again, nor would he speak of his mother. But many years later, when I picked up the black notebook again, I found my grandfather had inscribed one poem twice, first in his youth, and then, on the last, unfinished page, tremblingly he had traced its first words, "Help of the helpless, O Lord, abide with me . . ."

Only nine words they were, but placed just before the silence of the book's end, they sank deep into my mind, evoking the thoughts even a young person has of the dark distance into which all things are swept. And as life goes on,

other deaths and losses add to this store of darkness, so it deepens, until the smallest natural happening—a roll of thunder, the edge of a wind lifting the hair, an animal cry at night—can open, again, the sluiceway behind which waits one's own death, ahead.

"It is gone, the beloved clan," I imagine my grandfather saying, sitting on his narrow iron bed in Ohio, staring down at his black, bulbous city shoes.

It would be twilight of a winter evening. His little room at the back of the house was pleasant enough in summer, for it overlooked the garden. But in February, it surveyed a desolate scene of flower beds in burlap, icicles along the window-frame.

A frozen branch rattles against the roof, the radiator bubbles and begin to knock. The old man remembers the harsh, sweet smell of woodsmoke and peaches cooking.

"The land lies behind, covered in mist," he thinks. "The river will find the sea.

"I believe we shall meet again.

"But where is the past, and what is the shape of the world to come—these are mysteries."

The radiator falls silent. A pall of cold air falls from the window onto the old man's knees, drifts down to his shins.

"Mudwayushka, little firefly," he mutters, laying his hands on his knees, fingers outstretched, his gaunt head sinking, his eyes big behind heavy lenses.

A whippoorwill calls. A bobcat screams.

The children are on his knees, pressed shoulder to shoulder.

"O Bappa, when will you die? You are so old, your eyes are red."

Golden is gone, brown is gone.

How then shall we all come back together in the end?

CIRCLING EDEN I

The meadow melts to a transparency, and a backyard in Ohio shows through. Through the scrim of years, I see a turning sprinkler, four flower beds and, at the cross-point where the neat beds meet, an apple tree, under whose boughs my mother sits in my imagination still, in archetypal pose, cross-legged in the grass.

She wears a blue peasant jumper. Puffed organdy sleeves fall halfway down her freckled arms. Her dainty nose is snubbed; her chin ends in a piquant mound; her grey-green eyes are set deep in sockets ringed by pale auburn lashes. Most extraordinary, however, to me, even so young, is her hair that rises in amber frizzles the minute she slips out the tortoiseshell pins that hold it down in coils over each ear.

Green shadows mottle our skin as the sun drifts through the leaves. Behind us over the flower beds bees hum and a butterfly floats over the bridal veil. We are waiting for mother's Harper Method hairdresser, Vera, whom I loathe with a jealous passion for her access to Mother's head. But meanwhile, she is teaching me to read from her worn volume of Eugene Field. Inside the cover is a dedication that will tantalize me all my life, for the handwriting is not my father's: *To Kinkie: inarticulate the lips of love must ever be.*

She reads, then shuts her eyes and turns to the sun. What is she thinking as she sits there in the grass, ignoring me? She is always on the verge of being lost. Would she care if she lost me? Each time she leaves me alone in the car while she runs into the grocery store, I know she will never come back.

I push her shoulder to bring her back now, to tell me about the Maxfield Parrish picture on the page that lies open in her lap. It shows an old man drowsing over his cane, facing across a gameboard a child whose hair is an auburn bush.

"Shuffle Shoon and Amber Locks, sit together, building blocks . . ."

Between the figures lie blocks and towers, placed here and there on the squares, moved by each player in his partial knowledge of the game, his partial blindness. I stare at the self-absorbed figures bound by yellow half-light. I know the old man, Shuffle Shoon of my imagination. He is my grandfather. But who is Amber Locks? Her, I cannot catch. Far off, magnetic, my mother my stranger, elusive quarry of my imagination.

When I was a little older, I was beset by the idea the answer was hidden in the house. I would begin methodically in her bureau. I would lift and look between her stockings, her folded laces. I searched the purses, brocade and needlepoint, batik and tapestry. I felt among the gloves. I ran my hand around the back of the drawer in case the secret was a folded paper.

I moved on to her jewelry boxes to finger the brooches, the necklaces and rings. I passed to the old iron safe that stood unlocked and sifted photographs, documents, love letters. One of them was from my father and had the line, "I am remembering you as you were before the fire, all gold and ivory, with your lips on the corner of my mouth, very soft."

Eventually, I went downstairs to open every drawer, even those rarely opened that held only a ball of fluff or a paper clip. But the answer was nowhere, though sometimes my scalp lifted with anticipation, and I thought I was nearly there.

Later, as an adolescent, I would seek her in her closets, down the full length of her dresses, soft and perfumed against my arms, my cheeks. I would push aside the padded hangers to finger the steel-grey satin, the rough green cotton. And always I sought her at her glass-topped dressing table, between twin lamps with pleated pink silk shades, where I saw

her face thrice, once in profile framed by her uplifted arms, again in the mirror, again in the little wedding photos she had mounted under the glass.

Doing her hair, her fingers flew braiding, then twisting it to pin over each ear. She reached out to her perfumes, rows of crystal bottles in green boxes, brought from Paris long years before. Evenings, she played a game of choices, fingering the bottles, selecting one, unscrewing the golden cap, serving herself a drop on the nape of her neck, her ears, her collarbone. I leaned against the mirror post carved with grapevines or I crouched by the foot of the table looking up at her, such a stranger in her hair and dressing.

How it hurt me then, as if there were something I could never understand about her, that every time I said something like "I love your hair . . . ," she would toss down the brush and say, "I hate it . . . nigger hair my mother said, and she called me Kinkie."

"Oh!" she would go on, "you can't imagine how ugly I was with this hair like a bush!"

An engraving in one of my books seemed to touch on her mystery. It showed the gypsy Mignon dancing between eggs set on end across a carpet. Lightly, on her toes, she tripped between the eggs. Nearby sat Wilhelm Meister, thoughtfully watching. The words under the picture made me stop reading, lay my hand on the page and lift my eyes to the window each time:

> Knowst thou the land where the citrons grow,
> And oranges under the green leaves glow?

The story went on.

" 'The land must be Italy,' Wilhelm said. Then he asked, 'Have you been there?'

"But the child did not answer."

So heavy with unexplained matters did that last line seem

to me that, at some time in those early years, I took a pencil and underlined it in my book, word by word.

In later years I would pick up my mother's trail among people I'd not known in Ohio—Europeans, artists, aliens of one kind or another. For a long time, there seemed to be danger in this quest. Coming closer, I beat as if on glass, broke out in hives and flushes, driven by anxiety, never reaching my goal.

How could I? Caught as if in amber, she ignored my approaches, sitting now under the apple tree, now at her dressing table, lost in contemplation of herself in the dogwood meadow as a mountain bride.

But we were in Cleveland.

In 1925 when they married, my father, a protégé of John Dewey, was associate director of education at the famous— soon to be infamous—Barnes Foundation in Philadelphia. Within a year he had split, relatively amicably, with his employer and moved to Rutgers. Then, in 1931, he accepted a call to the museum in Cleveland, once one of the most civilized cities in the nation, then on the cusp of social change.

That city was a larger mirror of our family. Its roots, like my father's mother's, lay in puritan New England. It had been founded after the Revolution by citizen "sufferers," as they called themselves, of the post-war social disruptions. Granted settlement rights south of the Great Lakes to rebuild their lives, these New Englanders shipped out the furniture of a high culture—books, paintings, pianos and surgeons' tools— and laid out what they envisioned as timeless cities in the wilderness—Athens, Sparta, Oxford, Concord, Sharon. Cleveland began as one of these.

The settlers put great store on benevolent institutions. They started libraries, academies, clinics, endowed galleries

of natural history and fine arts. In the era of robber baron
capitalists, the institutions profited. Rockefellers, Severances,
Carnegies left their names on walls and plaques. The academy
became a university. The clinic acquired marble halls. The
picture gallery became a museum rich in bronzes, tapestries,
suits of armor, and portraits of kings. When I was a child,
descendants of the original founders still lived along the lake
in granite mansions hung with El Grecos, Rembrandts and
Cézannes. Solemn with responsibility, they promenaded at
cultural events, Edwardian men in dinner suits and plain,
intelligent women in great-girthed brocade gowns. It was the
enlightened among them who, following Dewey's advice,
hired my father to set up a broad-based educational program
through which the museum, in accord with old evangelical
and modern educational principles, would extend its benefits
to the whole city. It was the social challenge that appealed to
my father, he later told me.

In fact, in the Twenties, Cleveland was sometimes called
a model democratic city, an amalgam of immigrant groups—
Greek, Russian, Italian, Czech and so on—centered on their
own churches, temples, meeting houses and restaurants.
There was a pilgrimage trail of national shrines that coursed
a local park; at the dedication of the Irish one, William Butler
Yeats was the honored guest. In those days and until World
War II, the Lake Erie fishing fleet was blessed each spring
as fleets still are on the Massachusetts coast, and Orthodox
children carried Easter baskets to their priests for blessing.
When I was a child, Italian women still climbed the hill to
our neighborhood on summer days, fanning out, ringing door-
bells offering to clear the lawns of dandelions. Hired, they'd
pull out penknives, spread their big cotton aprons, and sit on
the grass all afternoon, gossiping in soft Italian dialects. They
got some money and could keep the greens. So far as I knew,

only my mother, of all the women on our block, paid extra for a basketful to be left behind for our own table.

There was a literary and theatrical life in Cleveland in the old days, too, drawing on local artists, and mildly indecorous artists' balls, and discussion clubs where Christians and Jews—businessmen and lawyers who customarily didn't meet socially—got together. Cleveland was democracy in action, another Athens, some people said, though others, like Hart Crane, who was born there and fled, disagreed.

Crane was more right than wrong. There was a bleaker side to Cleveland. The first settlement had been laid out in the fetid swamps of the Cuyahoga River delta. Eventually the riverbanks or Flats, as they were called—linked to the high banks east and west by bridge spans flying off from massive stone piers—were firmed up with cobblestone roads, docks and railroad trestles. Soon the furnaces and refineries of the iron and steel industry were built there. As these grew, so did Cleveland's population of immigrant workers, who began to push out along the plains to the east, settling into crowded enclaves which continued to grow cheek by jowl with the rising impersonal institutions of the financial city. In the Gilded Age, the gentry lived in quasi-rural elegance some miles to the east, well out of sight and hearing of the city's industrial core. But already by the 1930s, working-class neighborhoods, expanding ever eastward, began to catch the tail of the flight of the prosperous, taking over turreted and great-porched mansions recently vacated by the rich, surging into crowded ethnic neighborhoods at the foot of and on the backsides of the suburban uplands. Meanwhile, the fortunate moved ever outward, into Shaker Heights, on toward sunrise and the foothills of the Allegheny Mountains. Out there, beyond the tax net and social problems of the city, they live still, in New England-styled townships with historic names like Chagrin Falls and Hunting Valley, with all the perks of

a gracious past—polo, balls, skating and sleighing parties—
which I much relished in my adolescence.

Meanwhile, new waves of immigrants including unskilled
blacks from the South flooded the so-called inner city of
Cleveland in search of work and opportunity, and with crowd-
ing, unemployment and deepening poverty began inexorable
social decay, to be held off only temporarily by the labor boom
of the war. Even by the time we arrived, in 1931, what had
been in the Jamesian era one of America's fabled thorough-
fares, the idealistically named Euclid Avenue, originally laid
out alongside a rushing stream bordered by willows, ran
instead past small-tool factories and decaying wood-frame
dwellings: the remains of an American civic dream.

Thus by both geographical paradigm and economic evolu-
tion, Cleveland possessed both highlands and lowlands, for
anyone who cared to see.

Highlander, I made my abode in the boughs of the apple tree.
There, I lived my secret life.

I would climb up, find my roost and plan to stay. I could
live on sour green apples from its branches. I took my books
and read while keeping an eye on my mother as she bent her
trowel to the flower beds.

The days were long, the years a waking dream.

It snowed, it rained.

When it snowed, the world thickened and grew silent.
When it rained, the roof made many sounds. Outdoors, I took
a paper umbrella, brought by my parents from far-off Japan,
opened it halfway and crouched under it on the grass. Then
I was truly inside the rain.

Folding the parasol, I ran to the street where the gutters
were streaming. I built dams and channels, moats and river-
beds, forcing the stream here and there, widening it till it
spilled across the humped road, drawing it back. I braided the

streams of water until my knees ached from squatting and my clothes were soaked.

Suppertime came. My father was on a health regime. Longevity was his goal. To that end, one season he ate oatmeal, another, carrots, another, eggs, another, no eggs. Once, I remember, he and Mother dragged chairs out onto the back porch and ate Birchermuesli out of big white bowls. They smiled at each other as they lifted spoons to their lips. Honeysuckle poured down the trellis beside their chairs. I took my bowl and filled it with blossoms, bit off the end of each in turn, drew out the thread with its drop of nectar, touched my tongue to it.

"Heckameedes!" sighed Mother. "Slumgullion is what she needs, to put meat on her bones." She liked to make us laugh with names of outlandish foods she'd eaten as a child: cornpone and grits, goulash and mummaliga.

Butterflies drifted across the flower beds, slowly sinking down, and starlings who roosted under the eaves of the house flew out of the greying sky, homeward into silence. It grew dark.

I was alone in the yard under the last of the birds. I took a stub of pencil and wrote my first poem, about the bird who sings all day, the one who sings its life away and the one who wakes the child; and though the last line didn't scan, it seemed a right-enough letting-flow of feeling into words, so I took it to my mother, who was sitting at her dressing table unpinning her hair.

"You wrote that?" she asked. I nodded. "If you wrote it," she said, "you'll know it by heart. Say it to me."

My breath stopped. I felt I had been trapped in a lie. I hesitated, then began reciting. Miraculously, as if I were in deep water, reached down a toe and touched sand, I found the words in my mind, from where they had come.

* * *

I was put to bed early, as what cared-for child, including the
greatest of rememberers, was not? Those drifting hours when
the air turned to grainy dusk, sounds subsided and I was
alone in the upper reaches of the house, were lulling, as if I
were again in a dream that lay behind me in time as well as
ahead in the oncoming night.

I would creep out of bed, lean on my elbows and stare down
through the window screen. Across the street, in shadows, a
girl played ball with her father. Quietly, they threw and
caught, lifting their arms and lowering them slowly as if they
were moving in water. Slowly, the air around them and the
room behind me filled with grey light. Fireflies came out of
the hedges, and the hydrangeas down by the front door took
on a phosphorous glow.

I went back to bed, lay down and began to turn the pages
of my fairy tale book. I lingered over the princesses dancing
among trees of gold, silver and crystal and hastened by the
Snow Queen with her ice-cold face. I put down the book and
picked up another, about the Dog of Flanders, the children's
protector, grown old at last and left to die by a road.

Sleep came slowly.

Sometimes I woke from a nightmare and lay still. Then
the sense of being alone was terrifying. Perhaps it was a cat
in the yard that woke me, or some other sound from beyond
the walls of my room. Against the dread that then beset me,
my mother was no help, for she seemed to be, in a way I
was far from understanding, a participant in the events that
had disturbed me. I called not for her but for my father to
come sit with me and stroke my hair till my eyes closed
again.

"There are no ghosts," would come his quieting voice.
"There is nothing to fear. The street is quiet. All your friends
are sleeping.

"Cats cry in the night because they're lonely. Don't feel lonely. I'm here beside you."

Sometimes, on the other hand, I would be lulled awake by the sound of the shower running in the bathroom that joined my room to my parents'. Then I would half-open my eyes to a line of brilliant light under the door and the sound of their soft laughter. Never in life would I feel a more voluptuous calm and safety than when I lay there in my dark bed moored on that luminous line, listening to the rush of water and the rise and fall of guardian voices within it.

Then it was morning, with sun coming in darts through the elms. A spot of refracted light, yellow, appeared on the wall. Steady, blurred at the outside edge, clear in the center, it held its place. My eyes locked onto it. I lay there, neither thinking nor stirring, in attendance on that light, which came through space and through the elm leaves into my eyes, calling me effortlessly, unstoppably, into the harbor of the day from the night's illusions.

Wind moved the leaves. The light broke into moving patches. I turned back my covers and scrambled out of bed to stare down through the window onto the lawn where a robin, a brown rabbit, and hydrangeas heavy with dew awaited my coming.

The yard enlarged and became a suburban block. The block held gardens in rows, and back alleys, and houses with differences, one deep in ivy, one of cold white shingles, one of brown brick with low arches and a sullen door.

The houses, yards and sidewalks, and a single empty lot were a stage set for us children. We tramped the alleys and built hideouts of brush in which we crouched to eat our shredded carrot sandwiches. We invented secret codes and left messages in matchboxes under rocks. We peered in

neighbors' windows and reported to our fathers we'd seen thieves. There was little suburban crime in those days, yet we were forever busy creeping and spying, tiptoeing into the attics to spy on our cooks' undressing, rifling our brothers' desks, leaving no stone unturned in our investigations.

Of the pack of little girls I played with, the one who thought she was a fairy, the one whose bloomers were edged with hand-made lace, the one who would first show her budding breasts to the boys, the one who ran at the pack's head held that place by a stranger singularity. "I have a secret," she told each of us, one by one, hesitantly, turning her head away. "Never tell."

Her huge dark eyes were grave and often expressionless, as if she were listening to an inner call, or perhaps for such a call, that never came, though she prepared for it diligently, perfecting her manners, her posture, her courage.

She wouldn't play with dolls nor would her loyal followers. Then one day there was a revolution. Tears shone in her eyes as she heard out the defectors. She straightened her spine and walked away alone. By the next day, the rebels' dolls were put away again. But I couldn't forget the fierce way she had held back her tears.

Each of us felt a bond of protective intimacy with her, as if she stirred in us some recognition beyond our capacity to tell. She carried for us all the burden of stoicism of the adopted child, providing us dim inkling of the linked, inseparable mysteries of heritage and self-knowledge.

My dolls were put away for another reason. At a children's party, I saw a troupe of marionettes perform *Midsummer Night's Dream* on a gauzy stage aglow with green-yellow light. Soon I'd made a set of marionettes out of plaster blanks and bits of wood and string. For these little creatures that could speak, question and make reply, I laid away the silent ones—

my baby doll Ruby, Orange Bird and the Old Breton Woman, the Alsatian with black lace scarf and the Hopi corn doll. In camphor and tissue paper, they slept the years till I called them back in my dreams.

Of ourselves there was so much to learn, we must begin at the beginning. We were sitting around in a room with the door locked one summer day when someone shouted, "I'll show you if you show me!"

"Let's all show together!"

"Now all together!" And we tugged aside the crotches of our shorts and panties and screeched with shame to see ourselves in so many mirrors. Suddenly my father rattled the handle of the door and called, "Hey! What's going on in there?"

"We're playing nudist colony!" I yelled, to wild laughter behind me.

"Well, hurry up and finish and come on out," he said, not unkindly. We were up to educational play, and he approved of children appreciating their bodies. Besides, we were prepubescent, in free flight. We swung in the trees, leapt off the roofs of tool sheds. Roller skates were our feet; our bikes, our legs. We were still full owners of ourselves, and my father could sleep easy at night.

My friends' fathers had no such bearing on our lives. So far as I knew, they left our world in the morning and came home, silent, at suppertime. Mine was different. He often worked at home, typewriting, and in those days had jolly friends, tall men, artists and teachers, who played Ping-Pong in our cellar and decorated their wives as nymphs or Europa for costume parties. My friends' mothers dominated their homes like New England clipper-ship captains. They taught their daughters to jump to their feet on the bus for nuns, to curtsy to elders and to wear fresh underwear daily. They took them to downtown medical centers where their growth was

monitored. My mother was different. She was ignorant of such
duties. She drifted and dreamed, leaning her head against the
window behind the piano as I went running by in the snow,
freezing cold.

She was a pianist.

When she sat down to the piano in the evening, the minor-
keyed chansons and rhapsodies she played made me bury my
head in the sofa and weep. When I was sick and lay in bed,
the piano robbed me of her. All the years of my youth, her
morning practicing—concentrated, driving, obsessively ad-
dressed to the perfecting of works memorized long before—
was to me the very language of her inner life, by which, as
I slowly came to understand it, I began the climb into my own.

Our block enlarged and became a neighborhood. Still in its
confines, we followed driveways lost in greenery up to the foot
of abandoned mansions, built in a boom, then vacated. Daring
to go farther, we followed linked streets to their extremities,
a wide landscape of hills and gullies, the edge of some larger
geographical configuration of which our neighborhood was
but a fragment. And still we went on, on foot and bicycle, until
we came to wide boulevards and saw, beyond those concrete
ribbons unpassable by us, the signs of the city: a water-
purification plant, a veterans' hospital, a railroad trestle.

Those nights, I'd lie in my bed and listen, like many a
midwestern child, to the cry of freight trains on that track,
traveling west, traveling south, trailing their cries like mi-
grant geese. And later when the factories down in the Flats
began to work around the clock, that is, when the war came,
I would hear as well the melancholy cry that signaled the
changing of shifts.

The wind as well was harbinger then of change to come,
pouring down from Canada and over the lake, on over the
hedge-bound houses across our street, then racing through

the tops of our elms making them dance frantically, wind that also, rising in gusts skyward off the lawn, flipped the leaves until we would stop our game and call, "The leaves are silver... it's going to rain."

In fact the homely bluff we lived atop, Cedar Hill by name, marked the dividing line between the Great Central Plains and the first of the Allegheny foothills. This was my childhood Eden's outermost edge, toward which our father was gradually, with reasoned care and common sense, moving my brother and me, while he went freely back and forth from its green confines. Daily, he left our leafy street by a narrow path that descended through a short ravine to let him out on the plain just a couple of miles from where the museum stood. Evenings, he climbed back up the rustling hillside into the highlands where the westward-facing windows burned like signal fires calling him home.

And then after supper, he would send our imaginations traveling out beyond the walls of the house, out over the darkened yards and even the city's boundaries, on to the farthest ends of the world illumined by his wonderful adventure stories. If our grandfather's tales came out of the past, our father's carried us toward the future. My brother and I would curl on either side of him on the sofa. He'd give a short cough and forge forward into another evening's episode of his years-long epic, not of ancient heroes but four young Americans with names like ours, who traveled underground rivers into lost valleys where cavemen still lived, who went into the sea in bathyspheres and into the air in dirigibles, who believed in no gods and felt neither fear nor sorrow. Following his lead, I forgot melancholy. Before long on my own I'd read all of Nordhoff and Hall, knew Pitcairn Island, the Black Hole of Calcutta and the ports of the Horn, and when it was recess in the schoolyard and my friends traded playing cards of

Shirley Temple, the Dionne quintuplets or the Pullman kittens, I collected the cards with maps.

Our father also, back then when we were disciples, instructed us in the principles of humanism as other fathers might teach the catechism or the Commandments. Empiricism, scientific materialism, pragmatism—these words he didn't use, of course. But with many a straightforward assurance, he cleared our minds of what he considered old errors of thinking. We were not to imagine there were ghosts, for we can trust our senses. They don't lie, and as we can't see ghosts, they do not exist. Following that, the dead do not survive. Who has seen or heard a spirit without flesh or voice?

"There is no god. The cavemen saw shadows in the rocks and called them gods. The Greeks saw gods on the mountains. The Greeks, though wise in some ways, were more childish than you in believing in gods when there are none.

"It would be nice to think the gods would solve your problems. But you have to do it yourself. Study. Learn from experience. Improve yourself. Control your bad feelings.

"Let your goals be high ones. Compare yourself with the best. I'm always the optimist. Even if things go wrong, you can begin again, make progress."

Reason was everything to him, common-sense reason. He saw life then as a road leading across a gently rising plain, a Dutch landscape perhaps or an English pastoral painting with a small figure in it, himself, striding along, lighthearted, with a sense of ease and pleasure. "Death, O death . . . ," he said one evening in answer to some question I've forgotten. "That's a long way off. It's the worst, the end of everything. So enjoy life. We'll be together for many a long year still."

Then gradually, seemingly without cause or cure, the joined days of the endless time drew to a close. I was down in the

dumps or angry. In spite of my father's assurance that I could if I tried control my bad feelings, I couldn't, especially my detestation for the masseuse Vera. Mother would sit in the sun with a towel around her shoulders while Vera rubbed an herbaceous orange ointment into her scalp. One day when she was expected, I planned to trap her in a pit like a tiger. But when she rang the doorbell, I was certain she would read my mind, so I frantically disguised myself, covering my hair, my arms, even my face with an Arabic arrangement of my new-born sister's clean diapers. For a third child had been born. This event, and one birth more to come, obviously changed my circumstances, though not as negatively as one might think. Like many big sisters, I was given caretaking respon-sibilities and so learned to love babies instead of resenting them, even incorporating them into my dream-life as pretty phantoms of my own vanishing childhood. But undoubtedly I also felt my fragile hold on Mother's attention threatened.

I came down with a sore throat and the doctor was called. As he approached me holding out the wooden tongue depres-sor, I had a fit, screamed, thrashed and kicked. My father moved in and grabbed my arms. Mother, at his command, held my feet. The doctor pinched my nose, my mouth opened and he jammed in the stick. He can have seen nothing but a black hole, for I was out of my mind with fear and rage.

My father was shocked. He looked to his psychological training and turned a behaviorist arsenal on me. I was forbid-den the Sunday comic strips and commanded to write, five hundred times, "I will obey my parents." Raging, I scrawled the hated words, then crept downstairs to find the comics, and so learned hypocrisy and deceit.

On a summer holiday by the sea, I lifted three gold nuggets from the sewing box of an aged neighbor. Later that day there were troubled conversations and I was led back to the site.

A story came into my mind, and I believed it to be as true as the other one I couldn't remember. I said I'd found the nuggets in a stone wall. Behaviorism was called upon again. As if deliberately, my father began to alternate his former loving kindness with episodes of severe coldness, and let me know why. I was developing a bad character. I must change while I was young or no one would love me. My perverse behavior continued. I broke my arm and was nestled and read to for a while. The cast came off and so did my veneer. "I worried about you," said my father solemnly, sitting by my bed after a turbulent day. "Then you broke your arm and you were good. Now your arm is better and you're back to normal, sullen and disobedient." He didn't say "Repent," but the feeling was there.

To uncontrol, hypocrisy and deceit, I added treachery. In the footstool on which he propped his feet when he told us stories was a rip known only to me. At the bottom of it, under the stuffing, I hid a prayer book. Sometimes in the day, when he was gone, I took it out, locked myself in the bathroom and prayed. One day, a bit of paper lay on the floor. I said to God, "If you exist, pick up that piece of paper and give it to me." I felt on the brink of a dangerous possibility. If God were to show himself to me, would I be obliged to tell my father and incur his ridicule? I doubted I would have the courage.

In the spring of 1939, we moved to a larger house in the same neighborhood. It was of Georgian style, brick with a white portico and columns, fronted by wide lawns. The openness of the lawns was deceiving, however, for the house was closed in behind deep awnings that hung to the shrubbery on all sides, and the walls were dressed in such a coat of ivy it had to be ripped from the sills each season before it invaded the rooms. Indeed, the house wallowed in seas of green so sowed

with dandelions, daisies, crabgrass and clover no Italian weed-puller could keep them back for long, while around the borders of the lot grew redberry, snowberry, various low cedars and rhododendron. Nature would be forever overrunning her boundaries in that house.

The September after we moved, my youngest sister was born. And on Christmas Eve of that year, I traded my own childhood for the girlchild at home and became a fertile being myself.

That evening according to custom, my friends and I went out with our fathers to sing carols. It was snowing a real Ohio blizzard, and I was aware, at every step, of the thick new garment pressed against my body under my snowpants. Through the driving snow we shuffled, stopping at house after house to pick up more children, always led by the fathers in their heavy overcoats, their shoulders growing white with snow. Red and blue Christmas bulbs shone through the windows and splashed color on the drifts below. But to me that night the lights looked not cheerful but sad, sad and mystical, signifying an event so ancient and remote I had no sense at all of its meaning. So small a lonely troupe, we seemed, in a night so dense and scudding, and the songs we sang gave me a sense not of joy but of mystery. And my passage into biological maturity that night was also a lonely one, without a word of comfort tendered me by any elder, female or male, beyond the shy, halting instructions of my mother.

In a community of women bound by shared social forms, each learns her place in the curve of life, but there was no ceremony to welcome me over that threshold. On the contrary, anxious embarrassment was the only emotion I would learn to associate with an event that caused plugged toilets, attracted pet dogs and drove young brothers to snickers. The biggest worry was whether anyone "knew." Not until thirty years later, during a trip to Asia, was I suddenly faced with

visible proof of the community I'd passed into that winter night so long before. Touring the university in Taipei, I entered a ladies' room that looked as if all the wombs of the world had exploded in it at once. By custom or no custom, the women students had wrapped, bound, knotted or pinned anything and everything between their legs, then flung the rags into overflowing baskets, cubicles and sinks. There were handkerchiefs, patches of newspaper, torn bits of sheet and paper towel, underpants, lengths of cotton batting, all streaked with red. In sanitized middle-America, who could imagine such a tide from whose fluctuations not one of us was liberated?

That spring, a boy in school asked me to go for a walk with him after dark. "When you're older," said my father with shocked finality.

"It's too early to begin," said my mother. "Wait. Until sixteen or so."

Wait! I howled and beat my fists on the wall of my room. I had just turned twelve. Wait four years to begin? My wild head spun.

It was another beginning.

CIRCLING EDEN II

Naturally I knew nothing of my father's own needs and epiphanies when I was a girl and he spoke in a voice of eternal truth.

How did he come to be that way, my father?

Of his paternal ancestors, some were loyalists to the Free Church of Scotland, others evangelicals struck with spirit fever when the "time of the shaking of dry bones" came to Skye. But they all shared a faith that the scattered would come home when the promised restoration of Eden would take place. Meanwhile, each man and woman knew his or her place in the social model that reflected the divine one: an interlocked set of circling spheres, one within the other, with the Lord in the center. In human society, women, far from the axis of authority, orbited the men; sons circled the father; fathers, the chief; all parishioners, the elders of the church, and the elders, like the tribes of Israel, circled the Lord. Purely as an image in the mind, the model had power. It afforded the believer a sense of psychic and social equilibrium and also the promise of escape into its starry suburbs one day. Indeed the image was so vivid, so suggestive of parallel formulations across the extent of the natural world—from seashells to the intervals in the musical scale to the geometries of the solar system—that each generation might lose faith in details and still retain faith in the unity of the whole. So the model survived in the minds of my grandmother's people, too, who were Quakers and Congregationalists as well as Christian Scientists. In the end, what bind a Christian of any denomination to the foundation are a desire for philosophical order and faith in progress within the structures of the ordered model. Compared to orthodox, creed-bound fundamentalists, my father's father and mother called themselves liberals, but they still looked to their son

to pass forward the ancient form with its social, ethical and even metaphysical implications.

Then their son, in an intellectual leap that would strike the elders as a revolution, discovered Modernism. Thereafter, the parents would see the son lost, the son see the parents foolish. What none of the three realized was that, in his leap to so-called freedom, the young man must bring the grand old vision along.

From his birthplace in Nebraska, my father was carried east on his mother's lap and resettled in a Brooklyn that was no melting pot but a tight-knit homogeneous community of Anglo-Saxon churchgoers. It was the safety of the streets he long remembered, and also the quiet reasonableness at home, no argument, no raised voice, instead the lamp-lit hush of book pages being turned, broken by an occasional reading or quoting aloud from some classic work.

To be sure, there were outlanders seen or heard passing by in Brooklyn. On summer nights, the boy from the Great Plains lay in his bed under an open window listening to drifting conversations from the streets. Then with morning came tradesmen's calls, the iceman with his lilting summons, vegetable sellers announcing their wares in alien accents, chimes from the knife grinder's wagon. As an old man, he remembered the haunting curiosity of these voices with their flavor of foreign lands.

Yet the social line around his family was sharply drawn. Across the street lived a family of Irish Catholics, anathema for Presbyterians. Italian Catholics, readily identifiable by their mustaches, were also visible, some of them most likely criminals. At one point, word went around that the Munros were anti-Catholic; at the end of his life, my father still wondered how that rumor could have started, for his parents

exercised and taught him to exercise kindness toward minority groups and forbearance with their struggle up the ladder toward eventual absorption. At the time, however, if a Jew came into sight, it was likely a pushcart peddler. A yellow face was the laundryman. Each race, as each species, in its place on the evolutionary scale—so taught the Puritans and so, from another point of view, Spencer and the Social Darwinists who followed.

Mary Munro shaped her male child to that last. Early on, she set him problems to test his brain and judged him a genius. By two and a half, he read books on her lap. By five, he had memorized a good bit of Kipling and Longfellow and had enough hand-eye control to cut out of white paper, with tiny scissors, a set of sharply angled silhouettes of characters from *Hiawatha*. These his mother mounted on black paper and framed, and so they hung over my bed in the Catskills when I was a child.

After that she programmed his education, setting the curriculum and correcting lessons as he sat at his little desk overhung by reproductions of Rembrandt, Raphael, Burne-Jones and the like, which had entered his bloodstream before he was born. Guessing at his past from what I know of his future, I suppose she raised him as her Christian Scientist mother had her, in the puritan family ethic: to subordinate his will to that of his elders, to obey without question, to behave with modesty and propriety, do his work with diligence and climb as high in life as he could, for that way led to heaven. When he was seven, his mother married him off in a mock wedding to the daughter of the minister. She dressed him in a little tie and threaded a sky-blue flower through his buttonhole, and when someone asked him what he would be when he grew up, he announced, "the founder of a new religion," and shocked all four parents.

* * *

At only fifteen, after that one preparatory year at Erasmus Hall, he went off to Amherst, where boys from farms and villages met city youths for a traditional churchly education. In spite of his brains, my father was too young and small to make a dent in the place. He was bored with his courses in German Idealist philosophy and Christian ethics. From a line in one of his books about the loneliness of gifted children, I infer that his entry into collegiate male society was difficult. But he made one significant friend, the first Jewish person of his acquaintance, a young man who worked in the library and introduced him to Spinoza and Freud. So in one swoop he found himself two new worlds: humanity outside the Protestant Pale, and the human unconscious.

From his parents' point of view, his defection followed shortly; from his point of view, the notion that a dissident approach to learning was possible marked the beginning of life. If there had ever been a figurative image of God the Father in his mind, I suppose it dissolved without pain as, indeed, it already had for his Transcendentalist father. In the place of Divine Justice as the dominating force in moral life, my father now discovered the Oedipus Complex.

On the other hand, from other readings, he learned more than his father had in years of graduate study about democratic-socialist experiments here and in Europe, tending toward the actualization of One World in controlled prosperity. Attending a conference on international relations at Cornell in June of 1915 (to which he must have been one of the youngest delegates), he heard Norman Thomas, Norman Angell, Hiram Maxim—that paradoxical inventor of the machine gun and spokesman for peace—and other liberals speak. And from a fellow student delegate, Hu Shih, one of the future apostles of a democratic New China, he heard about John Dewey and the free yet socially responsible life.

That conversation was a turning point. For the first time, my father made a decision on his own. He judged Amherst old-fashioned and determined to transfer to Columbia to work with Dewey. By clan custom, the whole extended family was gathered to face the crisis, including dour Christian Science uncle Claude Spaulding down from Boston. It took some doing, but at last the elders agreed, on condition that the student live not in a dormitory but under his parents' roof and guidance. So the old folks, who had by then half-retired to the mountains, turned around and took an apartment on Claremont Avenue, and my father's intellectual life—and struggle with ancestral shadows—began.

His admiration, indeed love, for John Dewey was unbounded. Even when he was an old man, my father remembered with as much tenderness as he manifested for any man the shaggy, unself-conscious professor, rather like his own father, with unpressed pants and frequent spots on his tie, who made his way daily through what were called "lectures" but were really informal demonstrations of the way his mind worked. Actually, one could regard Dewey as a better parent, for he had no wish to lay down rules nor to control his students' lives or gain credit through their achievements.

Dewey's rejection of one whole current of Western thought was categorical. He simply bypassed issues philosophers had tussled over for centuries: the meaning of truth, beauty and immortality, the determination of moral law, the logical testing of God's existence. He considered these issues both irrelevant to actual life and incapable of meaningful answer. By contrast, he argued that the truth of an idea could only be known when it was put to the test. He called his teaching Instrumentalism, his version of nineteenth-century American Pragmatism.

In fact, Pragmatism was itself a sort of shield or buffer raised to save philosophy—the loving search for knowledge

—from the earlier, radical and potentially self-destructing theories of the eighteenth-century Scottish empiricist David Hume.

Undoubtedly, it was for my father in his early twenties, as it had been for Kant, that reading Hume woke him from his youthful mental sleep. Hume argued that we know things in the world as they impact on our senses, that is, through their colors, sounds, textures, visible shapes in space and so on. Of their intrinsic nature or the nature of their connection to one another, nothing can be known. To bring the question of the reality of things down to their impact on the senses was indeed to put one's mental foot on solid ground.

On the other hand, a strict empiricist will have trouble filling in the gaps between things, making of a welter of trees, clouds and stones a "world" that goes on being when he shuts his eyes. Hume himself hedged by saying normal people agree the world exists as a physical continuity, while abnormal people fail to make that reasonable adjustment to appearances. But the gap remains. When the empiricist sleeps, the world goes dark and beingless. Against that dead end, Pragmatism was a hedge. If common sense tells us the world is real and it's useful to say so, then let it be considered real, and get on with life!

The change in the direction of philosophy was radical. Instead of trying to answer deep questions about the nature of things, a philosopher in the modern mode would concentrate on human experience and works. The "meaning of life," if one cared to think about it, would be found in the kind of experience one had. Good experience was ordered and organized, not aimless or mechanical. If one looked at human history overall, clearly there has been progress toward more structured and also more diverse forms of culture. So evolution was law in human society, culture and the arts as well

as in biology, as Spencer and Darwin had already argued. Thus Dewey, too, drew on the great modern wellspring.

For the individual, Dewey's message was refreshing. The Instrumentalist could be the first free person, free of old binding ideas, free to choose, by trial and error, a way of living from the whole diverse world of human values: free, in short, of the past. There were no moral absolutes to guide human behavior nor esthetic absolutes to guide the artist. On the other hand, some forms of both behavior and art were more productive than others, and the normal person would gravitate to those.

Learn from experience! Reach out to the world and take from it the good and not the bad. Death, O death, will come in time, notwithstanding, and you may have learned by then to accept it. To my father, fed up with his father's mystical hypothesizing and his mother's domination, this teaching was an open door.

On assignment from Dewey, now an investigator not a parishioner, he visited churches, synagogues and cathedrals of New York. He toured Sing Sing, the Tombs, the Men's Municipal Night Lodging House, and he sat in trial court-rooms. Soon he resolved the religious issue for himself: belief in God was a utilitarian exercise. It had value insofar as it inspired good behavior. Churches had value insofar as they provided social and psychological guidance. Thus, to his own father's deep and lasting sorrow, my father decided he had no more need for Christian fellowship nor to go along with him to hear the Sunday sermon.

Learning as he practiced, my father discovered the exciting progressive-educational movements generated in Europe and fostered at Teachers College at Columbia. Meanwhile, since the ideal of pacifism was failing, he took courses in psychiatry

and clinical psychology in preparation for military service. In 1918, he became a university lecturer in philosophy and a few months later was drafted into the army medical corps.

He joined the psychological testing service and was assigned to work on the now-famous Beta tests for the placement of illiterate recruits. Here eugenics—still considered an ethically neutral approach to judging people's social value—was being put to the test and found amazingly predictive. My father recalled that many white farmboys of Anglo-Saxon, Scandinavian or German background, though unschooled, "knocked the top out of the tests," which called for lightning-quick visualization by the recruit of such tasks as measuring milk by the can or retrieving a lost plowhead from a field in the least number of forays. On the other hand, so went theory then, black recruits tested as fit for menial labor only, cheerful individuals gifted in song and dance but essentially uneducable.

My father found the procedures and results convincing. Also, like many a mild, obedient person himself, he eventually liked executing drills, seeing platoons turn on their heels when he shouted commands. And at three o'clock one morning on sentry duty, he met the young writer Joseph Wood Krutch, traded life stories in the dark and so discovered the New York intellectual circle that would be his for a decade thereafter. He was mustered out the same year, and returned to Columbia to prepare for his Ph.D.

When I think of my father's eager but unworldly figure against the background of the times—radical movements already launched in society, politics and the arts—I see him otherwise than I did in my own unworldly childhood. Nurtured on the pieties of great art in reproduction, on the Scriptures, Shakespeare and American Victorian classics, his emotional life dominated still by his parents, he knew almost

nothing of Modernist currents already reaching New York—nothing of *Leaves of Grass,* Cubism or abstract art, nothing of the epochal 1913 Armory Show—with its shocking array of European Modernist paintings and sculpture—or the premiere of *Rite of Spring* that same year, nor the next year's show of African sculpture at Alfred Stieglitz's gallery. In his studies, he was still plowing his father's furrows, writing a dissertation on social theories. But he now was teaching alongside future luminaries like Sidney Hook, Mark Van Doren and Irwin Edman, and meeting writers like Houston Peterson and Adin Ballou. For him, for them all, the decade ahead would be characterized, as Krutch put it, simply by "the curse of opportunity"—too many new ideas, too many openings for the young to outrun, outproduce, strike closer to the heart of things than their elders. "Progress" seemed a reality then and global peace a reasonable hope.

In those halcyon days, steamship travel was cheap and Paris the great magnet. My father went to see what the excitement was about, discovered the sources of those haunting nocturnal cries in Brooklyn and met the arts not in sepia reproduction but living color. He fell in love with opera, especially the Wagner cycles for their grandiose interwound mythological and tonal structures. He read Santayana and was so struck that he wrote him a letter and was asked to dine when he was next in Rome. So he did, and the acquaintenceship took. The philosopher lived in seclusion in a small, bare room the better to refine his thoughts. When he read someone else's book, he threw it into the fire to get rid of its material shell. He refused to be jostled by crowds. When he sailed to France and the boat docked at Cherbourg, all the passengers lined up to disembark save Santayana, who waited in a chair with his coat collar turned up till he had the gangplank to himself.

Santayana was a poetic naturalist. He had a low opinion of

"Hebraic religion" and woolly Germanic philosophy, and in the Modernist spirit rejected the idea of Christian immortality. He called most American philosophers second-rate, was unsympathetic to democracy and scorned the Protestant liberal as the enemy of ceremony, moral grace and art. Society of his time, which Dewey looked to improve by education, Santayana found disharmonious and rife with worldliness. By contrast, he praised the solitary life: imagination turning on the "bright images" of the natural world. He and Dewey, though alike in their rejection of old philosophical and religious clichés, appealed to opposite sides of my father's mind between which he alternated in those days without discomfort. Compared to Dewey, Santayana was the greater poet and esthete. Compared to Santayana, Dewey was the greater humanist. And so what? my father may have asked himself as he walked in the evening, as he sometimes did, down along the Hudson, swinging his cane, enjoying the looping lights on both sides of the river that mirrored the stars above. Or, as he was beginning to read in Walt Whitman, "Do I contradict myself? Very well then! I contradict myself."

As I see it now, my father at about age twenty-five was an esthetically awakened, evangelically inclined Instrumentalist, and he would pay a price for his divided nature when it would come time to commit himself in marriage and the raising of children.

Approaching his fate, my father thrived on the high life in New York. He became something of a blue-eyed dandy, dapper and witty. He went to nightclubs with a number of flapperish girls, though each night he took the subway back up to the quiet gloom of Claremont Avenue. His intelligence was acknowledged, but it was his air of sweet modesty and courteous unabrasiveness that endeared him to women. Edna St. Vincent Millay inscribed a book to him, "To my only son."

Around her, he met the world for which his mother had yearned but failed to find because of her socially inhibiting marriage. One night, he and his friend Peterson and a couple of girls were partying in some Greenwich Village garden when thunder rolled and rain beat down. They all stripped off their clothes, tossed them into the bushes and danced in the wet grass while lightning split the sky. Certainly my father had never seen so many bodies before, only a thigh here, a belly or breast there by accident, in domestic lamplight. To be naked was exalting and brought to mind the noble shapes of Phidias and Rubens. He dried himself with a dish towel, put on his suit and returned to Claremont Avenue, but he was restless now and would have moved out if it weren't that moving would have broken his mother's heart.

At twenty-five, the age his father had been when, virgin, he left the farm for the university, my father fell for Krutch's French sister-in-law. She turned him down, and it was well, for I can't imagine his finding courage to take a Roman Catholic home to dinner. But his own heart was warmed, and he began to crave a spouse in the old clan way. In such a mood, he went one autumn Sunday to a party on Washington Square. He walked into the living room with its fire cheerfully burning and there, to his delight, was a real Scottish laird in kilt, sporran and thistle pin, leaning on the mantel and talking a fair brogue. The two began a bantering dialogue about Highland lochs and demons and the ghosts of Culloden dead, and then with a couple of academic friends, he went off into a spiel on Scottish common-sense realism and how it was a bulwark against such superstition. And meanwhile, from a corner of the room where a grand piano stood catty-corner, so that one standing by the fireplace couldn't see the face of the one playing, came a series of chords stoutly struck, then a cascade of scales giving way to a Bach fugue so eloquent that, after a few minutes, my father stopped talking. He

wandered over to see who was at the keyboard. It was a woman of such painterly, indeed unsettling appearance he stopped still to watch her.

He would not say she was conventionally beautiful. He would never say that. She was about his age, he supposed, and a bit taller than he if she were standing. Her face was round and her nose snubbed. He could see a sprinkle of freckles under her white powder. She wore an overdress of green silk taffeta embroidered in heavy welts that entwined her arms like seaweed. There was a jade necklace on her breast and a gold circlet on one wrist. Most extraordinary, however, was the aureole of red hair she wore in coiled buns over each ear. As she played, she tilted back her head and half-closed her eyes, then bent close to the keyboard for the difficult passages. Finally, she came to the end, held the final chord a moment, then lifted her hands and rubbed them slowly together to release the tension. It was hard work, she said, finding the themes and letting them sing.

She was a student of the great Ernst Hutchison, lived on the West Side in a girls' residence with her younger sister, Charlotte, a violinist and a witch who drove her crazy. That evening, she was in charge of her elder sister, Clara, whose dark blurred beauty was an astonishment but who was nearly deaf, a result of botched mastoid operations. The pianist's name was Lucile. Nadler was the last name. Nadler.

At the end of the evening, my father escorted the sisters home on the subway. Clara sat watching the walls of the tunnel flash by, but Lucile talked as if she wanted to spill every last fact about herself before the ride came to an end. Her parents were Europeans. Her mother had run away from her convent school in France, sailed to America as an *au pair* girl and on the return ship met her future husband, who came from Rumania. Together, they had embarked for Savannah, traveled a bit and settled in Gadsden, Alabama, where Lucile

was born. She had come north to study piano and earned her way by teaching. She was innocent but not stupid. There was no positive joy or thought in life she didn't yearn to experience. Before Tom left her at her doorstep, she ran to her room to get her volume of Hindu love poetry, Kalidasa's *Shakuntala,* and lent it to him. "Now he'll have to come back!" she whispered to Charlotte. My father, for his part, sauntering away with the book under his arm, may have had the satisfying impression he'd been thrown a glove.

Their courtship was indecisive and prolonged. He would ask her to Claremont Avenue, where the silent rooms with their books in glass-fronted cases impressed and awed her. Her own home in Alabama had been filled with the sounds of fiddling (that would be Charlotte) or banging scales (herself) or shouting in anger or high spirits (her parents). Mary Munro was aloof when she was home, but often she was on tour for the Chautauqua. The old man seemed lonely, shuffling on a cane. It was clear to Lucile that Mary's whole interest went to her son.

Sometimes Tom would telephone, then whisper, "She's here . . . I can't talk." Or he would break a date, saying, "She's coming home . . . I can't make it." Meanwhile, at home his parents queried him about Lucile's background. There were perhaps no overt objections but silence and his mother's face turned away when he would have liked a smile of approval. Or there may have been tears and theatrical words whose residue of guilt, pain and foreboding he would never forget, which he would one day find himself repeating with his own child as if by Sophoclean rote.

Probably it wasn't easy for him, for my mother wasn't one of those light-minded flappers who could have helped him laugh off Mary Munro's fixations. She was set on her way, positive about her talent and commitment, which had both

been tested during soul-stifling years in Alabama while her brother was being educated first. When she played, her intensity both moved and disturbed my father. She would begin with a powerful series of chords struck with both hands, then launch into pieces she was "working up," the fugues and preludes, the "Pavannes" and "Pagodas," "Evenings in Granada" and "Sunken Cathedrals" which he could not hear without feeling a burden of emotion seeking expression.

It was her life coming through, immeasurably alien to him. It was childhood in a red-dirt town, endured by the ugly duckling, as she thought of herself, with a sharp, realistic mind. It was marching to the library, first of all her family to do so, and asking for a book, and when the librarian asked, "Which book?" replying with painful shyness, "I don't know . . . any book," and taking home the one proffered to become a reader. It was her opera-loving father, whom she adored and feared, clapping his hands every evening when supper was done and shouting, "Music! Why should I give my daughters music lessons if they won't play for me after dinner?" It was waking at night to such fights between him and her mother that she developed a desperate longing for peace and vowed never to oppose the man she might marry. It was practicing in the parlor with windows shut against heat and dust, driving herself to seek in those flights of notes the wings by which she might eventually get away from the town and the commands.

To that end, she did something else. She commuted by bus all the way to Birmingham to take a course in parliamentary law. Did she think to change the course of her life—or that of her financially struggling, daughter-burdened immigrant father—by legal argument?

Those were the days of tedium and despair she recalled bitterly years later, going to bed alone all the hot summer and

blowing winter nights in Alabama, weeping into her pillow with frustration, turning her energies back on herself in her prison from which only her hands on the keys could provide release.

What then was love, if my father called it that, that was coming to claim him? From where did he take his notion of it, aside from the old poets and his new friends? From self-chastising Mary or Alexander reduced to impotence? From puritan, body-negating Christian Science aunts and uncles? From effete Santayana? From Dewey, who would father offspring in his old age?

The roots of love are deeper than new philosophies. Back in Nebraska, his young parents must have sometimes turned to each other with desire, even if disappointment was being stored up in one of their minds. And if a child asleep in the night awoke and saw and heard . . . and then later, growing up in a family where such love was never referred to or reenacted . . . If the child remembered only in the buried part of his mind, harking back in imagination to what he could not know but felt burdening him from within: an image seeking to be born, which thereafter would have power to shape his life as if to some forgotten design . . . ?

My father, in spite of his Whitmanesque early gambols, wasn't given to revealing himself in words. Language was for him a tool of description not to be dulled by dipping into the mysteries. But the mysteries had their way with him from time to time, and he wrote a poem in those courtship years which, when I discovered it after his death, folded in a packet of old papers, had for me the gleam of revelation:

> A kiss of ice and great wings beating,
> The harsh cry of a hawk,

Then a priest low-bending, with a cross and a candle,
And a priest's talk.

The hearth-fire is a flaming finger,
(Oh, far hill under the moon)
But the child is hungry, and stirs in his cradle;
He will wake soon.

Comfort strange will he be craving
(Oh, dark lock among the gold).
And must I wait, nor hear again the hawk's cry,
Till I am old?

My father would grow old craving "comfort strange." "What would people think of me, if they knew what I was really like?" he would ask my mother when he was over seventy. However, he would not wait till then to hear the hawk's cry, but would take for himself a bride of his own. But she must be, in some part of his mind, forever "strange," perhaps as if from another country or people, someone both in and not-in the image of Mary-daughter-of-Americus. And this different feature of his wife's must be kept a secret, some quality to be sealed off in a part of his mind and, later, literally, in a room of his house. Only there could he reveal his true and needful nature. To the rest of the world, he might present an engaging front but it would hide a wary shyness, even a chill. "I feel so stiff and unreal when I am away from you," he wrote my mother before they were married. "My letters have no spontaneity. Yours, by contrast, seem open. You seem to be right here beside me."

"Oh, you don't know what he was like behind the closed door," my mother would say, long after he was gone. "He could make you feel so fine. He would call you a Cranach girl—the one with the white belly and red flaming hair he loved the best."

* * *

When the couple told Mary Munro their plans, she burst into
tears and cried for days, refusing to come to an engagement
party the bride-to-be was giving at the Plaza, pleading she was
too unworldly, and that despite her years on the lecture plat-
form. Then when my mother went south in January of 1925
to prepare for the wedding, the bridegroom-to-be sent her,
with no other message, another poem, "The Poet Laments His
Unworthiness to Bear the Thyrsus."

> . . . For I am least, of all her company,
> Touched by the sacred madness that I praise,
> And chill with reason her wild ecstasy . . .
> Upon my sleeve some cold, restraining hand.
>
> Cast thy spell quickly, goddess, I implore,
> Lest, aging, I may worship thee no more.

The wedding was held not at the bride's home as convention
would have had it but in the Catskills, where the couple had
already spent snowbound and sunwashed weekends. The sea-
son was May, and the dogwood was in bloom. At the cere-
mony, the four parents, disconnected but courteous, stood
awry, the men in wide-legged dark suits, the women in loose
dresses, their ample bosoms hung with necklaces of jet or
ivory. Mary tipped back her wide-brimmed hat for the cam-
era. Berthe laid her hand protectively on her husband's arm.
Jacques smiled ruminatively from under his mustache. Each
of them stood a bit defensively, as if to say, Am I not the finest
of them all? Only old Sandy stared into the middle distance,
seeming to feel the weight of the moment and the place, in
the words of his beloved Emerson, "sacred to thought and
to God."

Skye and Rumania, Crown Point and France: four points in my grandparents' journeys to the dogwood meadow, where they stood in an uneasy half-circle for an hour and never convened there again. For my mother too that day was a rare conjunction of hope and fulfillment. In time to come, she would more than once lose, then struggle to regain, her balance and place in the ring of disparates united around a flowering tree.

The couple then sailed for a working honeymoon in Europe. The previous year, at Dewey's recommendation, my father had accepted the job with Doctor Albert Barnes, chemist-inventor of the vastly profitable medicament Argyrol, art collector and founder of the Philadelphia foundation that still bears his name. In fact the honeymoon had been scheduled so the art-mad and frequently choleric Barnes could come along to enlighten his young employee, already proficient in social theory and philosophy, in esthetics. Therefore, each morning at seven, he was on their pension doorstep, banging the pavement with his cane, calling the bridegroom to be up and out. My mother, I suppose, would clap her hands to her ears and sleep for another hour, rise, wrap her orange silk Chinese robe around her shoulders, brush her hair into a savage corona and curse the collector for his indiscretion.

But they were on to something, Barnes and Munro. And so began the next stage of my father's intellectual pilgrimage.

THE
MODERNIST

The empiricist Hume, one of the historic progenitors of Modernism, was in his early twenties when, as he wrote, he came down to earth intellectually. My father, too, may have come down through Anglo-Scottish mists in his early twenties; however, like Kierkegaard, at the same age he experienced a leap to faith—practically a conversion. His conductor in that leap of what he would, however, never have called "faith" was Barnes, one of the most paradoxical men of the times. Abrasive, combative, probably a little mad, he was also a visionary educator who revered and was respected by John Dewey. Like Dewey, he was my father's elder, a rough-cut patriarchal figure. However, though he valued my father's mild manner—without the sharp edges that impeded his own social life—my father found him devious and erratic and in the end impossible to work for. Nevertheless, Thomas Munro made the critical step in his intellectual formation under Barnes, who first articulated in this country the principles of Modernist esthetics.

In earlier European tradition, esthetics was a subcompartment of philosophy, specifically, speculation on the nature of that amorphous term "the beautiful." The radically different Modernist tack implied a return to the root source of the word, the Greek *aisthetikos*: pertaining to sense perceptions. Modernist esthetics (today it's generally spelled thus for simplicity; my father preferred *ae* for lexigraphical accuracy), spearheaded by British and American writers from Roger Fry and Clive Bell to T. S. Eliot, and including my father, wouldn't be a minor offshoot of philosophy dealing with indefinable abstractions but an objective, scientific discipline on its own. Thus it would share in the mainstream of the modern age—the great progressive flow that ran from Newton and Descartes to Darwin and Freud and had recently revealed a

hitherto unknown stratum of radiant energized particles whose interactions hold the physical world together.

Barnes himself came to this discipline from a background of humiliating degradation in the slums of South Philadelphia. From his chaotic childhood, he had but one escape. Down the road was a Negro church. As a boy, he fell in love with Gospel music, so transporting in its rhythms and soaring melodies. He made friends of the singers, visited their homes and other black churches, and became a lifelong devotée of the "poetry and drama which the Negro actually lives every day." In that sense, he never forgot his proletarian roots, nor the liberation he felt among American blacks.

On the other hand, in years to come when he would be vilified by conservative art pundits of the time, he reacted like some others who project corrosive self-deprecation onto the world: that is, with fits of anti-Semitism. My father had copies of some letters he wrote in these moods, but at the end of his life destroyed them. At the time, I wondered why, since sooner or later they would have had biographical interest, but he gave me no answer. Now I think he shrank from adding to the infamy of one to whom he owed the principal insight of his career.

In fact, their relationship lasted only four years and ended when Barnes, in a characteristic move, signed Munro's name to an article critical of Bernard Berenson and making light of his effusions about Christian art. The piece seems innocuous today, but B.B. took it hard. Indeed, thirty years later, when my first husband proposed bringing me to meet him, he burst out, "What! You bring me the daughter of my mortal enemy?"

Barnes's engagement with art began in high school, where he met the future painters John Sloan and William Glackens. His own bent was for science. He went to medical school but left to train as a chemist, in order, he said, to afford to buy

paintings. First he bought academic landscapes and the like. But around 1910, beginning to reap profits from his Argyrol-producing business and aware of his cultural deficiencies, he gave Glackens $20,000 to buy the kind of art that, as he put it, artists admired. For that first investment, Barnes acquired a Renoir, a Cézanne and a few other works. By 1913, the year of the Armory Show, which he studied with care, he had spent two summers touring Europe's museums, churches and art galleries, often with Berenson's then popular book on Italian painting in hand. By then, he owned some fifty Renoirs and fourteen Cézannes.

More important, he set out methodically to try to under-stand these Post-Impressionist works that combined realistic and abstract passages. His own profession, chemistry, pro-ceeded by stripping compounds of their impurities and reduc-ing them to their elements. His procedure with works of art would be the same. He would deconstruct them—to use a later term—and find what they were made of.

If one sets aside the "impurities" in a work of art—its subject matter or story, one's own associations with it, the work's historical reputation and so on—what is left is what is presented to the senses. The elements of a painting, then, are colors, lines, shadows, highlights and shapes on a flat surface. These elements, what one sees (or hears in music or discovers in the terms of a poem), put together according to the artist's compositional intent, are "forms," abstract, bare of story content or emotional charge.

Forms can be combined in various ways, always subject to verifiable laws—for example, the laws of color, balance, har-mony, rhythm—into synthetic works more or less complex, all subject to the same deconstructive analysis and descrip-tion. Eventually, as my father would come to see it, the field of esthetics could be as wide as life itself and include the study of artists' psychology as well as all kinds of observable

relationships between formal works and those who receive them. For works of art obviously affect people's behavior and so society. If you could teach people to make beautiful things and respond to harmonious formal structures, they would become self-controlled, harmonious people. If you raised whole generations that way, society would become more balanced. Therefore esthetics, my father would say and later write, has political ramifications, and the citizens of a liberal democracy should be educated to recognize both the stabilizing and disruptive power of art.

In the creative arts themselves, the Modernist approach took many styles, all stemming from the idea that it was foolish to waste time imitating the surface look of things, as academic artists did, or concocting images of gods and other unnatural beings, as religious artists had for centuries. The modern challenge was to explore the real worlds both visible and invisible, to say deep and novel things about human experience and society, and by assembling forms in unique ways to create works of art with never-before-attained harmony and balance. The first experiments were made shortly after the turn of this century in Russia, Germany and Paris. From there, the ideas and examples of work were carried to New York even before the 1913 Armory Show. Meanwhile, an early Modernist approach to art education was tried out at Teachers College of Columbia University, where instructors and artists made pictures not of "things"—apples, trees, mountains, faces—but of the elements of design—lines, colors, shadows and lights, linking them in sequences with the flowing quality of music or Japanese calligraphy. Out of these early experiments, young Georgia O'Keeffe would take her lifelong style. And John Dewey became interested in the work as an extension of his theory that one learned by doing, not by being told what to do.

In time, the movement generated many sub-movements,

different from one another as psychology is from chemistry, yet all bound by belief that there is discernible formal structure in the world. In the field of painting, for example, there would be a transcendentalist Modernism, describing reality as space filled with radiant energy; and a platonizing Modernism, in which clean-cut abstract forms were set in perfect balanced juxtaposition. Also, there would be a politically centrist and optimistic strain of Modernism, embodying faith that a better world was just around the corner (the new art education, and Bauhaus and International-style architecture) and a radical, pessimistic Modernism, promoting political and esthetic revolution (Marxist social realism and Dadaism).

An exhilarating sense of promise was shared by the early Modernist artists and theorists. "Only we are the face of our time," a group of Russian painters proclaimed in a manifesto in 1917. "The horn of time trumpets through us." The British art critic Roger Fry believed a day would come "when art [would be] purified of its present unreality, [and society] might choose its poets and painters and philosophers and deep investigators, and make of such men and women a new kind of kings." In New York, art historian Meyer Schapiro anticipated the "universalizing of art . . . an immense confraternity of works of art, cutting across the barriers of time and place." And in 1938, in an article "Art and World Citizenship," my father would write, "To be a citizen of the world in the full and literal sense is still a dream of the future. . . . But there is another sense in which [it] means a state of mind. In the realm of ideas, its members are the true cosmopolitans . . . they speak the universal language of world civilization." This vision of a world-encompassing culture in which diverse peoples would be brought together by shared experiences with art echoed certain hopeful political visions of the time. It might even be said that, if the quintessential Modernist art was, as some art historians have

suggested, *assemblage,* or collage, then the quintessential Modernist political form was the League of Nations.

My father, as I've said, came to Barnes a divided man: born a Christian, in revolution against his background; a sometime poet born again to empiricism and scientific method. But the philosophical mind never stops reaching toward the universal, and the turning point in his life took place, I suggest, when he found a field of endeavor in which he could bridge that divided nature. He could be free of the past while consecrating his every working hour to the subject closest to his mother's heart: the arts. At the same time, he could faithfully confine his studies to empirical evidence—the lines, colors, rhythms, shapes and so on that appear, in various modes, across all the arts—while also proposing a general theory about the interrelationship of these forms in art through history and around the globe. Eventually, speculation even took wing into metaphysical realms my father would have disdained defining. For since fundamental forms can be perceived throughout organic and inorganic nature as well, and in nature's microcosms as well as galactic space, it could be said that *form* in general bound up the universe. Form was the membrane between things-in-space, the missing empirical evidence that the universe is One.

And so he turned away from his father's field of social philosophy rooted in Christian ethics, as he already had from the ancestral Munro weakness for vague ruminations on the meaning of life, and also away from the actual person of his mother on her lecture platform, and gave himself over, once and for all, to the study of form in the arts. Of scientific esthetics he would build a system whole and embracing as those in which his ancestors placed their faith.

For my father, scientific esthetics was the essential Modernist discipline. In years to come, it would provide him with

a model for understanding human life and the procedures of creative thought and art. It would become a progressive social philosophy and a faith. And so in a sense he found himself, as long before he had said he would be, an apostle of a new religion. Only the new faith would be preached not from a pulpit but in classrooms and museums, not in biblical rhetoric but in the diction of American scientific materialism.

Faithful to the mandate, and possibly in spite of himself, my father would purify his language of emotional expressions: "It is beautiful . . . ," "I love . . . ," ". . . gives me joy." Nor would he speculate on subjective matters, such as an artist's intentions, what he or she "meant," or "felt." For the Modernist esthetician, art was not a matter of personal emotions loosely expressed but of the containment of such emotions in clarified universally understandable form. Emotional, subjective, full of clichés and banalities, academic art and philosophy looked to the past. Scientific esthetics looked to the future.

By 1922, Barnes, who by then had acquired a large collection, including Matisse's masterwork, *The Joy of Living*, and a group of important African sculptures, decided to set up a foundation to exhibit the work and teach the principles of formal analysis. Dewey would be the institution's educational director; my father, his associate. It would operate like a laboratory for the analysis of art, without distracting class-associated social events, teas, banquets, balls and so on which other museums gave to attract patrons. No admission would be charged, but those who came must be prepared to subject themselves to the Doctor's methods.

The foundation opened in 1924. That year, my father taught alongside Barnes, who introduced the daily topic, a single element of form—line, color, mass or space—then left it to his young assistant to elaborate with reference to a

painting or sculpture displayed before the class. That summer, the two of them led a group through the museums and Modernist art galleries of Europe, including those of the engaging dealer Paul Guillaume, one of the first to have recognized the formal power of African art, even before 1907 when Picasso borrowed its forms for *Demoiselles d'Avignon*. The next spring, the first issue of the foundation's journal appeared, with an essay on the philosophy and future of art education by my father.

Now some sixty years after the publication of the article and ten after my father's death, I find in it a young man's struggle to bring together noble generalities about saving the world with a few up-to-date notions about psychology that had taken root in his mind. The goal of modern art education, he wrote, was to ensure a "good life for the educated, well-balanced human being in modern Western civilization." That balance would be achieved by developing "clear, spontaneous feeling and ability to organize experience creatively [into] a fresh, untrammeled and personal vision."

However, all people go through an Oedipal phase from which they come out either bent toward "overcompensation and neurotic symptoms . . . egotism, conceit, cruelty or pugnacity" or free to rise through "approved channels like those of art" toward sublimation and presumably a good life.

Still there was a problem that would never cease to trouble this art educator and future parent. For he allowed that, in some cases, "creative imagination arises in large part from neurotic conflict. If rational education tends to remove such conflict by bringing its sources into consciousness, much of the motivation of artistic fantasy (or certain kinds of it) may be lost.

"Again, we have the problem of whether creative originality in art can always be achieved along with a normal, happily

adjusted personality. If so, how?" Fifty years later, the parent would still be worrying that question in print.

In any case, as the foundation journal was going to press, the young teacher took a wife and sailed for the honeymoon so matitudinally disrupted by the Doctor. The bridegroom would never forget his attachment to certain works of art lingered over that summer which he—always insisting their subject matter was of small import—perceived as most formally rich and therefore of highest value. The greatest of these was . . . Titian's *Rape of Europa*.

My father's first, shared-byline book came out that year as well, *American Economic Life and the Means of Its Improvement*, on which he collaborated with Rexford Guy Tugwell. Later, when Tugwell became an adviser to Franklin Roosevelt, the authors joked that by this book, which advocated collective bargaining, government ownership and various income-apportioning schemes, they had set in motion the New Deal. However, his next book, co-signed with Paul Guillaume and published in 1926, marked his real beginning. It was *African Negro Sculpture*, one of the first to set before the public this art which had entered the bloodstream of Modernism only two decades before. In these pages, too, I hear my modestly raised, recently wed father struggling to put strong wine into shapely bottles: "A people used to unbridled sensual and emotional life, to handling, caressing, violently seizing and even rending the human body, will not feel toward a statue as does a people used to clothing and delicate restraint."

The formal exaggerations in African sculpture, he observed, "may be frankly sensual, the bodily organs emphatic . . . these may reawaken in a civilized man

disapproved and primitive impulses, a kinship with the savage, fought down and half-suppressed, yet obscurely potent. Feeling their stirring, beneath the inhibition of conscious tastes and standards, he experiences a sickening repulsion, a thrill of fear, and at the same time perhaps, a strange and inexplicable fascination. . . ."

The tribal sculptor himself "is obsessed, perhaps, by the feeling of rough, abrupt, irregular projections, that stirs his blood like the rhythm of war drums. In the grip of this rhythm, he will force the yielding block into step with it . . . As he goes down the body, the thought of each limb, each natural division of the trunk, incites him to stab the block into new embodiments of that rhythm. Yet, if he is an artist of self-control as well as intensity, he feels at the same time the necessity for restraint, balance, the unity of the whole."

Thereafter, my father proceeded to analyze individual sculptures, letting his eyes follow their outlines with perhaps as much concentrated attention as, one day in his childhood, he had, with a pair of tiny scissors and his mother's guiding hand, cut clear of their fields of paper the silhouettes of Hiawatha and old Nokomis.

If form held content in its arms, that content, unformed, must be the chaotic unconscious. That notion was reinforced by my father's early readings in the Modernist fields of abnormal psychology and cultural anthropology. *The Golden Bough* was only the beginning. In his research, he learned about practices of so-called primitive peoples not then known save by specialists—rites of passage like circumcision, male and female; subincision; ceremonial defloration; scarification; the knocking out of teeth; and the confinement of females in menstrual huts. From these subjects, he moved, always as he told himself with scholarly intent and scientific dispassion, to books on bizarre sexual practices of modern urban men and

women. During this period, he bought for a song in Paris from Guillaume a few first-class examples of African sculpture, which would go with him from house to house, together with his growing library of ethnological and psychosexual esoterica. My mother's loan of Kalidasa's exotic love poems had long repercussions.

Meanwhile, he set his mind to many delicate questions in the air at the time, for instance one at the heart of much art education debate: whether modern students should draw from nature and, if so, the living nude. In spite of his appreciation for abstract art, he disagreed with the way Teachers College forced its student teachers to use only abstract design elements in their classes. By now he felt himself an apostle of naturalism, of the Whitman school. He loved sunny mountain landscapes, the paintings of Renoir and Matisse. Student artists, he wrote, ought to work from nature and the nude. This modern idea was supported, as my father so often did in the crunch, by innocent reasoning of a kind that now makes me smile: "With repeated contemplation of the living nude model or its images in art, anxiety symptoms tend to disappear unless the student is repressed to a neurotic degree.

"Instead, a positive interest and attraction survive, partly erotic and partly sublimated along artistic lines. Where such familiarity has existed from early childhood, it arouses no highly emotional response later on . . . [if] art studies can help supply this familiarity even before adolescence, they may help to avert the shock of a first observation at the most sensitive period of life . . ."

Whereas, he continued, "precocious experience, acquired as it usually is in a furtive, bungling manner, is far from guaranteeing a genuinely humane and rational attitude in matters of sex. Without the beautifying influence of art, it is likely rather to be tainted by associations of shame, uncleanness and concealment."

Despite himself, it was a romantic's meditation, out of which, I suppose, would come one day the idylls of the Catskill meadow.

During these same years, however, a cooler man began to speak through his writings, who would thereafter struggle to take the thyrsus from the poet's hand. The first book of that kind was *Scientific Method in Aesthetics,* which appeared in 1928 when he was thirty. It was a landmark in his field comparable in influence to early texts in literary New Criticism and argued that out of correct study of the arts would come utopian transformations in society: "The transition to science, now at last proceeding in the fields of ethical and esthetic value, is only a later phase in the unending search for true knowledge and wisdom which the Greek philosophers first began and in the modern search for power to benefit man, through understanding physical and human nature."

But to go back to collect my mother where I left her on her honeymoon: the couple lunched one day with Santayana. He previously had escorted them to Vallombrosa, the summer residence of Berenson, who allowed them to tour the house and gardens but did not himself appear. After lunch, they visited a number of antique shops in the hills above Florence. My mother wanted to buy a sculpture of the Buddha to remember the day. But which Buddha and where? One was too dear, another had a sour expression, and so they went crossing streets and turning corners until Santayana stopped in his tracks, turned to my mother and said loftily, "Be your own Buddha." She turned on her heel and walked away.

It was advice she would have reason to remember, however.

For then they were sailing home, and my father was lecturing her in the cabin, where she always spent sea voyages flat on her back in misery, telling her they would soon be moving

to Philadelphia and not listening to her protests because it was woman's role to follow her mate. She cried the day long, not really for cause, for she could study there with Josef Hofmann at the Curtis Institute of Music and commute to her students in New York, but for being ordered to obey now a husband's command.

They moved into a walkup apartment in which her father's wedding gift of a Steinway grand filled the parlor. As newly-weds, they waited for invitations from Philadelphia society. There were none. Not a call to tea or dinner. Their isolation was sorely felt, and one of them may have wondered whether it was marriage to the other that was at the root of the trouble. However, when my father's job at the foundation tapered off after 1926, invitations rolled in and it was clear the taboo had been directed against Barnes, who was shunned by the Philadelphia elite. In any case, the couple moved to Brooklyn, from where my father commuted to posts at Rutgers, Columbia and Long Island University, while Mother continued with her private students and her own lessons. It was in Brooklyn that I was born.

Her own Buddha my mother had indeed to be for her first delivery. She went through the ordeal alone in the hospital, without family nearby save her husband, who was teaching a class. The only person she remembered from the delivery room was an intern who shouted over her own shrieks, "Shut your mouth, mother, and push." She never got over the horror of it. When I learned from her how I had come, I understood why I sometimes felt she wished me gone.

The effect on me remains a mystery. Like the world, I came out of chaos. If I try to remember, as according to some theories one can, there was a dark-red wall that wouldn't open, a banshee howling beyond, flashes of silver, a sudden elevation and suspension and then air split the membranes of

my throat. My lungs sprang open, my parachutes. I wrenched my head from side to side and opened wide my mouth to let my impressions out. Whether by genes or that experience, I came ready to raise my voice to whoever manhandled me.

My father named me. It was his right. He looked into the past, considered the name Flora for his father's littlest sister, sadly dead in Nebraska of a mastoid infection, or Mary or Mary Rose for his mother, then settled on his spinster aunt, Mary's sister, who had lovingly stitched up the dress Mother wore at her wedding. Perhaps he meant by this to stitch up the breach in his family caused by his marriage.

But the inclination was a mutual one, for my mother, too, as I've explained, had a need to bind the elements of a situation into harmony. "Make it sing," she would say of a musical theme, and her fingers would follow. Now she was no more Lucile Nadler, a separate being in the world, but *mother* as the intern had made clear. And the first thing required of the new mother, to which I have to suppose she acquiesced out of that childhood desire for peace, was to let go discordant aspects of her past.

In accord with his appreciation for formal unity and Modernist internationalism, my father claimed for his family freedom from any divisive provincial, ethnic or religious identity. The decision was in tune with the times. "Without religion" was what we—as many other progressive European and American families of the time—would be, but without a sense of cultural diversity either. Contrarily, when I was growing up, I took delight in my ancestral mix. "I'm a quarter Rumanian!" I would fling in the face of some Ohio small-tool manufacturer just done tallying his North German or Swedish ancestry and then flush with pride while registering with only part of my brain the eyebrows lifted and frequently the next question, "And what is that name?" to which I would naturally say "Nadler," and not think of it again.

There was a word not mentioned in the Munro family for many years. Long before that time came, in fact when I was attending a progressive kindergarten in Cleveland, I was asked by my friend Daniel, "Are you coming to my birthday party?"

"I don't know," I replied.

"Are you Jewish?" he asked. I replied that I didn't think so, but the fact was, I had never heard the word.

"Well, then, you're not, because only Jewish children are coming," said Daniel.

In my next memory, I am, for whatever reason, at the party. I'm undeniably there, but seated at the foot of the table well off from where the birthday boy sits enthroned. Red-orange crepe paper adorns his chair. On his head is a paper crown. Lofty, outspoken children across the table engage in a discussion of styles of picking the nose. There must be, for this instant, no grown-up in the room. I'm shocked. But I'm also astonished. I've never seen a child so honored. Birthdays in our family are simple affairs. None of us has a "party." We choose our meal, choose the kind of cake our mother will bake. But to make royalty of a child, crown and bedeck him! I am a stranger to a world of such ceremony, still innocent of the word so artlessly used by Daniel.

The word that was never used in our family, that apparently didn't, yet in some mysterious way must, concern us, was of course "Jewish." Since we discussed no religions at the dinner table, there was no reason for us to have investigated the customs or tenets of Judaism any more than of our father's rejected Christianity. Had we done so, we might have had enlightening discussions on the entwined natures of the two systems of thought.

Judaism and Protestantism, of course, share the same root. Both systems are based on books of revealed law, require

communal subservience to elder men, exclude females from the center of power and exercise influence through rhetorical language freighted with tragedy and portent. In each case, there is a heavy sense of the helplessness of the individual before divine predeterminations. Also, Judaism and Protestantism share an ethical style, preaching against time-wasting, frivolity, disobedience. Also, in both systems, a tribal line is drawn against outsiders, people beyond the edge of the Pale—seen from whichever side. All this was my father's heritage. By his conversion to Enlightenment empiricism and Modernism, he thought he had got rid of it.

He kept, as an instrumental good, his attachment to the form of the clan and the clan's microcosm, the family. For him, this "family" that he was on the way to formulating would be more than a simple union of adults and offspring. In the historic sense and as he would bring it into being, the family was a microcosm of larger social, even universal, order (instigated by the Lord, or arrived at on earth by cultural evolution), binding into one system the sun (the Lord, or the human father), the moon (mother) and lesser stars. Horace Bushnell, the Christian educator of the last century, put it that the family is an entity "designed of God to be the vehicle, not of depravity but of virtue." My father would have said it was a vehicle through which the values of liberal Western culture are passed on.

Fundamental to the working of this system was obedience. Generations must unfold one to the next in continuous patterns of behavior. Then the family's psychic integument—its "togetherness" in a term instrumental in post–World War II social reconstruction in this country—would protect against external disruption, while the individual defenses of each member against his or her irrational impulses, and all against the irrational impulses of the others, would keep the peace within.

In the One World of such a family, love shed on the young would be returned to the elders in temporal sequence. Males in this microcosm would be philosophers and moral guides. Females would be free of degrading dependence on unworthy males, in calm and reasonable control of their sex drives, which they would release for the rational end of appropriate marriage. In time, dominion by the father would become dominion by the son. To this end, my father laid down a bottle of Dewar's Scotch on the birth of his son, my brother, in 1931, proposing to let it age until my brother should produce a son. And so a man, though a scientific materialist, might preserve a sense of immortality.

Inevitably, therefore, because of his confidence in what he felt to be right principles for living, my father drew the lines clear and early in our house between appropriate and unacceptable behavior. And the happiness and also the pain he would reap from his experience of modern fatherhood in the old style, and the happiness and pain his children would experience in and beyond the family, would be harbingers of still deeper disruptions in society at large after the century would pass midpoint. For as the old China missionaries' faith would be tested by the fidelity of the people they had trained to be good followers, so a Modernist parent's faith must be confirmed by the agreement of those he raised to remain within its embrace. A perilous faith in a century of immeasurable swift and frequently irrational change!

Then all this baggage of faith and feeling both conscious and unconscious was, by the alchemy of my father's imagination, transposed into the metaphor of Modernist esthetics: again, the containment of unruly content in the arms of form.

Thus he maintained an appreciation for the unifying linear themes in the works of Titian and Matisse, Bach and Stravinsky, and also for family lines reaching back and forward

through human time. So he marveled at Michelangelo's and Wagner's juxtapositions of lights and darks and would have his family bring into like balance the lights and darks of its soul.

A word he avoided, by the way. He spoke neither of souls nor of sin. Yet he was—as by human standards who is not—a sinner. He had turned away from his father and mother and chosen a stranger to bear his children. For his inability or unwillingness to accept the consequences of his choices, a day could come when he might wake, for all his enlightenment, to consider himself in hell.

THE
MODERNIST'S
DAUGHTER

The September of the year that we moved, 1939, the year my sister Elisabeth was born and I became fertile, was also the year in which Hitler invaded Poland and Britain and France declared war. The next spring, Paris fell. My high school years would be lived against the distant background of war, only somewhat more fantastic to me than the inner city that lay just below my line of vision, only somewhat more inaccessible to me than the theories about the universality of form my father was shaping. And the spring I graduated, the atom bomb would be dropped. Thus my first maturing, like the rest of my generation's, kept pace with a far-off Armageddon and a widening cultural unknown. These circumstances added apocalyptic resonance and a depth of deeper mystery to my own small conflagrations. For my father, to this point the optimistic liberal, showed the first signs of temperamental change which he would, laboringly, year after year, attribute to the erosion of global social order, but which I, in my youthful narcissism, took to be his response to my deviation from his Way.

The Twenties had seen the springtime of his hopes, and my early childhood witnessed their rooting in the soil of an institution with a democratic mandate. If the Thirties were for many Americans a time of embattled suffering—strikes at automotive plants not a dozen miles from the museum, bank failures and breadlines—for my father they were still a time of productive growth. Salaried and underwritten in his pioneer art programs for the public schools, he had no cause to oppose the American political process. The International Congress of the Communist Party in 1935, responded to by so many Western liberals and intellectuals, left him unaffected. On the contrary, he saw hope in the New Deal, in the WPA, in regional and socially responsive painting and sculpture.

And he was absorbed in illuminating exchanges with behaviorist psychologists, anthropologists and other progressive educators.

So while some of his old friends moved to the political Left during these years, he didn't, though his voting Democratic made him a maverick to the museum trustees. In fact, we were all a little cocky about our politics in those days. I flashed my Roosevelt button at school in the face of buttons for Landon, later Willkie, Dewey and Taft, and felt proud the day I watched from a window of the new house as our Negro postman slowed his pace to unfold and read our issue of *P.M.* No one else I knew subscribed to it.

But the 1930s also, of course, brought war step by step closer. Having traveled much in Europe, my father felt foreboding over Germany's move into the Rhineland and the Italian invasion of Ethiopia. Those were the first unusual geographical names I'd heard and matched for oddness the faint, shrieking and crackling voice coming from a radio set installed on our school stage that was identified as "Hitler." When the Sudetenland was taken, my father turned from our radio at home and said in a voice I'd never heard him use, "I see no reason why they shouldn't roll right across Europe." The 1939 mass evacuation of women and children out of London, talked about only in ominous half-sentences before us children, was surely one of the things that made our Christmas Eve walk in the snow that year so strange to me, as if we were part of some vast and frightening universal turmoil.

In our small domestic sphere there were also darkening changes. In the economic boom of the war, my father's scholarly salary shrank in buying power compared to the profits made by Cleveland's industrialists. Beyond that, of course, there was a turning away nationwide from the liberal consensus of before. The Moscow trials of 1939 cut through the

American intellectual community. My father would have said, "I told you so," but his sense of distance from the Left increased. By 1943, the WPA had collapsed in factional argument, and Left and Right would further polarize as the war drew on.

Yet for a while, it was as if the new house were another Eden, shaggier, with more corners and possibilities, but heaven still. There was a towering elm in the front lawn and another as tall in the back overlooking an English garden, a romantic geometry of curved beds around a birdbath before a pair of flowering quince. Here my mother would come into her own, nurturing, with the same driving energy she applied to her piano and kitchen, a garden like an Anglo-Chinese dream. She loved the night-blooming flowers, nicotiana and verbena, which filled the summer air with perfume, and she loved a wild-seeming tangle of stock and peonies, columbine and asters, and roses—the same hues of rosy pink and blue, lavender and sour green she now adopted for her summer dresses in accord with my father's esthetic dictum: "No black! With all the colors of the rainbow, why black?" And these colors turned up again in her platters of food, Della Robbia roundels of meats and legumes composed as much for their dappled tonalities as their flavors, corn yellow and tomato red, burgundy beef and curries, and all the various greens.

Outside and in, my father's taste also found expression here. He would have been at home in Georgian England and happily dined at Brighton Pavilion between the porcelain Buddhas and Chinoiserie peacocks. In his own small collection, beside the African sculptures on the bookcases, were a fresco from a Tang Dynasty tomb, a bronze Osiris and a bust of Homer, a bronze Art Deco dancing girl with rippled hair and a marvelous Tanagra Europa being carried off by the bull. There was a Bauhaus candlestick—a single up-shooting silver

rod set in a silver disk—and bits of Chinese, Turkish, Venetian, Coptic and African textiles. In the bookshelf was an early edition of Joyce's *Ulysses*, bought in Paris. Also, having limited funds but great reverence for the Modernist masters Cézanne, Renoir, Matisse, Picasso and Kandinsky, my father hung, as his mother had, framed reproductions on the walls without embarrassment. Every object in the house was interesting, nothing coarse or ugly. Among them I grew into an acquisitive creature, desirous of holding beautiful things in my hands, turning them over, exploring their undersides and backs, laying my invisible mark on them. A perilous taste for a daughter of the provincial intelligentsia in a century of economic distress and war!

If my father was proud of his collection, he was as proud of the artists and intellectuals he invited to speak at the museum and then visit our house. I suppose they entered our little midwestern oasis with surprise, to be greeted, then politely served and listened to by us children dressed in Japanese, Hawaiian or Mexican costumes our parents had brought back from trips. Gertrude Stein had been one of his first guests, back in 1935 when she made her famous lecture tour. Later, many of his worldwide network of colleagues came: Tugwell and Margaret Mead, Lewis Mumford and Susanne Langer, George Boas, Rudolf Arnheim, and Hilla Rebay, Chinese and Indian musicians, and an Indonesian dancer of voluptuous charm who, after her performance, sat in our living room in a circle of museum trustees gesturing with delicate fingers as she recounted the love plots she had enacted. And as she fixed her shining triangular eyes on this, now that midwestern male face, I saw each take on the glow of candle wax about to melt.

Then, and for years to come, since my brother and I had grown too old for stories and our little sisters had other entertainments, family evenings would be spent listening to

records from our father's encyclopedic collection. It might be African circumcision ceremonies recorded by anthropological outfits, or Chinese flutes and drums, but it was as often the romantic French music we all loved. And Bach. Save the Masses. And Beethoven. Save the Ninth.

Moreover, when they became available but long before they were popular, he brought home recordings of plays and poetry, Shakespeare, Marvell, Milton, Whitman, the Old Testament and so on. And other evenings were filled, in a pilgrimage that would go on for forty years, with Mother's reading aloud from the world's great myths, epics, histories, novels—always the classics, never books of passing fashion, political or otherwise.

And there was appreciation expressed for our school papers and such, so that each child who shone in some art or event had the feeling of contributing to the general good of the family as someday we would contribute to the world, though in what way was unclear.

There was also an extension of our family life reenacted yearly long after our Cleveland lives would come apart. My father had an epicurean detestation for Cleveland winters and, the proper pragmatist, scheduled his academic holiday from January through March, moving us all, with his books and typewriter, Mother's spaghetti pots and our own school workbooks, out of our normal routines to a cottage on stilts in an undeveloped fishing village on the bay side of Florida. The beach there was so easy a slope we swam and roamed the sandbars looking for shells without supervision, while Dad applied himself to his work, then took long walks, swinging his cane and conversing in his most lighthearted philosophical way. And in the evenings, we sat on the porch in the dark, hearing the palms scrape the roof and the waves splash just beyond our feet, and we'd gravitate soon enough to the kind of thoughts he liked to stir in his children: what is beyond the

stars and what is the mind; how should one live, and what is life, after all.

He was, as I've suggested, though the Modernist, also a shy and lonely man in ways, as I suppose a philosopher is likely to be, and undoubtedly took as much comfort from our presence around him there as we did from his. For whatever else we drifted to, there was always, as I think of it now, one unvoiceable question in the air those evenings: How can we survive the breaking of this circle, as we will have to one day?

For all these many reasons, in these first years in the new house, my sense of our difference from my friends' families sharpened. Our father's work and taste set us apart, we knew. But with our mother, the difference lay in the way she *was*. Or was not. Which was it? I didn't know, having never seen another female nonconformist. Was it her driving concentration at the piano, in the garden, the kitchen and the authoritarian way she sometimes marshaled us to do the same? Was it her frequent lamentation that she was so tired she was "dead"? Or that I was hanging on her, being a pest, whining for attention? Or was it her occasional voluptuary self-indulgence, unlike the straightforward plainness of other mothers I knew? She had brought along to the new house the little green perfume bottles, though now nearly empty, and when she dressed to go out, she went through the old pantomime of searching out a bit of scent. By now, her jewelry collection, made by my father, was elaborate and curious, consisting of ethnic or antique necklaces, brooches, bracelets. Her clothes, too, were quietly theatrical, richly textured, in colors to point up her hair. Unusually, when she was carrying Elisabeth, she sometimes wore black, an evening dress of net spangled with tiny metallic stars. Amply pregnant, wrapped in that drifting galaxy, she was the most heavenly thing I had ever seen. And added to her appearance was the sense she always communicated that she was on the point of going away

forever, or breathless from just having arrived—that her real place was somewhere else.

Therefore her medium, music, retained its unfathomably painful hold on me. As we would sit in the semi-darkness of a summer or winter evening listening to records, slowly, as if the whole house became a diving bell, we sank together through the surface of things. Often it was only the three of us there, my parents and me, for my brother early went off to boarding school and my sisters had early bedtimes. Then the defections of the day—mine—were as if forgiven, and a sense of near-anguishing hunger for her would possess me together with guilt for my recent bad behavior, of whatever kind it had been. Then I would lie on the couch, or Mother would, and she would rub, or I would rub, her back, my back, while the music played and, in his chair, my father sat at the center of his universe, protected from the bad news beyond by the deepening black in our windows. Once—if only I could remember the circumstances—Mother burst out in the middle of some music, "I could die and be buried to that piece . . . ," and I swore never to forget what it was. And of course I have, for I have no musical memory at all.

All the same, in spite of so much good cultural experience, as our father saw it, the temperature of trouble within the house as without went on rising. When did vague disagreement turn into rebellious discontent? As ever, one can choose a day. It was that first spring of my fertility when both parents told me to "wait," and I howled with impatience.

The next school year, a trio of us girls began to leave our neighborhood daily for a long trolley-car ride out into the farther suburbs where our new private school was located. Before long, I began to see Cedar Hill for what it was, an enclave of decades-old homes now too close to the inner city to be entirely fashionable, kept up in the face of possible

"falling real estate values," while the newer money—our classmates'—was streaming farther east into still undeveloped reaches of Shaker Heights.

In our new school, my old friends and I went on mouthing conventions of the time but began to strain at our lines. "Would you rather be rich or poor?" was an article of our middle-class catechism we often rehearsed, jostling eastward on the trolley car toward school.

"Neither. Just in the middle."

"Me too."

"Me too."

"Me too."

But then seated on the same wicker seats, returning west in fading late-afternoon light, it went differently.

"I'll never compromise, will you?"

"Not I, no never."

"No, never."

"Not me either. Never."

To compromise would be to live without love. Our notion of romantic love was our heritage from unknown evangelical great-grandparents who waited, breathless and overheated, in little country churches for the spirit fever to catch. So it would come to us each and set the mold for the rest of our lives.

From other wellsprings, an intuition of more painful reality was fed. Our new teachers were of a breed now gone, without other lives than instructing girls, ageless women with white hair piled high and expressionless ivory faces. By the conversations they would terminate coolly, by responses not given to certain questions and also by the frozen stateliness of their persons and their dress, they impressed on us that life might not be what the love songs said. They imparted the virtue of solitude, the loneliness of excellence. They issued biting commands, ridiculed the stumbling and nurtured a bond with the

few that felt by the end of our school years like love, though it was never expressed as such.

A tiny plump one who walked on child's feet smiled at me after I turned in my first theme and said, "Here's one who likes to write." She taught grammar in the old style of diagramming sentences on the blackboard. Suddenly, as one watched, a cloud of thought would shake into organic form, with roots, branches, leaves all connected by law and logic. Under the vocal lash of another, we avoided Byron as too heated for our age level but were delivered to Keats and the nonpolitical Shelley. My temples pounded when that teacher sat bolt stiff in her chair, with one hand outstretched and curled upon her desk, stout shoes planted side by side on the floor, to let rumble forth from the caverns of her chest,

> Wild spirit, which art moving everywhere,
> Destroyer and preserver, hear, O hear! . . .

Another, who taught science, leading us one day through an arboretum near the school, flung up her hand to show us a bird on a branch and fell into a ditch, breaking her leg. *Doña Quixote.* From a book she lent me, I learned that "in nature, nothing is insignificant, nothing ignoble, nothing sinful, nothing repetitious. All the music is great music, all the lines have meaning . . ."

"A life of mediocrity would be more horrible than death," I wrote in my diary under pressure of that book. And likewise my father kept instructing me to compare myself with the best, the first-raters. Yes, he exhorted me to high deeds. But there was the great vacuum which I wouldn't have known how to complain of at the time: there were no models at all offered for the exceptional female life. There were literary and real heroes, like Stephen Daedalus and Robert Louis Stevenson. And how I loved the tinkling camel bells that, I read, hung

on Sir Richard Burton's tomb! But never did we read a woman
writer. Not Eliot, Dickinson or Woolf. The only biography of
a heroic woman on my bedside shelf was Helen Keller's, in
a green cloth cover whose every blemish I knew by heart. I
sometimes wished I'd been afflicted with a deformity, because
then like Keller I'd have no other pull on my mind than to
let it deepen and run underground, as according to Leonardo
da Vinci the deepest did.

"Maybe she'll turn out to be a philosopher," said my father
to my mother one day. "Lord!" said my mother, rather vio-
lently, turning around from her dressing table with her brush
in her hand. "I hope not!"

And so began my defection from the Middle Way. Jacob
Wasserman's darkly Germanic *The World's Illusion*, found in
an odd bookshelf, fed my brooding dualism. In one of its two
thematically opposed volumes I met the world of social con-
ventions I was growing up in. In the other, all was gloomy and
interesting: poverty, criminal corruption, spiritual disintegra-
tion. I thought I knew where the path into that world began.
The baleful archetype already lived in my mind. Halfway
downtown, on a corner of Euclid Avenue, was a Negro night-
club called the Black Cat. Driving home from an occasional
movie or concert, we passed it. Who could know how I peered
out the side window of the car to see its dim lights glowing
and shadows on the crooked venetian blinds, moving as if to
music?

So my friends and I moved in the first summer of our heat,
moths caught in the lamp of our years.

For a while, good manners held us to form. "Sir," the boys
called my father as they shoved and tripped into our living
room, staring sideways at the African sculptures with their
jutting phalluses, their needle-tipped breasts. "Sir," they re-
peated, leaping to their feet and bowing when he left or

reentered the room. The term, like filed teeth or cicatrices among the Africans, signified both hierarchy and bond, a recognition of the transfer of dominance to take place by custom in time.

Good girls, by contrast, deferred to one and all, curtsied to elders, leapt up from table to clear and dry dishes. Girls, after a sleepover, made the bed with fresh sheets. We girls, in frocks of taffeta or velveteen, in patent pumps with slippery soles, by our fathers were driven, in elated clusters as if gale-blown, to Friday dancing school. This high hour in each week's unfurling took place in a hotel ballroom washed in golden light, to the trills of a single piano. There, shy by fits or ecstatic, forward, hopeful or heartbroken, we all went together (turn-side-close, turn-side-close, backward-side-close, turn-side-close), learning the ways, we were told, of the great world beyond.

But the real forays into the unknown were made in other circumstances, like our side porch on summer evenings, when the peonies glowed from the garden beyond, and the elm cast a shadow intricate as a web over the lawn, the hedges, the flower beds.

Lampenfieber, the Germans call stage fright. We spent those summers of the war in a transport of lamp fever, pushing one another forward, shrinking back, pushing again toward the proscenium that framed the luminous world beyond the porch. At first, of an evening, sitting on the porch in the pall of the yellow light bulb, we played games of secret choices, making lists of favorite boys, favorite girls, favorite *Hit Parade* songs. Then we ran out into the garden to play, as if for the last time forever, games like hide-and-seek, dashing back and forth across the black bars of moonshadow on the grass, pretending our innocence of that solemn season in our lives, as Ondine said to her fisherman, "before you will have kissed me."

Another summer, we paired off with experimental mates. First kisses led on to a hand on a blouse; the next night, the hand within; then trembling lips would be pressed for the first time to a nipple. By the summer's end we were lying for hours in each other's arms, but chastely, for this was still the early 1940s. In a spirit of inquiry, therefore, I lay one summer night on the swinging bench on our porch while my boyfriend of the season took a handkerchief out of his pocket and laid it over the erection he had produced out of his trousers. "So you won't have to touch it," he said. In the shadows, with one finger, gingerly I explored its length, then circled it with my hand. The next day in a swimming pool with my girlfriends, I spied an iron water spout. I swam to it and spanned it with my thumb and fingers. It was the same! Thereafter all afternoon in joy and curiosity I eyed it and from time to time swam casually over to confirm the fitting with my hand.

In time, the threshold of our ethics shifted, and we applied ourselves to deeper anatomy, still holding back from final pleasure, building toward an orgasm that—as convention conspired for many females of my time—would take years to complete. For relief we went to little bars where there would be a jukebox, rum in thick glasses, and heaped ashtrays, and there we jitterbugged for hours, tossing our Veronica Lake hairdos in which we'd pinned fresh carnations. And self-consciousness was humming in our ears all the time, saying, Remember these times, this dancing at the end of a snake-arm, twirling out when he sends me, twirling back when he pulls, catching the beat, not wanting it to end . . .

The fever rose. I lay on my bed looking out through my window, still sealed against winter, while the spring storm broke over our roof.

Wind entered the top branches of the elm tree setting them lunging while it drove black funnels of rain clouds over the rooftops. When a low roll of thunder made my bed shake, I

ran downstairs and pushed the porch door against the wind
to stand in the open while lightning flashed over the house
and spat along the iron frames of the awnings. Twice, bolts
split our elms to the base, leaving splintered limbs to be reset
later by tree surgeons. And later the earth would be like a
marsh underfoot, sucking at my feet, making me want to sink
my hands in its rank muck, running off to the gutters, over-
flowing as I was myself to be out and gone from the child I
had been.

Nymph, nympholet, my own nympha unfolding, I suffo-
cated for the metamorphosis that would release me into my
new self. This flushing of my body with the hormones of
change lifted me daily, hourly, out of myself. And inevitably,
the balance in our house was wrecked by the clash of wills
between my father and me.

He was baffled, disappointed and fearful. He thought his
program for my development had been so enlightened. All he
wanted was for me to be liberated, free of what was appar-
ently driving me crazy: the deplorable female need, as he put
it repeatedly, "to marry the first one who comes along." He
couldn't see the contradiction: that having encouraged me to
develop "clear spontaneous feelings" and even the primitive
beginnings of a "fresh untrammeled personal vision," he now
expected me to cut my behavior to patterns of his own anxious
choosing. I suppose he turned the problem over in his mind
at first and meant to act with restraint. Anger would come in
time, perhaps against his better judgment at first, but once he
saw how effective an outburst was in making me shape up,
he used it as an instrument in my training.

"Your child seems to be having a difficult adolescence,"
one of mother's friends said to her, and she reported to me
in a fatigued voice, after yet another explosion in our house
had nearly shattered the windows.

Well, what of that? I could have gone my way, would have
had I been born two decades later, and come back a wiser
being ready to go on with my life. But my will was read as
treachery and my hunger to *live*, as I saw it, a sign of psycho-
logical imbalance. And so began the mutual confusion, pain
and guilt that would keep me in my father's thrall, and
possibly him in mine, long after the years would have taken
both of us elsewhere.

In fact, his anxieties were laid upon me one by one, sequen-
tially over time to come, as if in a narrative order. And there
would be a novelistic theme concealed there, which I would
understand in full only later on. The first imperative was
Obedience. It was the law of the tribe, Hiawatha-Painted-
feather's first rule of thumb. But now I questioned the law.
At the top of my lungs, I questioned by what authority and
to whom I owed obedience? It seemed to me a parody of
reason to exact it from a helpless individual who had not
agreed to be so.

My father would approach me from behind or the side,
impelled on a flare of his own sudden decision, and shout into
my ear, causing me to start, my heart to pound, adrenaline
to pour through my body. "What's this about last night?
What about tonight?

"Go upstairs and get my glasses," he would direct as if to
to restore a balance of power. "Get out of that chair. Get my
glasses."

"Get them yourself," I once shrieked, criminal daughter
lost to civilization. His rage came in a recoil quickly brought
under control. In measured words, he described my failings.
"You are disobedient. Obstreperous. Why do you raise your
voice? Everyone in the neighborhood is listening.

"You will never be happy. You will have an unhappy life.
You are selfish. What makes you selfish?

"Learn to control yourself or you'll ruin your life.

"Ah!" he would reply to my anguished protest, for his predictions always struck me with terror. "You want freedom. Who doesn't? But you have to earn it. Your wild behavior fills me with foreboding. Change. Let me see you have changed. Then I may have confidence in you."

In a way, he succeeded with his science of behaviorism, though he did it by laying on me a trial I believe he would have wanted to spare me. For with every hammer blow of negative conditioning he let fall on the child I had been, my will, the will of the woman I would be, belled out in the opposite direction impelled by my sense of desperate self-respect: if he called me selfish, *I would one day, by all the gods, be caring of others.* If he called me ungovernable, *I would one day subject myself to controls of my own election.* Or on the other side, if he called me disobedient, I would be a slave for years to the mystery of why he had become what he was, and why I had.

And through that long slavery to a hard question, I would in fact learn many things. For having loved him unquestioningly before, I would be driven to a further end than just rebellion: that is, to understand. And to understand in slowly widening perspectives not centered any more on Eden but on the Adamic figure he became in my mind, who had begun as one man, then become another.

For example, even in the course of those first battles, I was aware of being sustained, somehow, mysteriously, in my life. By allowing me to shout and vent my own anger and dig out every last insult from my swelling vocabulary, my father was sabotaging himself, or saving himself from a greater wrong, which would have been to crush me, as he obviously could have, for he was the stronger. Even as he stormed, he must have felt himself driven by something personal to himself, beyond me. And in the last episode of this saga, whose turning point between us took place oddly enough not face to face

but between myself and a taxi driver in New York, my illu-
mined will would shape itself into a lifelong need: to go to the
end, find the truth as I see it and tell it.

But for the time being, back there in Cleveland, I was all
inarticulate confusion. "But I feel . . . ," I would stammer.
"But I want . . ."

"Ridiculous. Inappropriate. Some children have total free-
dom. Come and go as they please. Nobody cares. I care. I'm
severe because I care. Would you rather grow up without
guidance . . . ?"

By then I would be weeping uncontrollably, feeling the
rightness of his appeal, the genuineness of his concern, the
justice of his view that there was some wild girl or alien
person in me who needed tempering before I was fit to face
the world.

And yet through my sobs I would record the fact, too, that
he was now watching me. He saw that he had reached me. His
technique had worked. I was his again.

He couldn't keep me. I made a false escape, the first of many,
into a new neighborhood, one easier, more standardized, and
therefore delightful.

As the war went on, our household helpers went off to work
in factories, and since there was no money for improvements,
our house looked increasingly shabby and gloomy. The over-
stuffed chairs sank lower, the peach slipcovers dragged on the
ancient carpet. From such decrepitude and my sensible old
friends, I fled to the new rich houses of Shaker Heights. I'd
leave home with an overnight bag and take the trolley to the
end of the line, then walk two or twenty blocks of empty lots
interspersed with a few mock-colonial houses to spend the
night in a ruffled bedroom with stuffed animals on the pillow
and a pink toilet seat in the bathroom.

There, seated on the floor around a panful of fudge, my

jollier new friends and I would talk the deep talk of the
midwestern middle classes. "Have you . . . ?" "Would you
ever . . . ?" "What do you think it's like . . . ?"

"Once a girl has, everyone knows. Then she can't stop . . .
has to do it again and again . . ."

"Well, I'll never compromise . . ."

"I won't either . . ."

"Nor me . . ."

"Nor me . . ."

Or: "I believe in God . . . I believe in the afterlife . . ."

"So do I . . ." "So do I . . ."

"My father hates Catholics. Does yours?"

"Yes, he does. I think he'd rather I married a Jew than a
Catholic . . ."

"So would mine. Oh, much!"

In these houses, meals were served by silent Negroes in
starched aprons. Mostly in silence, these families ate the ham,
the roast beef, the lime aspic, none of the umber stews and
broths of our house. There was none of the anxiety either.
These fathers didn't probe and press, follow up and interro-
gate. They did not come down hard on ideas they disagreed
with, having none of their own. Nor were the sweet and
passive mothers like the matriarchs of my neighborhood, nor
like my mother either.

My father's disquiet increased as our boyfriends passed the
milestone of sixteen, got licenses and began to drive mile by
mile beyond our accustomed routes. In their jalopies or bor-
rowed family cars, we drove dark and empty miles west of the
Black Cat Nightclub down into the Flats, then roared back
toward the Heights, accelerating through the Negro neighbor-
hoods, rolling down the windows to shriek "Jiggaboo!" at
passersby, screaming to each other in fear and unacknowl-
edged shame.

We knew nothing, were ignorant and willful. The historical catastrophe of our age was taking place while we played like children. But we wouldn't go free forever.

One night a crowd of us went as a lark to the city morgue, to make fun of what we'd heard was a routine presentation, there, of an unidentified body. Laughing, we pushed open a heavy institutional door and strode to a glass panel beyond which, on a chilled stone slab, lay my first dead person. Ordinary in life as his worn clothes and shoes showed, only a tramp or unknown traveler, that person out of life attained a dignity before which all of us stood still. Not one of us could smile.

It was yet another beginning.

THRESHOLD I

Contradictions in our house deepened my confusion. Downstairs stood the African figures, scarified, hung with cowries and bones, phalluses relaxed or rigidly erect. Frequently from the record player came jungle drummings and ritualistic howls. And stored not out of sight, just slightly out of reach, was a world of esoteric literature: Krafft-Ebing, *Magica Sexualis,* the Shunga and Kama Sutra, books anthropological and medical, psychological and literary, illustrated with charts and, frequently, erotic Art Nouveau engravings. One by one, I took them from the shelves to read on my bed. If there came a step outside the door, a hand on the doorknob, I'd fly to hide the volume in my bureau. When my school friends came to visit, we would huddle on my parents' big bed, between the four posts topped with pineapples for fertility and wound with ivy for joy, reading Marie Stokes aloud. There was no way to bring the scenes into focus: the married lovers on one hand and the tribal crone on the other, deflowering a girl my age with a stone, sewing her up with vines and thorns, throwing her into the healing hut till she could walk again. So that alternately I envisioned joys and alternately horrors, while the years thrust us all toward the romantic marriages we believed lay ahead. And my father kept reminding me he was educating me so I wouldn't have to settle for the first one who came around.

He couldn't control the tide of years, however, any more than I could. Eventually by his hair-spring temper he earned a reputation among my friends, who, as kids will, went to lengths to keep him on the alert. One day, more to taunt him than to flatter me, some boy or other carved an amorous word in one of the columns by our front door. Appalled, feeling himself shamed before the neighbors on my account, my

father commandeered carpenters to lift up the entire portico with a derrick and set a virgin column in place.

Not long after, our waterpipes burst and plumbers excavated the front lawn, leaving trenches and mounds of earth. In the night, someone set on the tallest mound a wooden tombstone with my father's name in black house paint. Such a father! Could he be put in his place only by a cortège?

Still another time, an evening as he and Mother were driving down the street toward home after a party, someone touched a match to our gravel driveway. It had been doused with gasoline. An arc of flame lit up the neighborhood. Though frightening, the episode was only a prank well-timed. The family car had been four houses away when the match was tossed, and the blaze burned out in a minute. But a message had been sent.

Evenings I'd go out the door in a turmoil of petticoats and gardenias to come home to a parent engorged. "At this hour! You disgrace yourself! You disgrace the family."

"Can't you see you're driving me crazy?" once I cried. I felt crushed in a vise, my breath smothered in my chest. His blue eyes were points of rage in a flushed face, and I was trembling from head to foot. "I can't stand it . . . I'll explode . . ." Then as he watched me, his eyes lightened and his flush begin to ebb. But he made no step toward me to relieve my frantic tension. And since that scene was played upstairs in my parents' bedroom, with me still in my coat from my date, I looked around desperately to find my mother, and there she was, lying on her pillow, silent, watching us, her red hair in a net nightcap.

So I flung myself into the chaos of my room, the perfect echo of my mental state, with unwashed underclothes, wrinkled party dresses, trails of powder, pins, notes, drying corsages, swizzle sticks, school notebooks and compositions

half-done and finished and, in the wastebasket, paper-wrapped sanitary napkins, jetsam of the pre-tampon era. From this maelstrom, my father shrank. Even Mother found it a pain to enter and, instead of facing me with the news that it was time to clean up, would in her drifting way leave me little notes pinned to my lampshade: "Clean your room today . . ."

"*Empty* your wastebasket."

"*Kindly* empty the wastebasket . . . third warning."

Only dimly in those days did a sense of my father's confusion reach me, a notion of the distance he must come down with sickening suddenness from his philosopher's empyrean to deal with me. Once, trying to drive him off my back, I hit by accident on a word that made him flinch. "Puritan!" I shrieked. A look of pain crossed his face and he fell silent. I too stood rooted for once in silence.

"But I am not a puritan," he said slowly. "I detest puritanism. Have, all my life." He spoke with astonishment, as if a young man looked in the mirror and saw wrinkles and white hair.

He set about repairing the damage done with a quiet explanation of his concern. "You should look ahead. Be more serious. Think about a profession. Something you can do wherever your husband has to live for his work.

"I recommend teaching. I've always thought it the best career. Freedom with security. Time to work out your ideas.

"Of course, you have to get along. Cooperate. Adapt. No one with a bad reputation can be part of an academic community."

I must move to more somber things. In the spring of 1941, my grandmother Munro died. Though the little house in the mountains was only a day's trip off by train, the old folks, for

whom their son was the be-all of their life, never once were brought to visit. More than anything else that happened in those years, that seems inexplicable to me now.

During her long suffering from cancer, letters arrived describing her plight, but my father seemed not to take it in. At last he did, boarded a train and arrived too late. He returned one night while I was sleeping and in the morning was at the breakfast table, alone, his boyish face strained, his eyes red-rimmed. I couldn't speak out of ignorance of what to say, and he said only a word or two, and that was, on the surface, the end of it. And a year or so later, my grandfather came to live with us awhile and then die.

Then, as the war intensified, and in due time all reasoning adults in the West were privy to dread events falling on certain helpless victims abroad, an anxious spirit began to spread through our house. Even out in mid-America, there were rumors of possible air raids. Yet our father's fears seemed more immediate than those of our neighbors. For example, he bought a big pump-operated fire extinguisher and put it in the attic along with several bags of sand. We teased him then, but this enactment of his feelings impressed us all. I began to share the nightmares millions of others were having, of fighter planes flying low to strafe refugees, so we would run for cover, and of men with knives breaking in my window, so I woke in terror. And gradually the diving bell of our household sank into dark waters.

For one thing, we were in extreme financial straits. Our genteel poverty had always been a matter of pride in our family. But this was different. There was no pride here. Now the one who had led us to the High Rocks made us sit in frigid gloom. "Turn off the light. Close the door. Shut the window. Turn down the heat."

The one who had stretched my mind now cut my wings. "Think clearly. That's an irrational argument.

"You're wrong. That's wrong.

"Don't contradict."

Now Mother fought to cut a dollar off a bill, to save fifty cents. She shopped the basements, inveigled cast-off clothes from my friends for me. Where had I been when she turned a corner? I held myself to blame, for as this new person, she often turned on me a look of cold anger, calling me as if by mistake, "Charlotte," her hated younger sister's name.

In fact, during these years, she gave way to pressures I had no more conception of than I did of the causes of my father's behavior. Who would want to meet again the mother of those years, driven to mute bouts of slave labor and a mood of martyrdom, washing down walls already clean, double-waxing the floors, sweeping the basement, ordering the attic, all in fetal silence that drove me into a panic. I would shout at her, harrowing her with words, anything to shatter the silence that sealed me out as utterly as, more cruelly than, her piano once had.

Her beauty was gone. She of the silver-grey satin and the blue sprigged peasant jumper now hung herself in sacks of dark wool over corsets that ridged her flesh until, at nightfall, she would give a groan of final protest, lift her skirt before our eyes, unhook, unzip, unwind, then hurl the whaleboned garment up to the top of the stair landing, where it would lie like chains till she dragged herself up an hour later to bed.

But the worst times were in the basement. From the upstairs hall, we dropped laundry into a chute that spilled onto a cement floor two stories down. Down there, she and I would go one evening a week as if into a nightmare. We would gather the sheets, the socks, the shirts, and drag them to a tin washtub boiling over a gas burner, to soak overnight. Next morning we would drag them, piece by heavy piece, splashing water on all sides, to our ancient machine. And when it had done its clanking best, down we'd go again to drag out the

clothes and force them through an ancient wringer that cranked by hand, then carry the wrinkled coils out to hang them on a line to freeze, be blown to the garden's edge or rained on.

No heavier labor seemed done by any human. She moved like a dead woman, which is I suppose how she saw herself. I understood nothing of what hurt or drove her, only that when I was working by her order at her side, without a vestige of shared enjoyment, I'd look at her out the corner of my eye and know this wasn't daughterhood but slavery.

These early years of the 1940s were, of course, marked by war-associated barbarisms certainly known to our parents but never discussed, at least before us children. Either in dark words or darker silences, my father and mother must have dwelt on the chain of events that led from Nuremberg and Kristallnacht to the deportations, to far-off Polish villages never heard of by us, either, of individuals with even one-sixteenth part Jewish blood. Some scholars suggest that the Holocaust was the *reductio ad horrem,* so to speak, of nineteenth-century Social Darwinism and eugenics theory, to which my father's Christian ancestors and Modernist fellow educators paid innocently hopeful mind, and this isn't the place to argue that historic devolution of an ideal. But the tragedy that ensued caused smaller waves in many of the world's backwaters, of which our Cedar Hill may have been one. My father's exaggerated anxiety about my behavior and the neighbors' opinion of me and us, my mother's crushed silence—these reactions may have been to another circumstance than the one I took upon myself: my adolescent frivolity.

The deep causes for my parents' silence on these issues are buried with my father and lost in my mother's memory if not unfolded in these pages, but a contributing factor must have been his ingrained adaptability, the nether side of which was

a timidity about bucking social norms. In those days anti-, or, more accurately, *non*-Semitism was widespread in American cultural life. In my father's profession, there were almost no Jews. Museum personnel, by tradition stemming from their required social life with Christian patrons, were of the same stripe, the more socially unguent the better. Indeed, my father, among whose early pals and bohemian cohorts in Cleveland were at least a trio of Jewish men, tried once to have one of them hired by the museum for curatorial work for which he was qualified, but the man was turned down without equivocation. Nor in my own school and social life did I meet Jewish, much less black, children. After my progressive kindergarten closed and I went first to public school, then private, I had no friend of the tribe of which Daniel had made me vaguely aware. There were but a couple of Jewish girls in my school, and though I was once or twice driven for an afternoon's play with the daughter of a respected lawyer or musician with a long name, the nature of these girls' difference from what I felt myself "to be" was something of which I was only, again, vaguely aware.

A turning point did come for our mother, however, again unknown to us children, when she chose to break one kind of silence and return from the dead. At issue was the house. There were the debts, and my father, who prized the abstract form more than brick and mortar, determined to put it up for sale. At that, Mother unbarred an iron will.

She would not sell the house.

"The Lord will provide . . . ," my father used to say of the future. He said it kiddingly but with a little deferential smile at the sky all the same, the same as when he pinned on the dashboard of our car a St. Christopher medal given him by a nun in one of his classes. So "the Lord will provide," he said when there was a mortgage payment due and nothing but the house to sell.

But that acre of garden and brick was terra firma under my mother's feet. She remembered her immigrant father's fear of ending in the poorhouse. There were streets in inner Cleveland that filled her with such dread. It was existential, her recoil from double-family dwellings in rows, fronted by monotonous stoops. So she could not sell our house. She turned instead to her own father, who had long suspected ours of impracticality, and got her inheritance early and paid off the mortgage. And then she had the house put in her own name.

We knew nothing of this. Nor were we there the day she addressed our father, standing with her back to the windows overlooking the lawn and the elm, and said in a low voice so no one else could hear, "You always told me the Lord would provide. Now I have provided. And I am the Lord."

"Take a wife from hell," goes an old Gaelic saying, "and she will take you to her own house." My father may have remembered these words sometimes, for from that moment, Mother built herself a new ego on hard rock, and the rock, as for many women who find themselves helpless for a while and then make themselves strong, was property. In the next years, as war gave way to Cold War anxieties and she entered a new and colder phase of her own life, she would become a master builder. She pushed. She drove. She climbed. She became her own Buddha.

She did it for herself and her children. She gained us some of the world's goods, but she didn't win our thanks. As I'd fought her distant self, then her martyred one, I fought her new hard self, never knowing that mine was only one of many rejections she suffered as she struggled to survive during those years in Cleveland.

She wouldn't cry, for instance. "Why don't you let me see you cry?" I asked. My friends' mothers shed companionable tears and even turned to their daughters for comfort. "I've nothing to cry about," would come the cold voice, as much

as to say, against whatever it is I suffer, I have only one defense: to refuse to cry.

I fought her new hard look, the tight curls she imposed on her hair instead of the braided coils and natural frizz of before. I fought her new social standards. "Who is that boy? Who is his mother? Who is his family?

"What do they do? Where do they live?

"He's loathsome to look at. His hair is a bush and fills me with disgust."

I fought her communications on sex. "Don't trust them. First it's your hand, then your arm, then your shoulder. Next they want to be fondling your breasts . . ." Sick with shame, I told her to shut up and turned away.

And in those times, I fought my father for having let her down by being aloof, letting her be a slave to the house and to drudgery he never lifted a hand to, for failing to see the person she really was, though I did not know that person.

And I fought her for losing her pride, which would have taught me pride in myself.

And so between the two of them, struggling to hold together in those years, there I came up, their firstborn like a scourge, aggressive, smart, argumentative; insatiably obsessed with what I took to be their wrongs and failures, returning again and again to judge them, and finding them both incomprehensible and wanting.

And seeing the pain I was adding to their own, and the incomprehension of each of us vis-à-vis the others, and the resentment of my three siblings witness to it all, I was dragged back to my ancient dread: I shall lose her forever.

Such is the strength of youth, however, that I lived along on one level while these stresses were hollowing out an emptiness into which I'd one day fall.

I began tapping my way around that holy place called Art,

working after school at the Cleveland Playhouse repertory theater. There I tasted the pleasure of technique, learning to move on stage and project my voice through the tunnels of lines from the great plays. "Multitudinous seas" sounded in my mind, and I wrote poetry. In school, I felt myself unchallenged. In the College Board exam my senior year, the given theme was "It's a long road that has no turning." With a flying pen, I envisioned a future rich if short, with many turnings. To have praised the straight one wouldn't have occurred to me. In June, we graduated carrying armfuls of blue delphiniums. Our white dresses blew in the wind as we stood in an arc on our school's outdoor Greek stage, and I took away a medal for the French prize and a book by my father's old friend Houston Peterson for the poetry prize.

That August, in an unusual effort to heal the latest but not the last of my broken hearts, this one caused by a soldier boyfriend who left me hanging after V-E Day, my father took me with him to the Catskill mountain house. I sat under the old locust tree, smoked my cigarettes in the outhouse, walked the hills and recovered my balance. And as we were packing to return home, word came over the radio that the atomic bomb had been dropped. Like the rest of the world, at the news I felt the emptiness at the bottom of my mind widen a degree.

Preparing a couple of weeks later to leave for college, I picked up my old diary for the last time. I leafed through my girlhood entries—the ones that wondered: "What is fire, flesh, air, sound? Why is consciousness sad to me?" and the ones that hoped: "I hope I can be popular and smart." Then on the last page I made a final entry—"I feel a great fear, what will happen. I hope nothing bad. My life is so up and down. I hope it will not be bad"—and closed the book for thirty years.

* * *

I was the first woman in my family to go to college and went
on a scholarship with no choice of place but a sharp sense of
responsibility. The college routine was back to normalcy—
the system *in loco parentis.* The WAVES who had trained on
the campus had been swept off and all memory of their
training for useful experience forgotten. There in pastoral
New England, in a women's college, it was as if the war had
never been. Our dormitory houses were locked at eleven.
Parents' permission was required for off-campus visits. Visits
to our rooms by male family members were heralded by
warning shouts of "Man coming up!"

One of the functions of women's education then was to
orient the social person. The cliques and groupings one was
shut out of or drawn into served as a mirror of the self still
unknown, and most students went along fairly straight tracks
from their home environments. However, I was dazzled by the
social choices and gyrated among groups. There were daugh-
ters of corporate executives, long-legged girls fated to impor-
tant marriages and, in a rare case, a far-reaching career.
There were my fond old childhood friends, middle-American
Protestants, moving toward lives of civic responsibility. There
were a couple of bohemian artists and as many political radi-
cals, for the Marxist discussion group was waning before
McCarthyism would invade the campuses. There were clus-
ters of Jewish girls, some of whom would have poignant
literary flowerings in college. I drifted toward this company
new to me. I found them lovable, individualistic, funny. They
laughed about their hang-ups, their traumas, their overindul-
gent mothers and indecorous fathers. When a book about
growing up Jewish in America was published, they went whis-
pering, "Yes . . . at last someone has said it," and their
bitterness caught my attention.

As to my courses, my father helped me choose so as to take a wide look at world culture, Asian and Western. His breadth was stimulating, but wide vision was also a function of his notion that women were the guardians of culture behind the scenes and didn't need special training. After I performed an uncomprehending *Antigone,* he suggested acting wasn't a good life choice for a woman who would be married. "Women support the orchestras, the museums, the hospitals," he often pointed out. "Educated women will pass on the values of our civilization." He meant to be encouraging, but the thought of spending a lifetime behind the scenes of orchestras was depressing.

Discouraged from specializing, I gyrated also among interests, a course in T.S. Eliot here, a course in Chinese philosophy there, and finally majored in art history. What briefly stopped the directionless spin of my mind was the way works of art looked on a screen aglow with projected light. I would sit bolt up and feel my pulse trip. Those Archaic Greek boys and maidens with calm faces, crystal eyes and rounded shoulders! Those carefree sexual beings enlarged to heroic scale, light-shot till the tissue of the stone seemed to shine from within! Before them, I may have felt the same astonishment I'd felt in the Catskill meadows so long before, though by then I'd quite forgotten those earlier days.

Was it still *Lampenfieber* and a sense that I wasn't flying a straight path toward a single goal but veering toward bobbing lights that slowly began to fill me with renewed anxiety during my college years, despite, as before, my achievements? So much in my future seemed defined by negatives: not to become an actress or an anthropologist. Not to marry the first one to come along, but not to make love with anyone either. And once married, not to be only a housewife but not to work at something at odds with a husband's needs.

I read *The Well of Loneliness* and was deep in it one summer day when my father came to sit beside me. "Yes," he said, when I told him the name of the book. "There are people who are unfitted for normal life. But that happens rarely. You see them in hospitals. But most people find their place in the normal stream." He willed me normal. But where was normal for me, with my vague dreams of love and achievement but no map save the single word: experience?

It was May of our senior year. I climbed the steps of my dorm toward my room, leaned on the window frame midway up and stared into the heart of a nearby tree, feeling my own blood ruffle and rush as if I were flayed, without skin for clothing.

I came down with one of those heavy fevers of youth and went to the infirmary. In the night, I dreamed I was standing in a meadow looking off toward a woods from where came a howling of voices. Then coming toward me I saw a host of creatures made of tree trunks and branches. Their dirt-brown hair fell in knotted tangles. On stiff limbs they stumped along like cripples, raising that communal keen as if calling me to them. I woke in a sweat, with my heart pounding. Was that the tribe of women coming to claim me on the threshold of my life?

I'd been reading Freud's theory of Thanatos, and it seemed correct to me that some lives were death-haunted. My mother, for one. Also, recently a beautiful, intellectual Indian girl had told me she was going home to marry a man she'd never seen. How could she do that? "It's expected," she said, bowing her head. It seemed terrible but true that some women were driven to deform or spoil their lives.

I had doubts about my ability to save myself. My old classmates from Ohio seemed not to feel these things. They were going home to work behind the scenes of symphonies and hospitals. One by one, each of their faces would cloud up

with inner thoughts, then take on a mask of solemn calm. Soon would come the announcement of a wedding engagement. These women thought their way was the right and natural one. I had no such assurance.

I gave the valedictorian speech for my class that June, preaching hopeful pieties amounting to the fact that the world had nothing to fear from the graduates of 1949, in our case, five hundred middle-class girls mostly en route to the altar. But even as I left the podium, I realized the message had little relevance to what I might be or become. To "find yourself" was the abstract imperative that beleaguered women in those days. But I was bare of both self-knowledge and knowledge of the world as I stepped at last across the proscenium as if into the summer-night garden where I'd stood in a trance of *Lampenfieber* some years before. It would be a dark place I'd wander in for the next few years. If I'd once departed from Eden through widening orbits, I now sank through shrinking orbits to the fulfillment of my fears.

And in my groping I did make contact with a certain melancholy element in the post-war world. My fragmentary searches reflected, in a minor way, the sense of purposelessness suffered by some, women especially, of my generation. There was then no community of middle-class women moving into professions. All social pressures were toward the restoration of family society. Even American women with a developed gift for the arts or scholarship had hard times in the early 1950s. But for those like myself, who wouldn't adjust to expected patterns yet required some wander-years before finding direction, that phase of wrong or no choices was devastating. One felt so bitterly the waste of time.

THRESHOLD II

The war and attendant horrors shook the world, producing transformations across the whole range of culture as people turned in revulsion from what science had achieved and utilitarian ethics allowed. Deep under the surface, the Modernist world vision began to decompose, the old Platonic model of One World giving way to the divisive realities of national and ethnic self-consciousness.

The shocks of the process continue today at all levels. Responding to these tremors like many other liberals of a past generation, my father began to voice revived fears which he attributed to the immediate dangers of Cold War. Then of course I didn't see the relevance of the larger picture to our own, but in time, the vast cultural slippage would be shown to me in personal microcosm.

In the post-war years, the scope of his reputation and activities widened. He met intellectuals from abroad and his awareness of ominous new power balances in the world sharpened. Disturbing books revived ancestral anxieties. He read Paul Blanshard and his Highland fear of Catholic conspiracy sprang into life. He read Koestler and feared Slavic power. As one of the founding members of UNESCO, he saw it soon weakened—eventually to be rendered impotent—by conflicting self-interest.

America, safe during the war, wasn't immune to its aftermath. Many European scholars and artists had taken refuge here, bringing bitter memories of the way abstract social and esthetic theories lent themselves to misuse by Fascist governments. To this day, writers in the American social sciences shy away from the kind of large-scale, interfield operation that was my father's gift and style, born of the hopeful Twenties. No field in the humanities is more particularized than American art history today, and anthropology and sociology

are close behind. It seemed that my father's vision of saving the world through scientific esthetics was no sooner born than out of fashion.

The goal of Modernist art and art education had been an evangelistic one, right for an optimistic age in which cultural opportunities offered at the bottom of the economic scale seemed to promise profit for the whole nation. It wasn't in post-war mentality to have confidence in so-called cultural Band-Aids to heal the world's wounds. So a breach widened between my father's generation and immigrant and younger scholars who soon made up the academic mainstream in this country. He wouldn't be alone, in coming decades, to feel bewilderment, then painful disappointment, as he saw the tissue of Modernist confidence come apart in alternate phases of social conformity, then disorientation, in the course of which new art and behavioral styles emerged that were uncongenial to him. There would be one final flowering of Modernism in the visual arts—the deep-dragging idiom of Abstract Expressionism, full of portent and released energy—but essentially the era was over. Abstract Expressionism would be institutionalized in museum shows in decades to come, but its root esthetic—belief that a human gesture, recorded in paint or steel, had power to redeem the world—was played out.

As my father took account of the gulf between his early hopes and the realities as they were coming to be, his discouragement grew, and still the gulf widened and revealed depths apparently never to be closed over in his lifetime. Therefore in years to come he would disengage from the active art world, in which his Modernist colleague and friend Alfred H. Barr, Jr., would play a shaping role, and turn to general enterprises he found more promising, editing an international *Journal of Aesthetics* and setting up a worldwide network of estheticians which extended even behind the Iron Curtain. His once pro-

gressive politics gave way to conservatism as he took refuge in, or forged forward to—depending on how one saw it—the books of his maturity, in which not the social reformer but the philosopher would speak.

In this phase of his work, he felt himself to be, like his Darwinian ancestors, a pioneer. He was laying out a new field, the proper study of which would bring benefits not in the short term but the very long. His intent was still to approach the arts from the standpoint of the natural sciences, to describe and classify them in the manner of Aristotle, Linneas, Spencer. The first of this series of books, published the year I graduated from college, was *The Arts and Their Interrelations.* It began with a section on "the need for clear thinking about the arts," which tried to deflate those who had less faith in science, from Emerson on. "As long as we stay inside the old compartments of thought, we tend to retravel the same old paths within them," he wrote. "It is time for new surveys of the territory of the arts, and for new explorations within it." Though always the empiricist, he was no technocrat but a utopian who would put objective methodology to the service of a better life.

Yet as I think now about my father's growing absorption in this universal *form*, which would occupy him until his death, I see the process shot through with subjectivity. I remember with what attention to its implications he explained to me, when I was a child, Michaelson and Morley's famous experiment disproving the theory of "ether," in which, to put it broadly, the stars, sun and earth were thought to float. If the empiricist finds himself in a corner from which individual things have no logical connection with one another and so can't be proved to cohere or endure, then for the esthetician, as I suggested earlier, *form* may serve that stabilizing end. Like ether, *form* interweaves the universe, binding it into

coherence. My father's daily meditation on *form* may have been his saving grace. It insulated him from disorder within and without and was, I think, a mantra against mortality.

Thus in spite of discouragements, he still looked to productive years, daily to reexperience wonder at the spectacle of man's domination over death by giving transient matter form. And thus he felt that all he read, wrote and did had also a moral dimension. Monumental, plain-spoken, near-universal in detail, his books awed us children but were inaccessible to us, surrogate unwanted siblings and ones impervious to challenge.

In his enormous, windowless office at the museum, surrounded by thousands of volumes on all the works of man, with eighteenth-century music on the phonograph, our father was daily self-elevated out of self-doubt's way to a Confucian degree of serenity. That office, all those years, filled me with dread and gluttony. So many books, to each of which he had the key and correct point of view! My ignorance, by contrast, felt bottomless. My feeling about books in general, therefore, became like that of Tantalus toward water. I thirsted for them, to take them in with underlinings, margin notes and endpaper indexes which, taken all together, conceal at their graphic core the small grey-suited figure of my father at his desk.

From these ruminations about my father's work I've drawn a further conclusion. I'm convinced that, in the most apparently impersonal constructive labor—writing, art, philosophy, scholarship, whatever—personality, the projected persona of the worker, is hidden. I'm driven to seek that hidden face and hand. Intuition leads me to it almost without my knowing. I see projected pain or hope in a scientist's choice of experiments. I feel breath in statistical graphs and

hear footsteps in appendices. Out of life experience we make our work, and work is our lived life reflected outward, or it has no authenticity.

In this respect, I read with new eyes a paper my father wrote to present from lecture platforms in Europe. Leaving college, I'd won a longed-for fellowship to study in Paris. But when most I craved independence, Mother with tears of happiness in her eyes announced the whole lot of them were coming along, for my father had been named the first Fulbright professor to the University of Paris.

His major offering would be a study of *The Afternoon of a Faun* in several interrelated works: Mallarmé's poem of 1876, Manet's illustration for it, Debussy's tone poem of 1894 and Diaghilev's 1912 ballet with sets by Bakst, starring Nijinsky. The story, of course, concerns an amorous faun who spies a group of nymphs in the far distance. The faun "has seen, or thinks he has seen, a group of nymphs. He is not sure they were not swans or birds. He is not sure whether he really saw or only imagined them." The faun of course represents erotic passion kindled then fading, but in my father's mind it may have also represented the young poet, thyrsus in his hand.

He then wrote of the time before World War I, "that period of creative exuberance which now appears as a Paradise Lost to those of us who have lived on to the middle of the century." He was thinking of his youth, perhaps even the years at the side of his mother, who so loved "all the arts" that she gave him to their lifelong study. And so he wrote, and so I read, of that time when—in dreams or reality—the faun heard the nymphs, followed them for a while and then—in dreams or reality?—fell into a waking drowse in which the music was heard no more.

If a reminiscent emotion moved him in the writing of that

paper, emotion not reminiscent but predictive moved him a little later when he charged himself with opening my eyes to certain dangers in my path. This he would do in a technical way, without sentimental gloss, to clear my head of misinformation. In fact, we were all worried about the European trip. As the sailing date drew near, I dreamed more than once that I was on a ship, and a storm came up and sank it.

For some tactical reason, he and I preceded the rest of the family by car to New York. We found our hotel and rooms, and he invited himself into mine for a drink before dinner, so unusual an event I was prepared for serious business.

He ordered two Manhattans from room service, bade me relax and began to speak.

"You are so eager for life," he said, clearing his throat several times. "You think you can do what you want in the world. Go your own way, have your friendships and love affairs.

"But let me tell you, wherever you are, whoever you're with, people will know what you've been doing and talk about you.

"You want to be the equal of men. So you are. I brought you up to be an independent thinker. Not to marry the first man who comes along. However, it's sad but true . . . a virgin brings more on the marriage market. Therefore, I counsel you . . ."

In a sense, it was too late. One evening that summer, I'd come home from my steady date vaguely knowing myself to be unvirgined. But my gentle, trusted boyfriend, with precision, drew back at once, and so far as I was concerned, we still hadn't gone all the way, as we said in the 1940s. I was even so little impressed by my new state that when he brought me a gardenia the next day, I'd said, "O, I love flowers, especially when there's no occasion," and he ruefully pointed out, "But there *is* an occasion . . ."

* * *

But my father wasn't done with me that evening in New York. The room blistered with tension. Our Manhattans arrived, and who could drink them? "Bear in mind. If you become pregnant, you'll ruin your reputation. Ruin mine."

The pragmatist turned a cartwheel and became a fool.

"Men are all alike. Passionate and aggressive. It's our nature. Men will take you out, make smooth talk and have one thing on their minds . . .

"They'll get you onto a couch, and take no precautions, because what do they care? It's the woman's responsibility, they'll say, and so it is in our society, sad, but true . . . and the contraceptive can get loose or have a hole in it or drop off, for there's a good deal of moving about in sexual intercourse (forgive the technicality but these details are important) . . . and there's a method called *coitus interruptus,* but it's bad for the woman's health . . ."

My hair was standing on end. I was dying of shame while his voice ratcheted on. I would have fallen on my knees if I could have moved. But I couldn't. I was frozen by ruptured trust and, I suppose, somewhere, fear that all he said was true. For he sat on history as he talked. In some dark recess of his own fearful and vulnerable under-mind, he must have conceived it his duty to usher me into life by these rites of instruction, tearing not my flesh but my belief in my value as a whole human being, sewing me up with the thorns of pragmatic advice, leaving me to fester and one day to heal in the hut of my nightmares.

If the first defense against social chaos was obedience, he was telling me, the second was chastity—female chastity. Hadn't Samuel Johnson said it once and for all? "Consider of what importance to society the chastity of women is. Upon that, all the property in the world depends. We hang a thief for stealing a sheep, but the unchastity of a woman transfers

sheep and farm and all from the right owner." Then there was the example of his mother's lifestyle during her years on the platform. If the story was true, she managed an unconventional career without risk to her reputation at the price of her sexuality—not an unusual bargain for women in a time when there was no other safeguard against conception.

I can even see my father's problem in that middle year of this century of change, before the Pill. He had preached the liberated life and an open mind and waked my senses with stimulating works of art. Then, having opened so many doors, he looked around at the world and saw to what risks he had turned me and sought desperately to shut them—exactly as the Christian missionaries, having taught their converts how to spell, saw with a sense of nemesis what titles the natives chose to read.

And like those half-pagan, half-converted Chinese, I'd be strung for a long time between my father's values and fears and those that would be my own. For painful and frightening rites of passage are of course a tribal daughter's means to self-knowledge and social integration. But for the Modernist's daughter, as I'd learned already on the eve of my fertility, there was no larger identity or tradition into which my years were impelling me. My father had esthetics. Before me lay a void and a romantic fiction.

SLOUGHS
OF
CHASTITY I

During my year in France—the motherland of my mother—
I learned only a little more about myself and the world
than I knew in those days about her. The Paris I circulated in, a
transit place for survivors of the war, released stateless mili-
tary and displaced peoples, seemed permeated with lost inno-
cence and not-yet-discovered adulthood. Largely in this
population of the rootless and the homeless, I made my year,
seeking only passing contact with Americans living in comfort-
able digs, working for UNESCO or the Carnegie Foundation,
discussing reconstruction policies in the English language.
Instead, solitary, fluent in French, I plunged straight into the
haunted landscape of my early dreams.

In his foolishness, my father picked Yves for my initiator
in the first circle of my small infernal fall. He spotted him
across the dining room of the S.S. *deGrasse* as an interesting
example of post-war European mentality, "weak, but sensi-
tive to esthetic matters. A victim of the times." So alerted, I
presented myself the next morning as help of the helpless. He
was thin, with the studied finesse and mournful charm of a
kept man. By his side was his keeper, Janine, lean, chic, with
a simian face and, somewhere, a conflicted heart, for soon
after introducing him to us as her bachelor cousin, she took
my father aside to complain that I was trespassing. There
were scenes, of course, yet not two nights out of safe harbor
I was calling myself, yet again, in love at last.

After we landed, my parents settled in a hotel residence,
my college-age brother went to Grenoble to grow at his own
pace, my sisters were placed in a boarding school of appalling
severity and I took a room in the Foyer International des
Jeunes Filles on the Boulevard Saint-Michel. I also made
frequent visits to a hotel overlooking the spires of Saint-
Germain-d'Auxerrois, where I climbed the dim staircase,

heavy with odors of chicory and old carpet, to Yves's half-seductions and muted self-recriminations. For he had broken with Janine and expected to be salvaged by me. My idea, however, was for him to get a job so we could be married. In the end we were both disappointed. For Yves, who imagined he had won the backbone of America, found himself instead embracing a creature as boneless as himself.

Though I spoke French, I still read it haltingly—a frustration for one used to devouring print in swoops and gulps—and so had as yet little access to books or ideas but drifted on impressions that mirrored the condition of my mind. In the Luxembourg Gardens, wet packets of leaves covered the walks like shards of fallen buildings. Autumn passed with its mists and dripping roofs. Infatuation drained off in tears. We half-parted to communicate by letter. His were written in a thin hand on blue paper and slipped into my box at the Foyer. "Do not condemn me without understanding," one went. "You have never suffered the humiliation of subjugation. That experience has crushed our will, sapped our courage. One day, you will understand, when you come to know the history of our time and our generation." After a final absurd gesture at ending my state of technical chastity, his last letter turned the key. "The worst of all forbidden dreams is to believe oneself better than one is. I forgot that I had weaknesses. You reminded me, and now I have death in my heart."

There is no English translation of the French verb *mépriser*—literally to despise or scorn—sufficient to its vaguer implications of heavy judgment and holding to account. Turned on oneself, the word implies abysmal self-doubt, and foreboding. These punishments I took on myself for a crime I couldn't find words for either, and during some weeks bleakly slogged the streets of the student quarter, wearing black felt shoes that, too wide for my American feet, slipped

on my heels with each step, making me feel even more the hapless waif.

In February, I moved to a room in a flat facing the church of Saint-Germain-des-Prés. During the war, it had been a station on the underground escape route for Allied fliers. For my landlady, the war years had been full of high purpose. Now she mourned the marriage she hadn't made, the children she hadn't had. Only once while I was there did a lover appear. I tiptoed while the door of her bedroom was closed. All evening, it was closed, all night. In the morning it was open, and the man was gone. Red-eyed, she muttered only, "I'll always despise him for having made me remember what I once wanted."

Two refugees came into my life, one Polish, one Hungarian, both stateless, without support, not knowing where the future would take them. The Pole took me to his club. There, an older friend, also a Polish refugee, strained, his face haggard, missing a tooth, leaned across the table to talk about immigrating into the United States. "Our lives depend on you. Our lives. Don't forget. The lives of two men will depend on what you can do when you get home."

"Probably she can do nothing," said my friend uneasily.

"You don't know Americans," said the other. "You think they've forgotten you. For months, no word. Then a letter comes. They've arranged everything."

The Hungarian at twenty was a small man of ice. He was blond with a clipped young face, like a fraternity boy in America. But at sixteen on the Polish front, he'd learned to survive in deepest winter without shelter. You slow your breathing, he told me, till you almost die. That way, you may not die.

He had no passport so he was going to join the Foreign Legion. In the end, if he didn't die, he'd have a passport. But

in the meantime, he was beset by anxiety. He said people were looking for him. Whenever we sat down at a café or on a bench, he looked over his shoulder. "We're being followed," he said, but his fear was a wish sadly deformed, for there was nobody left in his family to come after him.

Later, back in the States, as I was forgetting the Pole, I would get letters from the Hungarian somewhere in North Africa with the Foreign Legion. "Send me some science books," he wrote. Then, "I am losing my mind here." Then— so it seemed, for his letters stopped—I was forgotten.

At the Sorbonne, too, students showed the effects of the war years and food shortages—hunched shoulders, sunken chests, thin double-breasted jackets buttoned against the cold. On an arm that reached for a coffee cup, I saw the tattooed numbers that signified experience beyond my capacity to share. I didn't even know what question to ask.

I went to my father's lecture on *The Afternoon of a Faun* before a packed hall at the university and gained a little understanding of another subject. He spoke flawless French. His modesty and erudition won the audience. Afterward, Serge Lifar, the dancer, leapt onto the stage from the front row where he had been sitting to describe his historic performance as the faun. My father was flattered and welcomed him, but even as Lifar spoke, four stocky men in blue workshirts shoved through the standing crowd at the back to plant themselves in a row with their arms crossed on their chests, staring down the collaborationist. It was Lifar's Maquis dishonor guard, which presented itself wherever he appeared in public, to let the world know his crimes were not forgotten.

Frequently I joined my family for meals, or my father and I met at a café to talk. The searing battles of the boat trip had tapered off into admonitory ruminations. "There are always

the weak to prey on the innocent," he would begin in a general way but soon veer to my case, making an effort to address me, now, as a conversational equal. He had watched me go through the exact stages Freud described. "Sometimes you and I are close, sometimes the opposite. I suppose you know Freud calls this the Oedipus complex. Or in the case of a female, it's the Electra complex. The point is, I'm dominant in your life and you're having a hard time finding someone your age you can respect. So you gravitate to the weak . . .

"But the first-raters are in their offices working, making something of themselves. Not idling . . . talking . . . talking.

"Think about what I say . . ." But I would be rising from my chair to flee lest I faint from the feelings his dissections stirred in me.

Or we talked about France. He was dismayed by the pessimism of the European intellectuals and even wrote an uncharacteristically pointed article, "The Failure Story," to describe current literature, including Faulkner, that seemed soaked in despair. At fifty-one, he was determined not to admit that the world was irrevocably darkened by the war. He rejected Existentialism because it faced into the abyss. Though death was a fact, he saw no value in thinking about it. Indeed, Existentialism seemed to him the solipsistic dead end of empiricism, arrived at in a time of crisis and mass suffering. Post-war Christian philosophy on the other hand he dismissed as medieval, without relevance to the real world. He kept accusing the apostles of these ideas of being weak-minded or, at best, victims of a sad time.

He had a life to lead and constructive goals to achieve. He didn't say the world was getting better day by day, as he had in his youth. But since he wouldn't let temporary circumstances distort his view of the long human enterprise, he

rejected also the pessimism of Spengler and Toynbee. He looked to the field of scientific esthetics as a refuge and a source of hopeful new information about the human mind and its potential. In this regard, he also had to reject art historians who wrote about "forms" in a way that bordered on Platonic mysticism, as if the forms had a real, disembodied life afloat in culture outside their appearances in works of art. This way, he drew a line between himself and writers like Gombrich, Langer, Focillon and others for whom he had in other respects admiration and, in some cases, friendship. His thinking was gradually being hedged in by many current ideas he couldn't accept.

But to me it seemed understandable that the problems I was experiencing and seeing around me should find expression in the ideas he rejected. Even considering my relative ignorance and lack of perspective, I felt I was closer to things-as-they-were, the transitional nature of the times, than he.

There were moments of discovery that year, of course, premonitions of experiences I'd one day build my life on. In March I swam out of winter drizzle. The sun dried the grey stone walls, shutters creaked as concierges flung them back, and trees broke into bud. At last I felt at home in the grey-green glooms and delicate lights of Paris. On a trip to Italy, I sensed for the first time the deep speechless pull of ancient cities in ruin. After a day rambling the fields at Ostia, I often thought about the white columns rooted in long grass, bare remaining gestures of the men and women whose shadows once passed across them. Perhaps I recognized in them some semblance to memories of my own, which from time to time drifted just beyond the reach of my mind. With a young man in the French consular service Outre Mer, for whom I was to be a *fontaine fraîche* in Africa, but not until we were wed, I trav-

eled Morocco and Algeria, feeling the narcotic languor of red-brown deserts and dark-blue dusks with slowly lifting stars. I vowed to return but would not do so for thirty years and then in another life.

Before sailing home, I touched real ground, like Antaeus, in the course of a bike trip through Brittany with my brother. He was a self-contained, companionable nineteen-year-old let grow up unharassed on sexual issues (though hard-pressed on academic ones) by our father. We sat on curbstones to eat out of tin cups. I bought my first pocketknife to spread cheese on my bread. And I was moved—and also moved to be so—by the salt-eroded stumps of Breton *calvaires*, old stones that seemed to speak of authority exercised with loving kindness, not in judgment.

And then I sailed, so changed by my year abroad that the yellow organdy dress I'd worn for shipboard parties on the way over lay like yesterday's mimosa on my bones.

Back in the States, my old school friends were mostly married, giving birth in a communal wave. When my mother looked at me I could see she found me anxious and drawn, no more her fiery impulsive daughter. To my father, I read some of my year's literary efforts, written at a table in my Paris room while late-night radio sounds had washed through my head. He looked at me sadly and said, "Do exercises. Write in many styles. All writers do." At that advice, my imagination failed entirely. Instead, I moved to New York, found a part-time job and an apartment in a featureless brick building behind the Plaza Hotel, and enrolled in Columbia for an M.A. I roomed with a friend who worked in publishing and frequented the Stork Club, mounting her gifts from Sherman Billingsley on our mantel. I too split myself between night-clubs and daylife, reading *The Odyssey* on the way to Morn-ingside Heights and *Don Quixote* on the way home. Falling

asleep at night in the apartment, I heard the wind roar in the airshaft like the sea, but it wasn't the sea, and before long I felt my life again descending in circles.

On the ship coming home, I'd met M., my first New York Jew, importunate yet hesitant, thrusting himself on me while rightly fearful of being hurt, with a gleeful smile, heavy chin that repelled me and, behind his glasses, witty dark eyes that enchanted me. He was brilliant, bitter, literary, and for a few weeks we talked floods, of which I remember nothing save that we walked by the East River at night and he compared the oil barges to funeral boats on the Nile.

He came from a Bronx ghetto and had delivered packages to Manhattan apartments through the service entries. My living where I did was a scourge for him. The last time I saw him, I drove him somewhere in a black Cadillac convertible a new beau had lent me. "We had a terrific night last night," he said. "New sensations never before experienced. A kind of sexual breakthrough." He was telling me about his new woman. "I feel I've grown a second brain," I responded, wanting to laugh at the disparity of our news. "This tall cool person who stands beside me all the time, watching what I do."

"That sounds important," he said thoughtfully. Feeling composed as a goddess, I waved a hand to him as he got out, drove away and never saw him again. A letter from him earlier had spelled out the reasons.

> You have a pilgrimage to make. No such excursion is permissible to me. Childhood suffocations from the Bronx were sufficient. Each of the streets I walk before reaching a subway drowns me in an enormity, a malice, a humiliation I lived through before I was equipped to conjure up departure.

When my course work was finished, I took a job in Washington with a nonprofit art foundation. The first morning there,

I was led to the addressograph machine and a pile of envelopes halfway up the wall. There I sat all day like the girl in *Rumpelstiltskin,* pounding the machine and weeping, turning nettles into money, for the envelopes held membership applications, and I was the chairman of the membership department.

I remembered my love for the theater, joined a local troupe and met a number of writers, poets and actors, most of them graduates of Black Mountain College. One by one, the fire danced atop their heads and I was drawn to each, Lorelei smoke breaking from my pores so that, one by one, they noticed me and I flew from one to another. Is it you? Or you?

A gawky playwright seemed to be it. I fluttered at him, performing fantasy love scenes in my mind. We acted together in a play, and my heart turned over each time our shoulders brushed backstage. Then he seized me, planted a kiss straight on my lips, and the flames burnt out and I couldn't look at him again for his broken front tooth and his goat eyes.

The most gifted of these Black Mountaineers was a Norwegian poet with yellow hair that bristled straight up and the grave, delicate manners of a browsing moth. "I'm living a myth," I told him, supposing that since he was a poet, he would understand. I thought of myself as Ulysses on the sea, or Penelope, chaste and starving, or Ishtar looking for Tammuz. In whatever language, the story was the same. I had lost my self when I lost Eden, and every year since had been lost looking for it.

"Every time I meet someone new I bring him into the story," I said. "I ask, will he save me? Will I save him?" It all seemed true but vague, like an underdeveloped film.

"Why do you do that? It's such a waste of time," he said, turning his blue-grey eyes on me, explaining he was constructing his life day by day in his poetry.

When I followed my job back to New York, as I soon did, I rode there in the car of a new friend, whose wife not long before had killed herself, and went on turning, promiscuous but cold, darting across surfaces, meeting different people for breakfast, tea, dinner, my head flying ahead of my body, until quite suddenly one evening, my mind shut down in overload. I came to, walking down a street not knowing how I'd got there. I was on the West Side heading south toward the lighted window of a store of cheap books, sex books, pornographic books.

I fled home shaking. Soon after, I lost my job when I flung a pencil at the feet of my boss. He took me to an expensive lunch to fire me, to hedge his bets. "You'll get there, Ellie, you will," he said through his teeth, "but you'll get there walking over bones." He meant to insult my energy and power of organization when I pulled myself together, but he spoke like a wizard, for I was walking on bones, but they were my own.

About then, I ran into an actor friend on the street, who introduced me to the person he was with, who called me the next day and asked me to a party.

It was one of those typical Village parties of the early 1950s, with a few ex-GIs on grants, bearded and nostalgic for Paris or Rome, some artists and writers without the cohesion of a group, some drifters, Ralph Ellison leaning against the doorjamb with middle-class clothes on, a couple of models and uptown heiresses with a taste for the mildly disreputable, and what we called spooks: terribly thin girls high on their own anxiety juices, with staring eyes and long hair, who spent their time, like Ellison, leaning against the wall. Ingenuous as I was, I was aware of no drugs, but there was free-floating tension on all sides, as a frog pond may feel to a tadpole when it begins to heat in the sun. In all that pulling jostle, some would soon become well known, others sink out of sight. So

the young New York bohemia was beginning to percolate in 1952 when I got there.

My host was a painter. He was handsome in a mannered way, with dark hair and eyes and narrow hips and shoulders, not exactly effeminate but tightly wired. His head was too big for his body and sat on his neck like a rock on a slope. His nose was clumsy and the muscles around his eyes were stretched tight as rubber bands, and when he walked, he hunched and went fast.

He was glad I'd come, in my uptown black dress with a red rose on my shoulder. To show me his work, he steered me next door into the room he used as a studio. It was dusk, and the windows were covered with grime, so the light was grainy and grey. He stood with an arm on my shoulder and pointed to the canvases. They were stacked along the wall, a warehouse of ghosts.

Images of figures hovered just on the edge of visibility. They had knobby heads, stunted limbs and torsos. A row of them stood before a white mansion with columns. But he had rubbed the whole lot down nearly to the underpaint, so the bodies were wraiths, the house a mere wash and the sky a few pale streaks. One could wipe out a family this way, and he had, for they were his people—his parents, his brother, his home or his fantasy of a home. His nightmare of a family.

I knew his type. He could murder me.

So I sang my siren song and seduced him to be my seducer, and the next day I made an appointment with a doctor for my first diaphragm, bought a yellow nightgown at Bloomingdale's and readied a bag to spend the weekend with him. When Friday came, I walked to the fountain by the Plaza and sat waiting for him to pick me up. Uptown the trees were in bloom with blossoms on the cusp of falling, so the wind over the park unbelievably lifted clouds of petals into the air, blew them over the walls and onto the shoulders of the passersby.

But down at the other end of the avenue, a great shadow seemed to have gathered. I took out my notebook and wrote, "I am waiting. He is late. I cannot control my shaking."

He came along with his head down, and when he looked up, it was with a sidewise glance as if he expected a blow. I had the idea he already regretted having asked me, that he was already bored by my excessive need. He threaded his way through people, around a turning car, and I could see he was angry. He looked as if he were trying to keep the atoms of his flesh from flying apart.

When we got to his studio, that same pale light was sifting in the windows, so the rooms seemed to float. Puffs of warm air stirred the curtains and moved the ferns in a bunch of flowers we'd bought on the way. Our behavior and small talk were tentative, as if the whole thing could come apart if the wrong thread were pulled. I looked around and touched a few things. Dust was everywhere. It lay on a plaster Roman head, covered the insides of the windowpanes. I was experiencing a flood of mixed emotions, a feeling for the numberless times of renewed innocence and hope, yet almost at once again the numbness that was by then my automatic reflex of survival.

There was a way he and others of the company of spooks would look at one that chilled me. The eyes would narrow, the lids tense and then the eyes would unfocus and partly close. "What are you thinking?" I would ask in a panic.

"Of a cigarette . . . of nothing . . . ," would be the reply.

After a while, the mood would pass and the person would turn alive again, warm even, almost friendly.

He set out to paint my portrait. That was the first thing to do. He was full of good intentions. This would be the painting that would bring his old unsuccessful life to an end and start him on his way. I had my own notion of what he would do for me.

"I want to look at you," he said, moving around the studio, setting out paints, turpentine. "I have to explore your eyes and the nerves around your mouth. I have to really see your cheeks, your jaw. To see a person, really. That's the hardest thing. Not to see what one wants to see, but see the person, apart." He spelled it all out. He'd been through it before.

He walked stiff-shouldered, as if he were strung on a wire. He made a sketch, a good one, I thought when he showed it to me, so I relaxed a little in my high-backed chair by the window and began to think that he really was a good painter and that it really would be me who would free his talent and he'd do the same for me. He turned to the canvas and began to work with oils, drawing with his brush first, then beginning to reach out and tap up bits of paint from his palette. He liked Larry Rivers's way of painting and wanted to work out the portrait with areas of drawing against thin washes.

The light faded and the furniture turned to shadows, and he kept on working in the half-light and began to lose the image. It was a terrible time for him. I began, simply, to dissolve. For an hour or so he wouldn't show me the canvas but went on hunching over it, picking up the brushes more and more nervously, then working for long stretches not looking at me at all. Finally, he turned the canvas around to me with a face of frozen misery and said, "I've lost it."

I was gone. Just like that, wiped out. I'd put myself in his hands. The fog had come up in his mind, and I was gone. It was my third small death or my fourth or fifth, but it was the one that counted.

The miserable affair drifted on for a few weeks. There were a couple of grotesque weekends I spent mainly in the kitchen with my arms up to the elbows in a dishpan, trying

to stay warm. Then came a party for his best friend's new book, a novel about quadriplegic war veterans representing the paralysis some men were said to prefer to human contact. It was a standard sort of event, crowded and loud, with staring faces thrust up between shoulders of suits. I saw my painter's head across the room on the too-thin stalk of his neck, weaving back and forth in smoke and the sparks of match lights, and felt my own limbs lose their power. At the top of my neck, the Highland mask concealed my self no longer. There was a sort of a scene in which I pursued him out into the street in a panic until he shook me off, saying "Well, at least you've got style. You'll manage," which cooled me off so I let him go.

But the next day, I had the distinct feeling the floor of my mind had broken through. My alert system had sprung leaks—perhaps a long-delayed effect of those explosive sudden admonitions of my father's back in my girlhood. At the slightest unexpected event, seeing a familiar face on the street, a friend on the bus, being asked an unexpected question—"Hi! What have *you* been doing lately?"—adrenaline would pour through my body, setting my limbs trembling. It became a nightmare to leave my apartment. I wasn't the only woman to go through such a crisis; many have, as they crossed the line from over-sheltered girlhood. But it was as if I were the only one at the time.

My friends disappeared. My evenings and weekends were empty. I'd walk and walk, come home to nothing. And I remembered the lighted window of books I had awakened to find before me. If it was to such a lamp I was drawn, I might as well hurl myself at it. So I sank myself into books about women used and ruined, and the *Songs of Bilitis* for relief, and late into the nights, I sat at my desk writing disconnected phrases of poems and the sterile beginnings of stories, trying to place myself outside the disintegration so as to survive it.

I would write, then flee to the street to walk. "That woman . . . she looked crazy," a pretty girl said to her companion as I rushed by one midnight, my black coat flying.

And I wrote on the cover of the folder in which I kept my piles of wastepaper writings Roethke's lines:

> A lively, understandable spirit once inhabited you.
> It will come again.
> Be still. Wait.

SLOUGHS
OF
CHASTITY II

Like my mother, I survived the walking shudders, though with residual damage to the nervous system, in my case, a tendency to panic in tight places. Formerly, whatever hot water I got into, I had an animal confidence in my ability to get out of. But now that confidence failed me. I was unable to do things I'd long found natural, like entering rooms full of people or speaking on my feet. It would be a long road back to the kind of ease with people I'd enjoyed before, and so certain life choices were closed to me—perhaps the "deformity" I'd wished for in my schooldays, forcing me to give up some goals and concentrate on others, in time become a writer. For a new life now began for me not with property, as for my mother, but work. I found two worlds in which the making of art—which I now understand to be the redemption in form of lost time and wasted grace—was the actual daily labor of everyone concerned. One world, the Living Theater, I only passed through, the other, *Art News* magazine, I would live in for a while.

Down at the Cherry Lane Theatre, back in 1952 when I returned to New York and lost my first job, Judith Malina and Julian Beck had been casting the only play Picasso wrote, *Desire Caught by the Tail*. I read for it and was offered the cubistic role of Lean Anguish. It was a good character for me. I came on stage out of a sewer, shaking French-fried potatoes and other garbage out of my hair, and my first words were "I come from afar . . ." But in this case, bits and pieces didn't go into oblivion. They coalesced in a collage of language and stage business, put together to the chimey tinkle of Lucille Dlugoszewski's prepared piano, before the rag-and-bone stage sets by Julian. In that play, John Ashbery and Frank O'Hara played dogs. In one performance, John, toting a bundle in his arms, lost his pants onstage.

As on stage, so off. Every rag and bone of bohemian society could find its place in the Malina-Beck world. During rehearsals and after-performance sit-arounds, artists, musicians and writers, hangers-on, suburban slummers and vagabond runaways appeared. There were also the ones I privately called freaks, wired in their ways, their natures deformed but unbending, free only in this company to be themselves. One was a once-handsome Ivy Leaguer, pathologically obsessed with growing old, who combed and combed his hair down over his brows and, with real tears in his eyes, pressed the wrinkles out of his face with a sponge dipped in makeup. I suppose I was one of the freaks at the time, for I displayed the sheen of midwestern integrity still. "Your smile is perfect serenity," said the miserable Ivy Leaguer to me one evening, and I received the news that though the inside had lately been in shambles, the surface had reknit.

All this sociable turmoil was merely the setting for the group's real labor of turning turmoil into studied pace and pattern. And the designing force, Hecuba at her stew, was Judith, intense, beady, thin-boned as a bird, with claw hands and feet and the face of a possessed gypsy. She was, like Li Po's Old Man Crazy for Poetry, ageless and mad for her art. It was total with her. Every day, every bedding, every reading and smoke of Judith's was a knot, to change the metaphor, in the tapestry of her work. And she had a virile grip on ideas and forced them into our heads—the background and thesis of the play at hand and the compositional strokes of individual speeches and movements. As we worked nights, the fragments drew together as if pulled by a magnet.

At the same time, in my new job at *Art News*, I began learning the mechanics of a craft, finding in precise editing tasks that I still had a talent or two and occasionally could say a clear thing myself. Manual tasks were still more healing: counting lines of type, making layouts, pasting, choosing

pictures, writing captions. My wastebasket filled to overflowing as I strove to reduce polysyllables to monosyllables to mere characters on the typewriter. The basket emptied, filled again. Thomas Hess, at whose elbow my desk stood, would stride by, gaze thoughtfully down into the fountain of crumpled copy paper, breathe "Christ . . ." and tell me the one in the machine wasn't yet right. But each formal task, right at last, built confidence. So that one evening when I got home, I wrote on the cover of my portfolio, beneath Roethke's lines, Emily Dickinson's about a "formal feeling after pain."

Then, for ten dollars a week, I purchased the ministrations of a bland-faced Hungarian analyst and we proceeded to lance my infected imagination.

From that time on, like thousands of other young women, I would rarely be without my shrink of the season. We were a guilty, suffering lot, scattered and lonely as my poor Scots forebears, undirected in any forward sense, impelled only from behind by fantasy hags and tyrants. In this respect, almost every session with a male Freudian therapist was for me a hideous Calvinist exercise in confession of past sins to the dreadful judge set up within, *Doppelgänger* of the one in the chair. For years, this misapplied pursuit of a "cure" absorbed and enraged me at once, as I lay or sat on plastic couches furiously analyzing the causes of my fury to the tune of hundreds of weeks' salary. At last, at a critical point, I found the one who would end my life among the Freudians forever.

He was a melancholy gnome whose office was a sealed chamber of stale air, cigarette smoke and body odor that, I felt, accounted for the fact he could barely keep awake in his chair. When I would say he seemed bored by my conversation, he'd prop open his eyes with his thumb and forefinger and grumble, "So. You think I'm not listening, eh? Very interesting . . ."

But he was the last. The last time I saw him, before leaving

on a vacation, he filled me with warnings. "Watch out," he said, leaning forward, awake for once and sullen. "You're riding for a fall. You'll get on your high horse. Go after some fantasy connection. End in disaster." So ominous were his words that I wrote them in my notebook along with a memo to myself to ask him what he'd meant when I returned in the autumn. I never had a chance. That August, he leapt off his apartment house roof.

Subjection to these male authority figures was, in the 1950s, practically an obligatory part of a young female New Yorker's life and a gruesome echo, for me, of my struggle with my father. For the orthodox principle they preached was one he frequently voiced: there were two kinds of people, healthy and neurotic. Pain, anger, frustration, especially on the part of unmarried women, were symptoms of neurotic maladjustment. The optimum bonum, again, for a healthy woman was, as my first analyst shortly informed me, to take delight in a phallus owned jointly in wedlock. So why didn't I go home to Cleveland and get married?

For a while, however, analysis and my newfound momentum at *Art News* moved me along, and I did well, moving up the editorial ladder. I worked closely with the editor, Alfred Frankfurter, helping him put out the book-size Christmas issues. He was then a magnetic figure in his late forties, with a bulldog head and dark hair combed straight back from his forehead in the European style. He was stocky and powerful, a fund of energy and a brilliant talker. He was also a man of wit and compassion and had charmed me when I applied for a job by taking my credentials and ambition seriously. He held a respectful view of my father's reputation, and my father, of his. So I had come to work for him, or rather, between him and Hess, his sidekick and spiritual younger brother, a former art student now an opinionated critic of the new art.

The office atmosphere was cliquish, electric and committed to the excellence of its performance. The magazine published articles by renowned art historians—mostly European friends of Frankfurter's—and was at the same time pushing the new-named Abstract Expressionism or Action Painting, nurturing its circle of poet-critics like my Living Theater friends Ashbery and O'Hara. The office was a center for artists, writers, musicians, poets. The future stars of the movement were still behind the horizon so far as the public went but ascending with unstoppable momentum.

The idea, so well known now, was that a new expressive language had been born. Since the late 1930s, these artists in their obscurity and penury had been seeking a way beyond the hyper-rational formalism, as they saw it, of Cubism and its descendant, American Non-objective Abstraction. The idiom to which they'd broken through in a sudden collective leap of mind and brush looked chaotic to those who didn't understand it. But despite the somber colors and ponderous images that filled the huge canvases, the few critics who knew what the search had been about—Hess was among them—found in them "disturbing degrees of intensity." Like the new physics, the new art purported to release energy for good or evil. "I paint the unconscious," said Pollock. "I am nature . . ." "Let no one underestimate the power of this work for life, or for death if it is misused," said Clyfford Still. Indeed, these American Westerners and sons of pre-war immigration, Russian-Jewish but also Armenian, Greek, Turkish, Dutch, now presented themselves as spokesmen for post-war culture as a whole. Action Painting was a way out of both a stylistic cul-de-sac and a historical abyss. Like a Bunyanesque ax blow on a tree, it was the American way of Existentialism.

The role *Art News* played in those events has been almost entirely passed over by today's art historians and even, to their discredit, by some who lived through them. The maga-

zine was unique in those days. There was no other American journal like it, nor had there been. On into the mid-sixties, it was a germinating bed for the new art, as if all bohemian Paris of the 1910s had been compressed into a little warren of plain American office rooms with a few old typewriters. Hess, whose reputation would soar in later decades, was the angel behind the new movement, but he was backed up and goaded on by Frankfurter, whose tough expertise and roots in the wider art world were critical to the movement's success. That is, while Tom was brother-confessor to the emerging artists and drum beater for his circle of younger critics, Frankfurter's combative, impassioned enthusiasm for the adventure kept the whole thing going. Far from a consciously orchestrated centrist political movement, as some critics have lately argued, Abstract Expressionism was the creature of a few powerfully ambitious men, including these, with sense for the contradictions of their age. Those of us of a younger generation lucky enough to be drawn into that ambiance of imaginative fire and historical momentum were aware our lives had taken a turn.

I suppose that for me to catch sight of this landscape, in which women as well as men followed their own purposes beneath the summoning shadows of "great artists" (the "great ones" albeit still always male), meant what traveling in Europe with Barnes had meant for my father. Beyond that, there was for me as well the hope of emotional freedom to be won in that country of humanity so different from the sloughs I was leaving behind.

Therefore I was troubled now in a new way by my father's exhortations to me, in letters and when we met, to write my small but enlarging contributions to the magazine strictly in the mode he approved of, that is, "objectively," eschewing "sentimentality" like poison. Apropos some fairly dry piece I once turned in, he wrote, "Congratulations! Now you're

writing aesthetics." But the poet-critics nurtured at *Art News*, like O'Hara, Ashbery, Barbara Guest, Elaine de Kooning and others, dived straight into language that was subjective, flooded with empathetic feeling. They were virtuosos of the pathetic fallacy. Forms "struggled," "exploded," "plunged," "collapsed." Space was "tortured," "buckled" and "bent." To tell the truth, the tone wasn't so different from that of my father's youthful ruminations on African sculpture, but he never made the connection, and I hadn't read the book.

In fact I held myself to a pretty narrow standard in my writing about the new art and became instead the house expert in fields beyond the mainstream, like Asian and ancient art. In my private reading, I continued to wander extravagantly, from the mental and stylistic billowings of *The Waves* and the poems of a young Sylvia Plath, just beginning to appear in small journals, to books by tiger hunters and survivors, now, of disasters at sea.

The autumn I went to work at the magazine, the Museum of Modern Art gave the group its official imprimatur in a big show, first of the establishment art institutions to do so. The effect on the public was upsetting. My father, with the earnest intent of appreciating once again an avant-garde movement, saw the show and came away repelled by its doom-heavy rhetoric. He found only a single work to praise, the Clavilux, a color-light organ invented by Thomas Wilfred, a still unappreciated genius whom he had, in fact, himself discovered years before in a remote upper New York State studio. We even had a small Clavilux in our Cleveland house for a while. But it wasn't Wilfred's serene and somewhat mechanical idiom—color forms unfolding like sunrise mists to the music of Bach—that represented the future, but the rough gestural handwork of Pollock, Kline, Still and others, whose canvases my father found mostly a mess.

I watched these self-made men—for all of them were

men—and studied how their behavior reflected not adaptive manners but authentic personality. Personal characteristics— awkward simplicity, arrogant pride, gentility, aggressive hunger for the world's goods—were no cause for self-condemnation. Instead, such features of personality were projected into the forms of the artist's work, which thus became the very metaphor of his humanity. Fairfield Porter would arrive, lean against a wall in embarrassed simplicity, converse in soft, courteous bursts of penetrating thoughts, then melt away. His every canvas was the same: formally soft, yet offering for as long as one studied it perfectly equilibriated a view of the real world. David Smith would stride in with authoritative gestures like his gestural ironworks. Willem de Kooning would pad in, diffident, secretive, with searching, studious eyes. Jackson Pollock never came in, but one saw him elsewhere. He would make an entrance into a crowd preceded by a wave of energy, so the room would fill with expectant excitement, people saying, "Jackson's coming . . . Jackson's coming . . . ," and then after a while, "Did you see him? Did you? Jackson was here."

In the same way, I watched the women around me, younger than the men by a half-generation. Malina was the first, but others, many painters among them, followed and became my friends. The Women's Movement still lay a decade in the future, and conventional women of my age were either married and housebound or waiting to be. But these women were determined both to live full lives and also reach creative goals. Fay Lansner lived in a brownstone walk-up with babies and a warm house mess save for the cleared cranny where she painted. Barbara Guest was trying to decide how to balance marriage to an academic and a creative writer's life, and writing her poetry all the while. Helen Frankenthaler was getting ready to fly, and the wind was Clement Greenberg though the wings were her own. She, Joan Mitchell, Grace

Hartigan, Nell Blaine and a few others had their first shows in these years. I was struck by their avid, pressured personalities. Their lives were far from peaceful, but nothing, however self-destructive as some might see it, was irrelevant to the life that lay ahead. Hurts, scandals, mistakes found their corrections in the life work. There was no waste.

I began to meet other young professionals, journalists, teachers, writers: the edge of my generation, moving forward. Philosophical, humorous, they were impatient with spooks and fools and conversed like respectful equals with their eminent elders. Through many channels they were proceeding under the direction of an overriding vision, realistic but still hopeful: to see the old world clear, judge but not destroy it, and make a better one.

Of the many new friends who came into my life in that space of healing time, I remember one who sent me Meleager's lines:

> The garland withers on Eleanora's head
> But she herself shines, the garland's garland . . .

and I took them to mean that Roethke's promise had held. Life had come again.

I began to reach out beyond *Art News,* doing other assignments by going home after work, sleeping awhile, then writing all night. I liked being published after the silent years. But at the same time, a capacity I'd always had for a language of my own, that pressed out of my mind so I'd fill notebooks with disjointed passages, gradually dissipated. I thought the reason might be my writing prose always descriptive of other people's work, or the therapy, which was running along on standard Freudian rails. I began to feel I was paying a price for my composure. In fact, I had no personal stake in what I was writing.

There was still a stoppage somewhere. I was homesick, I mean sick with home, and my father was heartsick, sick in his heart with something I couldn't fathom.

I kept going home for vacations. I idealized it when I was away, supported by my father's letters. Frequent, affectionate, calm, without anxiety or criticism, they glided along the mountaintops, keeping me abreast, as they had for years, of doings at home and his interesting projects. In that spirit I'd arrive each time with my newborn self like a gift on a plate, as eager to show it off as to study it myself in the mirror of the household. My father too was always eager for the arrival of his children after their absence. He'd lean a little forward in joy, his youthful face alight. Behind him would be the warm illuminated rooms, fire in the fireplace if it was winter, garden bouquets if summer. I'd sink into the family embrace, basking in the evangelical circle, listening to music, rambling among ideas, occasionally those Dad was working out in his books. Some warm evenings when we ate outdoors under the elm tree, I and my sisters, then schoolgirls in their own adolescence, sat around after the table was cleared and sang rounds, and I'd hear in our plaintive voices an echo of my own straining but secure childhood.

But the texture of contentment wouldn't hold. Disruptive thoughts kept coming up from underneath. Sometimes as if to test the air, Dad would return to the old issue of progress in human affairs. Embattled optimist, he still looked for simple procedures to restore the balance in things. Things got better, but they could slide backward. We were all aware in those days of the decline of inner Cleveland. Its poverty-level populations down by the root-ends of Euclid and Carnegie avenues were drifting ever farther from the uptown institutions long before set up for their benefit. Eventually the neighborhood around the museum so decayed it was dangerous to walk there even in the daytime. Inevitably the

Saturday-morning art classes he'd pioneered for schoolchildren, model programs copied across the nation, lost their audience of the promising poor and wound up serving mostly the white middle class. So swift in his lifetime had been the pace of cultural change!

But I was dismayed, soon angered, by his responses to these problems. Ever the behaviorist, he would put down social unrest severely without attention to the causes. One issue caused me particular anxiety. Pressure was building toward racial integration in the Cleveland suburbs. But when he discussed the matter in theory, he had to say he wouldn't encourage it. His reasoning was pragmatic. Negroes were inclined to let their homes deteriorate, dragging down their neighborhoods. Our family's security was in our house. Yes, we looked for a better world to come, but in the meantime, we had to guard against falling real-estate values.

He said he had no prejudice, that he was being realistic, that it would be hypocritical to support disruptive social change while he was himself living like a bourgeois. But I wanted him to talk about principles. I saw that attitudes formed in one age could be inadequate to deal with a later one and began to question the relationship between pragmatism and other measures of value.

The mood darkened. I liked to make the family laugh with bits of raunchy gossip about life in the big city. But I'd soon notice a stiffening of the spines all around, led by him. It was as if my stories unsettled him in some personal way. "Impossible. I've known so-and-so for years, and there's never been a hint of his being a *homo*sexual." He stressed the first syllables as if to let me know he knew the word's derivation and logic.

"Certainly not. A distinguished woman. To my knowledge, she's never had any sort of a liaison, certainly not with the man you mention. She lives alone. She is a scholar."

Deviations from convention caused him to react with slashing swiftness. "Miss X is leaving the museum." I recalled she had been a loyal secretary for years, a plain, deferential woman. "Why?" I asked.

"She turns out to have been an *alco*holic all along. She has deceived us all. I never had the slightest inkling."

"But so what? Hasn't she done her work?"

"There is no place in a museum for an *alco*holic. She has to go."

"So-and-so is a *neu*rotic." Again, the emphasis on the first syllable. "One is either *neu*rotic or healthy. Normal people are drawn to a normal course of events." The shaft came straight at me, causing my hair to stand on end with alarm. But why? It was as if all the breadth and richness of his mind, all his experience of the world, suddenly shrank to the single obsession of one daughter's social life in New York. "You think New York is the center of the world. But it's full of slick, superficial people. If I hadn't got out, I'd never have written my books . . ." Now trouble was building and no one could stop it. As the day for my departure would draw near, the air would fry. "Whom are you seeing these days?" sooner or later would come the question. A muttered reply would be enough. "Artists and writers! Editors and fancy talkers! Can you not love a normal American man?" It was the Scottish Modernist talking, turning for corroboration to his wife, whose background was European. Who here was a "normal American"?

Through such scenes I became the house scapegoat, wrecking the harmony every time. My holiday up, I'd slink to my train or plane trailing blackened robes, sit in my seat in a frenzy of rage and remorse, siphon off the tension into a notebook, return to New York, where I now lived in a brownstone basement with bars on the window like a cell, stir the kettle of my despair and slowly come out of it.

* * *

Why did I keep going back and back as if to the door of the
Kirk on a Sabbath, to stand in the snow and be straightened
out by my particular elder? Was I weak-kneed, without a
mind of my own?

I think that wasn't so. I still after so many years of it
couldn't understand how a person could give himself a shake
and turn in a moment's time into his opposite. The lover of
art, of books, of—so he claimed—the liberated mind and the
open life! There was some mistake being acted out here. I was
sickened by my father's own pain. For increasingly, I saw he
suffered too.

Take the matter of what sounded like blatant anti-
Semitism, though he protested it wasn't. What was the mean-
ing of that? My attention was caught by his immoderate
vehemence. For example, I brought home an agreeable medi-
cal student named Shaw. *Shaw?* After he left, my father
bolted himself to the arms of his chair, held fast as if to the
pommel of a saddle and, in a voice pale with anxiety, gave
me his opinion the doctor had a changed name. Hadn't I
noticed his facial characteristics? What was wrong with my
eyes? The horse landed on the far side of the jump that time
and there were no broken bones. But by the time I now speak
of, he seemed distraught over the idea that I might marry a
Jew. Here then was the strange third step in the sequence of
my father's anxieties. It was as if, to protect me—us—against
some dreaded breakdown, I must be obedient and chaste, and
not force him to reveal a Jewish son-in-law to his neighbors
and colleagues. But in spite of the arguments he came up
with, as often as I said to myself, "Heart, love another—
someone fair and blue-eyed," I invariably fell, like the Rose
of Sharon, for the ones who were dark-eyed, with bushy locks
and lips like the biblical spices.

* * *

I think I had to keep going home because I sensed the answer was there to be found.

It was about that time that I had a premonitory waking dream. I was lying on my bed and closed my eyes to see a rippled beach that stretched out ahead. I banked over it, soared low and swift as the sand turned slowly to threads, and the threads to my mother's hair as she had worn it long before, in open waves.

I knew so little about her. She'd been the idealized stranger of my childhood. But since then, she had hardened herself, and I'd lost touch with her entirely. Now I began to wonder about her. Well, she was French and Rumanian, both ancestries cause for pride, I'd always felt. And though her mother was born a Catholic, after fleeing her girlhood convent school she had not practiced religion, so there was no mystery there.

One day in Cleveland, I went off on one of those compulsive searches of her things and found in a tiny box a man's lapel pin with a star on it. Star of David? The room whirled around me. I stopped by the big bed, held on to the carved bedpost and quieted myself. Later that day, I asked my father casually whether my grandfather, Jacques Nadler, had been Jewish.

"Who knows?" he said brusquely, turning his back on me and busying himself looking for a handkerchief in his drawer. "You can't ever be sure what these Eastern Europeans are."

Now I began to track a quarry, and the quarry was me.

I went on being drawn to my Jewish friends. I loved that they talked about themselves, analyzing richly, purposefully, with bitterness and wit, with the intent of driving the nail into the very heart of truth, if they could. Toward me, in a gathering, some men showed a protective warmth that felt even motherly. They drew me into their search for identity: the fact of being *this one*, since so much of the world was *the other*.

Of such a gathering, I'd choose willy-nilly, or be chosen by,

an escort home or a special confidant. "And you, what is your background?" I would ask a pointy-nosed, blond man with an English accent and a name like Higgins, always thinking I might fish one out to my father's prescription. "Ah, me!" he would explain, "Why, I am Jewish on my mother's side . . . we went to England from Poland, early in the war."

And so on.

Then one day I hailed a taxi on Madison Avenue, climbed in, sat down, looked at the driver's identity card and saw on it the name NADLER.

I leaned back in the seat. I held me in the sights of my gun.

I talked with the driver. From where had he come? From Rumania, he said. And what was it like there, so far away behind the Iron Curtain, where we could never go, though often thought about it? Beautiful, he allowed, though unhappy. Not like the old times. It was better to be in America. And "Are you Jewish?" I asked, and "Ha!" he said. "What else with a name like that?" and the body of the mystery of our family fell into my hands.

Then in floods of thoughts that filled my next weeks and indeed would go on for years, I remembered, first, a single photo of my mother's father with his own family back in Bucharest. There was the patriarch, an imposing figure with a square white beard. Beside him stood his girlish wife and the offspring: Clara and Celia, in Paris frocks with leg-o'-mutton sleeves, and the son, my grandfather, a youth with bright button eyes and a snappy mustache.

Celia had a bush of wild hair.

It was always my mother's hair that had captured me. That was what imprinted itself on my imagination as a child, tantalized me and made me wonder, what appeared in sweet dreams and nightmares to remind me there was something I should know: my mother's wild red hair, the Nadler gene, carried

west by the luck of the game to explode in the American Deep South.

During her own childhood, and again in the bad years of her maturity, her hair had been to her a mark of shame: "nigger hair," something to despise, to braid, pin, clamp into finger-waves, anything to disguise its irrepressible flying energy.

And hadn't she been taught to hate it by her own mother, who also suffered the loss of her past and then, as I construe it, withheld love from the one of her children who announced her racial composition to the land of the Ku Klux Klan?

And hadn't it been a sign of my father's original love for her and acceptance of her uniqueness that he had prized her hair in the firelight which, as he once wrote in a love letter, turned her gold and ivory, and also of his later blindness to her suffering, that he countenanced the way she tortured it to make it fashionable in the Cleveland way?

And wasn't it because only there she appeared to be joined to herself—seated at her dressing table, now looking in the mirror, now down at the photograph of herself in the Catskill meadow—that I returned obsessively in memory to that image of her at her toilette, dressing her hair, glancing back and forth and fingering the green bottles?

So my mother's hair had been more than a crown of troubles for her, and the instinct that held me fixed on the image of her combing it was correct. Her hair was a clue to the revelation I'd sought from childhood: the origin and nature of the stranger. The stranger in me.

Her whole married life in that sense had been an exile from truth. Small wonder she appeared to her children as one who came from another world, and then, when she took herself in hand in order to survive, as one living a fiction of herself.

She'd tried to go her own way. When a Jewish family moved next door and filled their half-acre with an Asiatic

abundance of yard couches, birdbaths and reflecting balls, she was the only neighbor to squeeze through the hedge and make friends. Indeed after she'd got her house under her control, she came back in many ways, opening up in bound-less generosity toward her friends, loading them with flowers from her gardens, inviting the women to artful tea parties under the elm, even—when Dad's back was turned, for he was as vigilant over her behavior as his daughters'—flirting, like the belle she'd never had a chance to be, with an occa-sional courtly husband.

But I now saw how the lie had also deformed her, made her defensive when she might have been bending or silently passive when she might have been firm. Had she lived her mature life as the one who came into life, that is as a whole being, she would have seen me whole, too, her offspring in blood and heritage, and not left my formation entirely to my father. I believe she would have come to my rescue when I lost my way.

So I saw in their true light her dark-haired sullen or lan-guid sisters, and also their father, my grandfather, who, every time he visited us in Cleveland, went off alone to some bakery in a neighborhood foreign to us from where he brought back, to produce at our dinner table with a flourish, a loaf of chalav—only we didn't call it chalav but "French bread."

As later years passed, I'd see in the lives of her siblings the lamentable results of minds forced to deny a category of themselves. My Aunt Charlotte divorced her only husband and aborted her only pregnancy, and when she retired from the orchestra in which she'd played for thirty years, flung down her fiddle and never touched it again, saying it had ruined her life.

Clara, Mother's elder sister, widowed after a brief mar-riage, isolated by her deafness in a household of nervous women, broke down several times. In between, she turned

herself out like a gypsy-throwback to a Rumania she'd never known. Magenta scarves trailed from her belts, coral earrings dangled from under her piled-up black hair. She collected fancy gloves and beaded purses, fox furs and feather boas, and incredible hats, of velvet, feather, straw, wire ruching, pleats and points. Her face was an exaggerated mix of dainty, turned-up features and hysteric hollows, with eyes drawn wide to see what she couldn't hear.

The art she chose to survive by was painting. Her technique was crude and her compositions inept, but I don't mean by that to say she was not an artist. Art was what she lived for, and one time she achieved that rare thing, a revelation of her intrinsic self: a self-portrait in a black dress with a huge-brimmed hat coming down on her as if to shut out the world, while on her breast bloomed dark red gobbets of roses, the life she was full of but couldn't otherwise express.

She died in a nursing home. There I stood by while her nurse, Parnell, lifted her up, hushing her plaints ("I wish I could die . . . how can I die? . . . my pain is the grief pain, all over my body . . .") and let her down slowly into her bath. But Clara's thin knees were pressed together in fear, and she wouldn't let her head rest on Parnell's breast, because she was black.

And on his deathbed, my bachelor salesman uncle, with unmitigated sadness, endowed a memorial tablet to his father to hang in the hall where Jacob Nadler—not yet renamed "Jacques"—gathered a minyan for the first synagogue meeting in that part of Alabama. Very bitter at the end were that uncle's memories of our "lily-white Christian" household in Cleveland, where whatever reference he, like his father, might have wanted to make to other ways of doing things was cut off by the conspiracy of silence his sister, our mother, had joined. His birth name had been Solomon, in accord with his father's wish for a wise son. But to us he was always "Uncle

Joe," and his rule in life, he once told me, wasn't wisdom but "Root, hog. Or die."

Those instrumental partial renamings, my siblings and I eventually determined, took place after the dread years 1912 to 1913, when the South was torn by race hatred culminating in the lynching of Jewish Leo Frank in Atlanta. Thousands of Jewish businesses in Georgia and Alabama were destroyed in the aftermath of that horror, and the local white sheets took my grandfather Jacob/Jacques for a ride one evening, depositing him back with a warning on his doorstep, where his wife and children—my mother then a girl of fifteen—were waiting along with the family doctor, in case he came back in bad shape. After that episode, the prosperous Nadler furniture business, housed in a stone building proudly built to his order, with his name and the date "1903" on its gable, passed into other hands. My grandfather had grown up knowing the score. His own father had moved from Jassy to Bucharest in a time of pogroms. Now he did the same. He uprooted his family from Gadsden and moved to Birmingham, where one could disappear in a crowd, and became a traveling salesman of other people's goods.

And then in my mother's adulthood, just when she thought she was safe in the Protestant highlands of Ohio, began the trembling from abroad, beginning with the Nuremberg Laws, published when I was five, then the yellow stars and eventually children of a sixteenth part Jewish put on the trains east. And her husband wouldn't speak of it or let her do so, but exhibited his repressed fears in his supervision of his offspring. None of this, as I've said earlier, was alluded to in our house in the dark days. But how could it not have been a cause of the stopped-up misery—maybe guilt—she refused to analyze or in any way talk about, making her protest one of silence: a refusal to cry?

I also remembered how, when she was a child, she'd trav-

eled all the way from Gadsden to Birmingham to take a course in parliamentary law, and I understood that initiative as her way of trying to protect her father, and I had to understand her hard economic realism, beginning when I was an adolescent, as her way of providing safe haven for us all.

Had I to blame my mother, knowing all that? Had I to blame my father, who may not have known all of it or knowing, didn't want his children to know?

By the time the full power of the matter struck me, that is in this writing, they were no longer accountable. For it had taken me some thirty-five years fully to draw out the thread that had trailed across my childhood until the episode in the taxi. Only slowly did it work its way to the surface of my mind, beginning in disguised form in my curiosity about the China missionaries.

It took me a long time to see that my father's problem had been more complicated than prejudice, which he protested all along he didn't feel. His problem wasn't narrowness but too much height and breadth. He was a behaviorist who wouldn't admit he was himself conditioned. Committed to the abstract ideal of a family, he felt it irrelevant, maybe even ethically deficient, to take account of its divided nature. But I now believe the lie had lain at the bottom of his mind all the years of his adulthood, deforming him as it had Mother, gradually exerting pressure on him to become what he was by nature not. And so it blinded him to what I his daughter might by my own nature be.

But for me, ignorance drove me. I grew through learning. *Sapere aude*. Dare to know.

At the time of the taxi ride, however, my new knowledge put a fine point on my anger. For he was hounding me for moving in the very direction he had and driving me straight toward what he wanted me not to want: someone warmer, more accepting, more ancient in strangeness, whom I could love.

* * *

The issue, as we began to touch on it glancingly in family discussions, lived and became a living heartache. He developed signs of angina pectoris that terrified him. Now there could never be another outburst between us. He might literally die of it.

There came a season I began in my mind to fly again, as I had many times before, experiencing again that unfounded excitation, sense of anticipation, riding an updraft, aware of anxiety underneath but ignoring it, rising higher.

Or, to change the image, like a freshwater fish I swam and jostled in the sea breakers of the art world, felt the radiation and the fume, but I was not a painter, did not love my identity as a critic, and I sought a river of my own.

I was engrossed in writing historical projects under Frankfurter's lead. He was even more fragmented than I, though more extravagantly knowledgeable. He talked with manic intensity about himself, his family, his German ancestors, about art and his emotional responses to it. He talked compulsively about death. "My great aunt died at eighty, waltzing! My great-grandmother died at ninety-two, walking in the mountains! I'll outdo them, don't you think?" and he would explode into laughter, rocking back in his desk chair, his bright eyes flashing at the thought of those ancients dancing, walking, climbing to their long-postponed ends.

One day, impelled to divine the course my life was taking, I gave in to a whim and, in a shop, reached out and stole a party fortune from a box of them on display. Not looking behind me, I walked out of the store, and when I was well away, unrolled the little piece of yellow parchment.

"Lo," it said, "I have set before you an open door, and no man shall close it."

KEROPHON

He was intense, overwhelming, flattering. He talked a steady streak in a style florid with jokes and visual descriptions, dropping names and names of places—palaces, villas, homes of the great, private collections, out-of-the-way historic monuments—and anecdotes about his past life.

He was obsessed with the idea of cheating death, and with cause. He had been warned by doctors that the pace he kept up, overeating and drinking, driving himself in work and pleasure, would put an end to him early. But he went on insisting otherwise.

He was corpulent, obese when on an eating binge, but his body was powerful, not soft, his back and chest capacious as a bear's, and he moved with command. He was a figure people noticed, at museum openings for instance, standing with his feet planted solidly apart, leaning slightly backward as he made notes in the margin of a catalogue, dangling his heavy round tortoise-framed glasses from the hand that held the book. Women would ask who he was. Just so, he told me with boyish pride, head waiters in the best restaurants in Italy signaled him out for special treatment and called him Excellency!

His magnificent eyes were brown and full of wit. His mouth was almost lewd in its carnality, and his square hands were always gesturing, flying out, stroking his hair, twisting the knot of his tie, shuffling papers.

On the other hand, when he stopped moving and concentrated on a manuscript or the photograph of a work of art before him on the low table in his office, he focused himself so totally one thought of a pendulum stilled. His hands hung down between his knees, motionless, and his feet were still. His head was bowed. Minutes would pass. People would wait.

His power of concentration was equaled only by his inclina-
tion to dissipate his energy, and to procrastinate.

He was born in 1906 in Chicago to German-Jewish immi-
grants who had arrived only two years before. His mother was
a sweet-faced, plump girl who, like my French grandmother,
loved best to shop and primp. His father, a Proustian-looking
man with thin mustache, long face and protruding eyes, set
up an import business and then a service to appraise antique
furniture. Through his father's example, Alfred Frankfurter
learned it was possible to make a living in the land of barbari-
ans with a trained eye.

For Europe was always the mother lode for him, as for his
parents. Each year, the family returned to Stuttgart to visit rel-
atives who, in bowlers and frock coats, promenaded chestnut-
lined boulevards with the cousins from afar. At a regatta
during one of these visits, Alfred, a trim boy in a sailor suit,
was unforgettably presented to the Kaiser.

He went to school in Chicago and then began a course of
unsettled wandering that culminated in a doctorate at the
Institute for Art History of Humboldt University, now in East
Berlin. The reason these biographical facts are few is that,
like other idealists I've known, he changed facts to fit his
notion of what should have been. Undoubtedly he spent that
time abroad, for his languages were flawless and by the time
I knew him there was hardly a corner of Western Europe he
didn't know intimately, its landscape, history and art, how the
one shed light on the other, and how the whole was enhanced
by local food and wines and even types of humor.

One thing he did was to earn that doctorate. I know, be-
cause at the end of his life, when he was the victim of a
campaign of vilification by an enemy he had baited too
often, the rumor spread that he hadn't. So he flew to Berlin,

crossed into the East Zone—not an easy thing to do in 1962—and came back with a photostat of the document. I was married to him then, and I wondered at the brute determination that sent him on such a trek and also at his sense of vulnerability.

His thesis was on the relationship between Italian and Northern European painting in the fifteenth century, when the Renaissance turned artists' interest toward the wonders that are man. Thus early on he showed an open interest in cultural crosscurrents and also a feeling of divided kinship between the Jewish-Protestant North and a South rooted in classical antiquity. Around that time, he must have met Bernard Berenson, for later on he spent time at I Tatti, perhaps doing the kind of library-apprentice jobs many future art historians did under B.B.'s wing. Early, too, would have begun the love-hate relationship that bound them in uneasy friendship. Each recognized in the other a child of Jewish immigrants risen as far beyond his origin as he might most wildly have imagined and profiting by that ascension to satisfy guilt-provoking appetites for the gold that soothes and the company of those who possess it.

At the age of twenty-two, in the year I was born, he returned to New York and his first job, as a cable editor with the New York *Herald Tribune*. For the next seven years, he worked for publications like *Fine Arts* and *The Antiquarian*, and then took over the editorship of *Art News*, the post he kept until his death in 1965. When I met him, he had achieved international eminence for his catalytic writing, his art-historical expertise and his social charisma. He felt and willed himself to be one of the noble company of humanistically oriented art historians: Berenson, Goldschmidt, Friedlander, Panofsky and younger peers like Kenneth Clark and John Pope-Hennessy. He wielded his influence for good but

also against his enemies, who were legion. He dealt in power and prestige, loved what he considered the true and beautiful, and despised mediocrity, vulgarity and cheap commercialism.

I was ready for him.

For some time, I'd felt on the brink of a wider world than my own. Evenings in Manhattan as I plodded my genteel career-girl way, I sensed the lustrous sea envelope of that other world around me—limousines drawing out of garages, nosing down the avenues with their headlights flashing and intersecting with rebounding flashes, sounds of honkings, clicks of doors, high heels on sidewalks, clouds of perfume passed through as one walked. These lights, sounds and odors filled the darkness as, long before, soft rain had filled the world beyond my Japanese parasol. And in the daytime, handling photographs at the magazine, writing reviews and articles, I browsed on beautiful things—paintings, sculptures, glass, antique jewelry, textiles, rare porcelains, furniture by the greatest *ébénistes*—as alluring to me then as the pink ruffled bedrooms of the girls of Shaker Heights had been so long before.

My appetite for extravagance was a function of unfocused ambition. Once when I'd first come to New York, I saw Gloria Vanderbilt at a party, encased in voluptuous white silks, nodding and smiling like an idol. I was so transported that when I got home, I knelt by my sleeping roommate's bed—this was in the days of roommates—to whisper in her ear what I'd seen. Now, at museum openings, I began to see other olympian figures—the art collector with her panoplies of rubies, the famous painter with hair in batwings like a nun's coif, the cummerbunded tycoon with a good word for each lesser being he deigned to address. In my imagination, doors began to open and I could see these divinities sitting at their tables, turning their backs or narrowing their eyes at me,

asking who I was, and was I on the way to joining their number, and if so by what means?

Each dressing for a party in those days was preparation for apotheosis. For by the rouges and mascaras; by little diamonds inherited from a grandmother and silk shifts made over from an aunt's recital gowns or picked up from thrift shops under the El; by the wines, champagnes and whiskies; and finally by the light itself in party rooms, rosy-tinted, showering from chandeliers, I felt myself sea-changed and began to swim, not certain yet toward what far light but forward.

I'd never met anyone like Alfred, and I was both drawn to him and terrified, as I was by his powerful friends who swept into the office on occasion, stayed for spates of hilarious laughter then swept away. Once one of these, an authentic and insulting Prussian baron with a monocle, lifted his cane in the elevator and held it across my stomach when the door opened to let his silken companion exit first. My rage was Homeric. I could have killed him.

Alfred's behavior, too, seemed often out of place, his laugh too loud, his way of playing his worlds against one another discomfiting. His cuff links, his finger ring in the shape of a lion, his key ring of grimacing griffons, his watch and several pillboxes all were heavy gold, original, gifts of rich friends and indebted clients. With these social friends, he held prolonged phone conversations full of gossip while we editors sat rocking back and forth in our chairs riveted and repelled. Observe how I'm admired! he seemed to be saying to us subalterns. How I am loved!

The season I'm remembering, he was on a creative high. He had just come back from a working trip to Europe during which time I, the new managing editor, had been in charge, and I was proud to report progress. We began to work late

evenings to put the *Annual* to press. I was writing with ease, and collaborating with Alfred was exciting. His mind was inspirational but chaotic. But when I transcribed his words, revised them and gave them back to him for approval, a finished article took shape. I began to wonder how he'd managed before I arrived. Later, of course, I learned I was far from the first to play this role.

Yet something more was building between us. When he talked in his agitated fashion, I found myself looking straight into his eyes not knowing how else to hold him to the course. Then something would come into his expression that I read as "Can you take this on?" Then a burst of nervous laughter would inform me he knew the communication had been received, but that he had no clear answer back.

One of the evenings I wasn't working late, I saw a television performance of Giraudoux's play *The Apollo of Bellac,* in which a diffident girl, played by my friend the actress Gaby Rogers, learns that she can make any man want to marry her simply by saying, with a special lilt in the voice, *"How . . . handsome* you are . . . !"

Not long after, I found myself standing before Alfred's desk while he drove along through one of his convoluted anecdotes. As he wound toward the end of it, on a sudden impulse, I leaned over and interrupted him exactly in Gaby's voice to say, "How handsome you are . . ."

He stopped in mid-phrase, gazed at me deeply for a long moment, then broke into a wide innocent smile. Many years later, when I would write these words for the first time, I also wondered for the first time whether he too hadn't seen the play.

We had dinner a couple of times and then one evening he suggested we go to a nightclub. I was in office clothes, un-

primped, unrouged, but I agreed, and we went to that arche-
typal trysting place, the Rainbow Room, where he ordered
champagne and we danced. He was short and stout and pro-
pelled me around the room in an old-fashioned, clipped
rhythm, leaning from side to side or backward to keep up the
flow of talk. I felt people must be noticing us and drawing the
expected conclusions. But when we sat down and talked, the
rest of the room dimmed out. He told me his life story, and
I told him mine. Of course, there was an imbalance between
us, for he was reshaping a story often told, while I had never
talked so openly about myself and felt incapable of artifice out
of surprise to find him so interested.

Other evenings followed. I continued to feel awkward
about being seen with a man so obviously older, who I well
knew was married, but I forgot this each time in my delight
in his company. He charmed me with talk about all the arts
from painting to fashion and his travels in Europe in search
of rare examples of them. There was nothing abstract or
doctrinaire in his approach, which was curbed only by his
respect for historical facts and his emotionally expressive
style. And he kept talking about what he called the peaks of
experience, esthetic and romantic, what he said he lived for,
using Dante's words I'd not heard before—*l'amor che muove
il sole e l'altre stelle.*

As yet we hadn't made love, a prospect that filled me
with anxiety. Still, it was clear how things were going. And
there was this that relieved me of guilt: I wouldn't have to
lie to the world about our relationship for long. Forgetting
Giraudoux, I told myself it would be an adventure instru-
mental in my development, without responsibility or long-
term ties, a techno-sentimental education to be kept in a
compartment of my life, since I'd obviously be kept in a
compartment of his. Alfred spelled it out—to give him

credit. "It isn't really fair. You have to realize if you become pregnant, I can't marry you." I heard the words, and they angered me, but I let them go.

Instead, I let myself be carried forward, telling myself that a liberating experience was what I wanted. Whatever is imagined is in a way already at hand, but the cost is not always figured in advance.

That long-avoided threshold was crossed when Alfred helped me find a new apartment after my basement brownstone lease ended. I rented one in an anonymous brick building that backed on a tenement near the East River. It was outside my regular beat, but I told myself its impersonality was an advantage. I could become someone new there. I bought some thrift-shop furniture, hung up a Japanese screen of herons in flight, and some old striped curtains that served for our childhood theatricals back in Cleveland. There was a plant in a white pot, and books, and new "Rocket Blue" towels, and that was my new home. The night I moved in, I made the bed with new sheets. We were standing on either side of it, and I said, more as a prayer than a point of information, "I've never . . ." and "Is that so . . . ?" he replied with a smile.

It was August of 1955. I was twenty-seven years old, and no man till that hour had stopped my complaints, brushed aside my repressions, pulled me down, loved and labored me into collaboration until I lay drained and gloating and burst into such wild laughter—we both did—that I imagined my neighbors on all sides putting down their newspapers and smiling at one another. Alfred then broke out into the Russian revolutionary song "Stenka Razin," and we rambled off into the esthetics of the musical scale, completion and final resolving chords. And I had bargained for a compartmentalized affair!

Our first season passed like a storm. In spite of Alfred's

marriage, he seemed free to spend most evenings with me. A couple of hours after we'd both left the office and parted, he would be at my door spilling small gifts out of his pockets and packages—flowers, books, handkerchiefs, German sausages, pickles, sauerkraut, pâtés, breads, fruit, cans of exotic soups, cakes, bottles of wine and spirits, especially Russian Zubrovka, flavored with buffalo grass, that knocked me asleep twelve minutes after I downed a glass of it every time.

Pulling off his coat, he'd plant himself on my little sofa, scowling at first over some reserve in my manner, for my defenses always grew back like brambles between his late-night departure and the next day, and I had to be seduced anew. He would run his hand through his hair, smile, cross one leg over the other at the ankle, shift about and begin to talk. As he talked, he gestured with one hand, shifted again, planted his feet apart on the floor, pointed his toes out, then in, while all the time the talking continued, broken by bursts of laughter. So frenetic and scattered, he shot these glancing conversational arrows at whoever would receive them, and none can have been more avid for them than I.

The whole: with Alfred, it always came back to that. He revered Goethe, who exclaimed, *"So ganz!"* when he saw his first Roman temple. What he said he most loved was Goethe's reach for a form large enough to embrace both art and life experience. The answer was *Die-and-become*: the metaphor of death giving rise to new life. He quoted the line: "So long as you have not realized this *die-and-become*, you are but a dismal guest on earth." I understood. In a bad time, hadn't I found support in Roethke's lines of the same order? Whereas, I reflected, my father had no appreciation for the transmutation of trouble into art or even into his chosen procedure, philosophy. For him, works of art and scholarship were consciously assembled formal structures tending toward a deliberate effect or goal. He seemed not to accept that, under the

inevitable passages of depression or confusion in a lifetime, a process can be at work tending toward some future insight. And as he saw it, natural death was the end of everything.

There was another difference between the man whose house I hadn't yet really left and the one whose house I didn't yet share. Once visiting us in Cleveland, Alfred grumbled apropos some polite talk about a musical performance, "Everyone in this house glorifies mediocrity!" But the Middle Way, the way of adaptation and balance, was my father's deliberate choice in the manner of the Greek Epicurus, whom he now called the wisest of philosophers, calumnied through time by Platonists and Christians. Son of the Enlightenment, my father set himself to live by the rule of reason. Son of Romanticism, Alfred was proud of his capacity for enthusiasm. *Im ganzen, guten, schönen resolut zu leben,* was his motto, and in that windy line I felt lifted beyond my old constrictions and set free.

There was so much sheer enjoyment in our outings. He loved to walk the city streets, striding out with bold, vigorous steps, his well-coated, sturdy body full of energy. His just-greying hair would blow in the wind and his eyes shine as he talked loudly, pointing out architectural sights, arguing about proportion, design, function. Once we stood shoulder to shoulder for half an hour before the new Seagram building, leaning back to look up at its façade of bronze-tinted glass, so elegant to me, and he lectured me on why the proportions were all wrong. I didn't see then, nor do I know now, what he meant, but he was convinced he was right and it was such a pleasure to hear him talk that I listened rapt. A friend saw us that day from a taxi and later told me she'd gone home and reported to her daughter that the communication Alfred and I shared was the best a person could hope for in life. And so it seemed to me.

Also of course there was ardent flattery from him along

age-old lines which were new to me and which I took as gospel-true communications of his feelings. Nor do I think he was pretending, for he said he was as surprised by the intensity of the affair as I. He was my teacher, he kept saying, but my learner, too, and he joked about what would befall him when I learned my lessons. "Nature's lay Ideot," he quoted Donne, "I taught thee to love . . ." He kept saying it was only in chronology we were out of tune, for he was just coming out of a long tunnel that I was heading into. At the time, I thought he was talking about sex and protested he had years to go. But now I think he was talking about emotional maturity and meant to suggest I wasn't yet there.

We exchanged symbolic gifts. He gave me a handkerchief printed with the flowers and their meanings, and a ring with a cameo of a woman with amber coils of hair. I prized it more than any other jewelry because the head looked to me like my mother's, and when I lost the ring in a taxi one day after he died, I felt I lost a bit of her as well. In turn, I gave him a little compass set in jade, along with a note saying he had showed me the way out of the forest.

Alfred also chose symbolic names for us. He wanted to be Kerophon, in an obscure old Greek form "Slayer of the Necessity of Death," and I was Norina O'Groats. Norina was French, compliant and lived for her man. O'Groats stirred the oatmeal on a pike over a blackened fireplace and growled. The charm of having one I so admired take my critical inner conflict and nullify it by a joke caused me, every time, surprise and then a flood of purposeful happiness, in the sense of wanting to return the gift of understanding.

The subject we talked about more than anything save art was family. What obsessed him was the very thing that had immobilized me for so long: the need to cope with a bewildering father. We picked at the threads that had led us to our present

place, trying to understand our fathers' behavior and our own
struggles with anger and guilt. At the same time, he under-
stood family loyalty. By his courtly respect for my father he
relieved me of the idea I should simply have broken with him.
And by his intuition of my mother's needs he steered me back
to her.

She was coming for a visit, and I was already worried.
"Nonsense," he said. "Treat her like a child. She wants to
be spoiled a little. A *joli gâteau* is what she needs. Give her
a *joli gâteau*. You'll see."

He told me to buy a bottle of perfume and put it on her
pillow, and to reserve theater tickets. She arrived at my new
apartment in the morning while I was at work. As she later
told me, when she opened the door, a draft from the alleyway
stirred the glass curtains, and something about the room—its
quiet order, or a bowl of flowers on the table—told her my
life had changed. When I came home that evening, she looked
at me hard, once, and we were never distant again. Eventu-
ally, it would be she who would strengthen my will before our
marriage, saying, "No, I don't think you're making a mistake.
I think you're courageous." And when Alfred died, it was I
who had to comfort her. "I could handle him," she once said
to me when we were having one of our terrible arguments. "It
would be easy for me." She knew that for him, too, the *joli
gâteau* would have healed the wounds, that we are all children
in the arms of those we love and can be soothed, at least for
a while, by a pretty cake.

For Alfred, however, there were memories too painful to
forget for long. He still couldn't forgive his father's punitive
cruelty to him as a boy save to say it was German tradition
or a German-Jewish father's effort to out-Prussian the Prus-
sians. But his own self-denial was as deep. He was a school-

boy when World War I broke out and, as he told it, refused to shout some patriotic slogan like "Down with the Kaiser!" in class. The teacher insulted him, the children threw stones and he went home a raging Prussian. The fury never ended, against himself as a German-Jewish-American, against his father and the Fatherland and also against blind anti-Germanism. In the 1930s, like many other German-American Jews, he saw with dread the Fascist brown and black shirts multiplying, knowing that for himself it would be one more war between the sides of his own nature. As it turned out, he never was able to sort out his allegiances and antipathies between the political Left and Right. As the war came on, Hitler even became a dreadful fantasy figure in his dreams, and in his later dealings with underlings, he occasionally gave in to temperamental excesses inspired by such nightmare authorities. In this light, his frequent reference to *"So ganz!"* was painful to hear.

But more than politics, his childhood had shaped him. "We had Christmas in the German style," he would begin a story told each time with bitter passion. "All the children coming downstairs and presents on the tables. We'd march around them and only afterward could we pick up our gifts.

"But one Christmas I wanted something special. Maybe a helmet or a drum or book. When I opened the door of the room and saw my table, there without wrapping was the one thing I most wanted. So I forgot the orders, and ran over to it and picked it up.

"My father walked over to me. I can still see his face like iron. He picked up all my gifts including, of course, the one I most wanted, but the others, too, still in their wrappings, and carried them out of the room. I never saw them again. Never!

"That was the way he was.

"Or another time, I was having my tonsils out as it was done in those days, without anesthetic. You just opened your mouth, and out.

"The doctor took me between his knees and naturally, because I was just a little boy, maybe seven or eight, I began to cry. 'Wait a minute, sir,' said my father, who was standing in the room. He walked over to me, turned my head around with his hand and delivered a blow across my mouth that almost made me faint. Then he said, 'Now. Obey the doctor.' So I did.

"And goddammit!" and he would hit his knee with his fist. "It wasn't all bad, goddammit! A damn sight better way to bring up men than having them faint at the sound of a gun. To be obedient! To endure pain! To suffer cold!" And each time, he would strike his knee with his fist, working himself into a rage defending the memory of his father whom the next moment he would attack with the same bitterness.

What did it matter what he struck out against, I finally decided. He had to find release from the pressure of experiences beyond understanding—his own small corner on imponderables behind the times themselves. I understood. I remembered the dark wartime years in Cleveland and the evening of my educational humiliation before we left for Paris, and I understood.

But what united us even more than such memories was that neither of us had broken away but kept going back to the family circle. "My father was dying," as he described a scene, "and I was sitting by his bed. He turned away and began to cry. Then turned back and said, 'Alfred, you were our Golden Boy.' " Alfred would tell the story, then look at me with astonishment. "If I was his golden boy, why did he brutalize me when I was too small to protect myself? Or if he despised me, as I later felt he did, then what had I done to make the change?

"Well, perhaps that was it. He expected so much of me. Still, I went on to make something of myself. He could have enjoyed that. Taken some pride in what I became."

Still he remained a dedicated son and wrote his father letters of tortured, even craven, tenderness:

Dear Papi . . .
I feel a joy, a spiritual ease, in being able to write you on your birthday . . . of my gratitude for your care, your consideration and thoughtfulness, your teaching and, above all, your sacrifices on my behalf. Do not think I will ever forget them but instead will bear them in mind and, whenever possible, attempt to compensate you for the irrepayable debt I owe you.

Yet a joke he told repeatedly was the scathing one about the father who finds his son standing on a chair waiting to be lifted down.

He holds out his arms and says, "Jump! Jump, my son!" but the child shakes his head.

"Come on! Jump!" repeats the father, holding out his arms again. But the boy refuses.

"Yes! Yes, jump to your papa, my son! Trust me!" Finally, the boy jumps, and his father steps aside and lets him fall to the floor. Naturally the child howls, but his father shakes a finger and says, "That'll teach you never to trust a kike."

But from Alfred's memories of his sister Cecile, there was no escape by black humor. Two years his junior, she was his spirit sibling, and as always in a German home her brother was her protector. Then she became ill. There were frightening seizures, witnessed by the boy. During these spells, the house was darkened, with the doctor coming and going, and their mother pushing the older child aside in her grief. Eventually his sister was institutionalized and later died.

This experience set the pattern for Alfred's subsequent

feeling for women. He was a womanizer, but his adventures
were motivated by more than desire for conquest. He pursued
women with talent and energy, whom he respected and whose
company he enjoyed but then found himself unable to master
or to let go. The melancholy woman he'd been restlessly
married to for twenty years when I met him was a painter.
Other friends had been musicians, artists, writers—though
it's true to say, often younger and vulnerable when he first
met them. But to find a kindred spirit who spoke his language
and touched him by her plight, whatever it might be, then
flood her with anxious, motherly concern—such was his con-
ditioned need, which fit so fatefully with mine.

Even sex was shadowed for Alfred by his sister's ghost, for
he once told me women's cries filled him with fear, and he
never could see Bernini's paroxysmal *St. Teresa* without a
pang. Such troubled sensuality transmuted itself, as some-
times happens, into esthetic idealism and provided the
ground for his most intense experiences with works of art. For
he called himself a Platonist and gravitated to the Christian
religious arts, those hierarchies of images, ascending and
descending cadences of suffering Madonnas, anguished Cru-
cifixions, Depositions, Resurrections and numberless saintly
ecstacies which gave my father dyspepsia and, until I saw
them through Alfred's eyes, left me cold.

Less seriously, he adored tales of people who in one way
or another, ludicrous or admirable, aspired to an ideal. How
he laughed, for instance, at his friend a Jewish museum
director, whom he, Alfred, standing by chance in the shadows
of a crypt in France, had seen approach the altar with hesitant
step, look furtively behind him, then kneel, cross himself and
pray to Christ. How he laughed at the well-known reply of
Berenson's Quaker wife, Mary, who, when asked how she
survived his infidelities, replied, "Mr. Berenson has wor-
shiped at many chapels, but I am satisfied I have always been

the high altar." And among artists, how he admired those who saw their lives in enhanced terms, like Jackson Pollock, who told the world, as he swung his arms back and forth over the furrows of his canvas, "I am nature . . ."

With artists he respected, old and young, he struck fire. So he did with anyone with whom he could laugh. He considered himself gifted with Homeric laughter, the kind the gods indulge in. He and his cronies, men and women, had what they called the Rabinowitz Society, a couple of Russians, a Scandinavian, a couple of WASPs, a few Jews, all self-raised from base beginnings to world-class success. It was a club of egocentrics buttressing those egos on jokes whose principal object was the wayward Jew, serving here to remind them that the pushcart peddler, fur merchant, seamstress, still lived in their skins. As Alfred often told me, celebrity parties he went to were mortally dull, with tongue-tied luminaries gaping at one another. But at their annual meeting each Christmas Eve, this gang staved off boredom by exchanging malevolent jokes, anti-Semitic but also anti-Russian, anti-Swedish, anti-German and, abundantly, anti-American. I have no head for jokes, but one of the few I remember was the old saw that revealed the true and original nature of the universal Rabinowitz, however high he might rise in life.

On a station platform in Russia two friends meet. "So, where are you going, my friend?" asks one. "To Minsk!" says the other.

"To Minsk? Are you sure?"

"Yes, yes, why should you doubt? I am going to Minsk on the train today."

"Listen, Rabinowitz," says the first. "You tell me you are going to Minsk so I should think you are going to Pinsk. But I know you are really going to Minsk. So why do you lie to me?"

As natural a storyteller as ever lived, Alfred would pace

his way through the well-known turns to the wicked tag, then break out into laughter, his eyebrows lifting in half-embarrassment that he found himself so amusing and was so pleased—so pleased!—to be giving amusement to those he held in such high regard.

Beyond the reports of the Rabinowitzes, Alfred's tales of other characters in his world enthralled me. With relish, he told of their scandals, their miscegenations, their depravities—the art dealer who contrived to sleep with cadavers, the museum curator who stole phalluses off Greek and Roman statues, the hostesses who were playmates of the President, the transsexual triangles. All were subjects for laughter. None needed to be banished into outer darkness. What a freedom to be one's self, bad, bizarre or just unusual, seemed to exist in that world!

Freedom was what I thought I wanted from the start. But I'd made an odd bargain. I'd thought of freedom in terms of sexual responsiveness—that final trespass out of chastity—then chosen for my liberator an unfree man with an obsession of his own to reenact each time he fell in love.

How soon did I realize where my leap through the biblical open door had led me? From shortly after the beginning, there'd been rules of conduct I was supposed to obey if I wanted, as we both defined it, to be "a woman." I was to give up my old friends unless they acknowledged our relationship—unthinkable in those days, given his marriage, my so-called respectability, and the fact that we worked together. Beyond that, I was to break with men friends of all degree of closeness. If I was asked to a party, I was to ask if any of my former men friends were included and refuse to go if they were. No real woman would do otherwise. Directly opposite to my father's esthetic of feminine dress, according to Alfred

all real women, European women, wore only black after dark.
Especially, in view of my delicate coloring, I mustn't wear
bright colors. Nor was I to "flirt." Alfred wrote me tender
letters full of instruction, beginning with appreciative words:

> You have not only awakened a whole new part of a much
> older being, you have taught him how to live, what living
> can mean in a new and fuller sense, what to hope for and
> how . . .

then moving to admonitions:

> Keep yourself as rare and proud as you are, absolutely secure
> in yourself—no need for flirts or tests or even minor applause
> to convince you of being the Most Beautiful Woman. . . . All
> this truly not only for me but for yourself . . .

The archetypes of female submission are sowed through liter-
ature, and Alfred knew them well. A woman was a man's
altar. Accessibility was the lover's right and his monopoly of
it in accord with the altar's intrinsic nature. I sat one evening
on a barstool beside him arguing this issue in a state of
agitation. I knew it to be the dreadful old one my father had
raised: the special nature of the female, to be dealt with in
ways the men laid down. Infidelity by the female was a crime
against nature. He, Alfred, would teach me to live according
to nature and, by willingly submitting to it, to find peace and
happiness.

Wasn't I happy? Didn't I look more beautiful than ever
before in my life—*en beauté,* as the French say of a sexually
satisfied woman? So it went until, won over by his vehemence
and also his presence next to me on a barstool, I accepted that
what he said could well be true.

The result was that I didn't turn on my heel, any more than
I had with my father, but stayed on in the net I'd strung for

him. And over the months, as our arguments grew worse, he would accuse me of selfishness (yes, I could see I was when he pointed it out) and of coldness (yes, I could see that, too, always drawing a line between my freedom and his rights). Soon he would begin to shout and even break things, grab pencils, snap them in two and fling the pieces across the room. Once he brought me a leather-bound *Oxford Book of English Verse*, flew into a fury and in an hour had ripped all the pages out of the binding.

I wasn't aware of it then, but now I think these fits in some way must have echoed his sister's, for while he was in the throes, he talked about death, about how he'd die before me, about what my life would be like afterward, about times he'd nearly died, of too much Russian vodka, of threatened aneurysms, of swimming in deep water. Then would follow the flood of passionate words in hopes they'd erase the others, and often they did.

Out of this obsession with dying and my own seeming helplessness in putting an end to a situation that had begun hopefully but now was like a return of a bad dream, that unspeakable solution did come to stand between us. Then "you've promised me you would disappear and free me . . ." would be my unspoken half-truth, and "yes, I'll be gone and you'll be free not only of me but of what went before and brought you to me . . ." was Alfred's unspoken half-lie— while as a protection against any such disaster, we both clung to his talisman-identification of himself as "Slayer of the Necessity of Death."

Finally there came the first time he made a trip away from me. I bought him a gold nugget as a safeguard, not remembering how I'd stolen three from the old woman's basket so long before. This one I paid for out of my salary, and with it I sent a note:

. . . when you left the pall fell. I came home exhausted, found
the fabulous red flowers, lay down and listened to the Beetho-
ven and was alone and quiet for the first time in this apart-
ment.

I can't even begin to tell you what all this has meant . . .
how bereft you have made me without you. I think I am
thunderstruck. . . . You have changed my life.

A day or so later came a letter that said, along with expres-
sions of love and disquisitions on my faults and virtues
("with the elfin there is also a narcissism . . . mix this with
Scottish reserve, French caution and Rumanian romanticism,
and what do I get? Narcissa Apassionata O'Groats . . ."), that
the nugget had broken into two equal parts. "What does this
signify?" he asked. "We need Sir James Fraser and Panofsky
and Graves to answer."

Alfred and I met in Europe that summer for our first trip
together. We would attend a professional congress in Venice,
meeting there as if by chance, then travel on.

For weeks I hadn't been out of his company, and I chose
to take a ship instead of flying. He was furious. Twice, he
phoned shore-to-ship. I climbed through a labyrinth of rock-
ing corridors to the radio-telegraph office to take the calls at
an empty desk leaning on one elbow and covering the mouth-
piece with my hand, for he exploded into accusations and
lamentations. The calls were distressing, and after the cap-
tain's dinner the last night at sea, I walked out on the deck
alone and stood by the rail, thinking how it would be just to
let myself slip over, then watch the ship with all its dancing
lights sail on.

Then someone came to stand beside me, an elderly nun I
hadn't seen before. She wore an old-fashioned habit and stood
quietly for a minute, holding the rail with small hands. It was

very dark, and the wind off the waves was steady on my face, and I had a longing to hear a voice not full of ego and demands. She told me she came from Brittany. Though she'd been born by the sea, she'd had a lifelong fear of water. For this reason, and because she was so old, her Mother Superior offered to let her make this trip by air. But she'd chosen the sea.

Then she asked me whether I was traveling alone. I said I was. "Good luck, then, when you make your choice," she said, and walked away.

Tears filled my eyes, it was so confusing to be told I had a choice. Only years later did it occur to me the nun needn't have meant a choice among infinite possibilities but between a single predestined one or a lifetime of drifting.

In any case, when I saw Alfred the next morning on the dock in Genoa, standing a little way back from the crowd, looking as he always did, more European than American and therefore perfectly at home and self-assured, I was filled with relief and happiness. He'd rented a car and planned to drive us to Milan, then Verona, from where I'd travel by rail to Venice, arriving there alone.

It was late when we got to Milan after rushing through the cobblestoned outskirts of the city, alongside boarded-up cafés and country houses asleep behind high walls. But the heart of the city was aglow with light from shops and the great windows of our hotel. Alfred parked, called baggage boys, gave in our passports, took my arm and steered me to our room. It was an apartment with a sleeping balcony suspended in a large salon.

The furniture was modernistic, veneered in some demateri-alized silver plastic, and across one whole wall, sheer curtains shone from behind as if by moonlight. Alfred pulled the curtain cord, the white cloth swept aside and there beyond the

window stood the floodlit cathedral, its buttresses and pilasters turned to silver filigree and shimmering like a Hans Christian Andersen forest.

And so my reservations about Alfred were swept away, too, and I began to learn to live alongside him in his Europe, in which, because I willingly acknowledged him as my leader, he was my infinitely wise guide. And, passionate partner that I was on this as on other trips with him, I shared his perceptions, began to grow and add my own to them, but would wait a long time to put them into words.

To begin with, he instructed me in what I felt was the very art of living, to formulate and live as integrally in time as one ordinarily does in place. A single one of our days together had the shape of a lifetime. Breakfast was no quick stoking of fires but a slow rising into conversation while the butter melted, the tea grew cold in our cups and the orbs, crescents and slivers of fruit and toast on our plates drew honeybees in the window. Alfred would shuffle around in his memory and let his associations flow, perhaps taking a subject related to some magazine project, maybe the meaning of painterly "light," or the condition of the *Last Supper,* or the Egyptian sources of Napoleonic style, then rambling on, leaping to conclusions and tossing out topics for future study.

The rest of the morning followed a rising curve as we visited museums and galleries and explored sanctuaries to their innermost crypts, until the sun at its zenith brought us to a glorious lunch—no frugal sandwich and quick coffee— and more conversation, after which we rested, then set off on another gradually subsiding glide of exploration until day's end, when we would have found, in the courtyard of some old palace or convent, a concert of rare music or a play, and then, still talking, walk slowly to our hotel. So the days dilated and closed like living beings, each one a part of the "whole,"

which outwardly was always a quest for art-historical material
for the magazine but actually was that ineffable highest good
we both understood as "experience."

That first day, however, we were in a rush to reach Verona,
for if we did so, there'd be time to stop before my train left
in the evening. By twilight, we were still on the highway. It
narrowed to two lanes choked with motor scooters and
trucks. Traffic-filled intersections slowed us. Darkness fell.
As we drove into downtown Verona, single light bulbs high
up on the mud-colored walls of old buildings led us as if by
torches. In a hotel, we were shown to a tiny room with
brown walls. Yellow lamps lit the wooden bedstead and its
cover of homespun. The sheets were rough to the touch and
the pillows high and deep. We felt pushed by time and anxi-
ety, yet in that hour we seemed to be in the very valley of
our lives, where there was neither arriving nor going away
for either of us.

At the train station, I pressed against Alfred and he put
his arms around me and talked seriously, as he always did
at the outset of a trip, explaining once again how we'd meet
as if by chance among our friends in Venice. He said that
one day we'd be together without the need to lie or sepa-
rate. He seemed confident this would happen, and so was I.

When the whistle blew, I climbed into a compartment, sat
down one seat from the window and leaned across the man
next to me to wave. Alfred waved, too, and kept waving until
we were out of sight.

In the compartment was an Italian family going to Venice
for the holidays. The mother sat facing me, a plain woman in
black with hair neatly knotted on the back of her head. When
I pulled out my Italian dictionary and tried out a couple of
words, she nodded encouragingly. Then she began to study
me with what felt like impolite directness. "That man," she

said at last, shrugging her shoulder toward the station, "the man you were saying good-bye to . . . your papa, I suppose?"

I was taken aback. Of course Alfred was older and dominated me in the way he stood and spoke. But I'd forgotten my discomfort with such matters here in Europe, where most women were deferential toward men and men signaled their status by commonly accepted behavior.

But I was so filled with hope, I couldn't be upset for long. "No," I said, leaning toward her, trying to make myself understood, "not my papa . . . a friend, a friend." The woman didn't answer. In fact, she seemed determined not to understand nor to give me the blessing of a smile I would so liked to have had from her.

So I sat watching the lights of little country stations I'd never visit, while the train rolled on toward Venice. And I was aware the woman went on studying me with an expression of thoughtful puzzlement, as if she were imagining many things about me, my being in love unsuitably, perhaps, and doomed to tragedy. But this last thought I brushed off as too Shakespearean and went on looking out into the darkness beyond the glass, across which from time to time drifted my own transparent face.

We met as planned, and deceiving our friends was a delicious game. Of all the first sights in that city, from gondolas to paintings in shadowed churches and the mosaic fires of San Marco, what moved me most was Venetian light itself, filtering into Alfred's hotel room, grander than the pension with sagging beds where Ruskin had dwelt and I was officially booked. Beyond his windows stood the *Salute*, its great scrolled and spiraled forms awash in reflections from the canals. When the louvered shutters were partly closed, that pearly light entered and moved across the ceiling opening into tremulous circles as gondolas drifted by on the water below.

We lay side by side watching the light move on the ceiling and across our bodies. I never knew such a union of voluptuousness and esthetic transport as those hours suspended between the light overhead and the water below, as caged in luxury as the emperor's golden bird, which in a sense I was.

Yet, as can happen in the course of a romantic but uncertain trip, there came a moment of truth, one person voicing it, the other listening but not ready to respond. We were walking along the canal one evening and our thoughts turned on ourselves. "The trouble is," Alfred said, "you won't realize what we have for years to come. I'm too much part of the past for you. I weigh you down with old burdens that keep you from seeing me clearly. And that's very sad. Because I have a simple need. And you can't see that."

It was true. Our relationship weighed on me. I couldn't give it up or move freely in it. Alfred was too heavy for me in the sense of having demanded to be too much. At the same time, he craved the simple trust I couldn't give him save when I was learning from him, at his side.

He was married, and I should be getting on with my life.

For the present, however, we set off toward Austria and a research course in Bavarian architecture. This style and its cultural roots represented a part of Alfred's German heritage he hadn't explored before save through the Rococo seductions of Mozart. Therefore, the trip was a kind of pilgrimage for him, a return to origins and a reorientation of life thereafter, according to most basic coordinates of understanding. And as must happen on a pilgrimage, our outer finds reflected our inner condition, so that as we talked of some things, we meant others. Thus day after day we drove by winding roads through forests toward the grey stone abbeys, monasteries and churches so imperiously forbidding on their rock pinnacles.

But each time the twisted black-iron gates barring the entry were passed, we found ourselves released from heavy thoughts and lifted, as it were, into paradise by lofty domes opening over our heads, lit from little sun-wise windows bordered by stucco froth in which angels played. Again and again, we experienced this transit from historic fear and gloom to sensuous and imaginative transport, and knew it for the mirror of our love affair.

After some such days, we stopped in Velden on the Worthersee for Alfred to write up his notes. I swore I'd never forget our lakeshore rooms there, so creamy cool in color and, for me, thick with inarticulated thoughts, but I have. I only remember we breakfasted on grapes, peaches and pears and that each evening, the calendar brought a chill and the smell of woodsmoke closer, and I drifted in and out of a question. What was my life to be?

We drove on toward Vienna to hear an opera and stopped by the Faakersee, where under red-bronze chestnut trees we lunched on lake trout and drank a smoky white wine. Then again, we found ourselves on the road, running late. Driving through the pine woods that border the city, Dante's very place of being lost in the middle of life, we found ourselves blockaded in a traffic jam. As furious drivers honked their horns and shouted Germanic imprecations, a policeman on a bicycle, riding up and down the lines, waved his arms and shouted words Alfred translated for me as "no compassion! No compassion!"

We arrived and rushed straight to the opera house. The overture had begun. It was *Madame Butterfly*. Already the sad descending intervals were foretelling the end of that chance meeting between worlds that didn't mix. We dashed into a box and found the chairs taken. Alfred tapped a man on the back and asked him to allow me to sit. The man

pushed his hand away. Alfred pushed back. "Sir," the man whispered, "you are at the opera!" Alfred flew into a rage. "Get up!" he said loudly, and all the house turned toward us. I left to wait outside, fueling his anger. In the anteroom we had an appalling battle in whispers, but when the performance was over and we were back in our hotel, the storm broke.

"You'll regret this very dearly indeed," Alfred said in fury. His eyes blazed. There was a scene, and he became ill. And then to tell the truth I was drawn to him. Sometimes, I missed my younger friends and longed to get away. But when he was frantic and suffering, I feared and pitied him, and the old nectar flowed.

Our next stop was Salzburg. Our rooms hung over the river. I stood on our balcony looking at the cathedral's bronze-green domes against the stars—painful swellings as if the earth itself had grown breasts and were about to bear— and thought I could let my life slip by in this attachment. Below me, the glacial waters poured by in a flood. How they roared and rushed away! With one voice, they spoke one word to me: Go.

How did it come about then that our last evening in Europe we were to be found at a Russian nightclub in Paris, hearing violins, drinking vodka and toasting our future daughter, with whom Alfred petitioned the gods to let him live long enough to dance some future night, in the same place, to the same music?

The question of marriage, thrown out by me in a moment's whim and then forgotten, was raised again when Alfred wrote what he considered a formal proposal on the back of one sheet of a many-paged letter, which I failed to turn over. I did so when told, and there it was. Our affair had begun in the immediate aftermath—after long separation

from his wife and the manic purchase, considering his income, of an enormous house—of a reconciliation with her. He was then forty-nine and had finally made peace with his longing for domesticity. And before the ink on the bill of sale was dry, he was writing of marriage to me. At the time, I answered his proposal, fantastical as it was, by setting it aside.

However, through long months of struggle, I set in motion the process that would bring us both to points of decision. I left the magazine, full of self-doubt at first, to work on my first book, on art history. Soon to my joy my writer's voice began to speak in harmony with what I knew. I wrote as I'd learned from Alfred, reflecting on works of art I'd seen, and also as I'd learned from my father, trying to find clear words for thoughts, and also as I'd learned from my mother, allowing my feelings to sing through my fingers.

Now I saw that writing about art could mean writing not only about appearances but life: private longings, collective movements, rises and falls of nations and empires. I saw the world as a theater of *die-and-become*: the globe breaking out in temples which then shrank until, as Gibbon put it with piercing specificity, "just after the fork of the road to Belgium, everything was desolate, uncared for, rank, silent and dismal." But desolation bred cathedrals and *Last Suppers,* which were consumed by war and time's decay, and the process began again. The lion by the library was kin to the one at Nineveh. Columns on the bank were sons of those in Corinth. It would never end, the organic process.

When summer came, I sublet my apartment and rented one in Boston. I was determined to make a break with Alfred that might bring us back together. The last things I remember about the flat that had seen such a beginning give way to need for flight were these: across the alley, a man sat in his bathroom window staring at me with turgid eyes, performing, I

was meant to know, on himself. In horror I pulled the blinds and worked the last week in a cell without daylight. My last day there, I lifted the shade and in another window saw another man whose deep malignant coughing I had heard at night. Now he sat with his head in his hands and wept. He took a handkerchief, blew his nose, covered his face with it and went on weeping. That day, I tore out my New York roots, moved to Boston, drank by mistake a can of spoiled soup for supper, went to bed as if to death, slept two full days, recovered and set back to work on my book.

Summer ended and I couldn't return to the faces in the windows. It was the autumn of 1958, a time of traumatic change in the art world. New names had risen since I'd left the magazine. Jasper Johns's *Target* had run on the cover of *Art News,* disjointed segments of a male head in boxes, the whole—so good and beautiful in classical terms—reduced to bits. The new art was promoted by new dealers, touted by new critics. Transfer of power from the old tyrants, among whom Alfred had been one of the first, was beginning. In the next decade, reputations would be savaged. Disinvolved, my manuscript turned in, having made my intention clear to Alfred, I had no call to stay.

I traveled west and eventually settled in San Francisco. Several times, Alfred flew out to see me. I looked forward to his arrival. Then driving to the airport to meet him, I'd give way to other feelings and I would be saying it was a lie that I wanted him. I'd say all my travels were attempts to leave him behind.

I'd sit in the airport writing in my notebook:

If I do not love him, why even now did my heart move when I wrote his name? And why does my heart lurch when he steps down off the plane and walks this way with his mouth like a sword?

I drove down the coast to Big Sur. From the ocean came the smell of seaweed and fog. A couple of times, I stopped the car and climbed partway down a gulch to watch the sea pour in and out of tidepools, sucking in and disgorging huge tangles of red-brown sea-hair. At my feet were redwood boles, monstrous births of bark cells and fern fronds out of which the trees of a thousand years from now were growing. At night, the coast with me standing on it rolled eastward; the stars swung west over my head. On that coast, all was geometry and natural law. People who tried to do more than come to terms with it failed. A person who stood against necessity was nothing. The disobedient would end without a world at all. There was no way, anymore, for me to deny what was always coming up behind me.

So when Alfred called to tell me he was going to Arkansas to get a divorce, I said I'd fly home. I said good-bye to my closest friends out there, a sculptor and her journalist husband. "Of course your life will be *difficult,*" she said in her fluty voice, "but at least you'll have the feeling of being essential to someone's peace of mind. You'll be the one to smooth the way."

"But it's so wild when we're together," I said. When I remembered the bad times, I couldn't see why I was going back.

"When you're together, it will be different. Things that push you apart now will be acting to keep you together." Through round blue eyes, she saw life in terms of weights and balances. People who lived together were pressured to stay. People apart were forced further apart. Move with necessity was her rule. The only thing one could do to change things was to shed some light on them. She and I had laughed at the way we both ran around our houses at nightfall turning on lamps, making loud cheerful noises. One day, she would cast off from her husband and devote the rest of her life to her art.

Since I was going back to marry Alfred, she meant to say, it was right to go.

It was a philosophy that made it possible to do hard things.

"I'll tell you what," Alfred said some time in the weeks that followed, as we anguished back and forth over our decision. "We'll simply go forward." I agreed, and though the old weight of our relationship settled on me, I told myself it was the inevitable burden of a woman's destiny, hard for a character like me, but that I would go forward to it now. It was time to build on what was already mine.

For Alfred, it was a time of decision in another way. He wanted to expand *Art News Annual* to encompass both arts and sciences. It was a bold idea back in 1960 and his hopes were bound up in it.

"If there were but one quiet, sure sense of the future," he wrote me, "it would be different . . .

"If it were you upon whom I could count this way, sure of me, quietly understanding and nurturing me, I could cope with all else . . .

I am, you know, a Sensitive Ox—the sensitivity will need an immense amount of selfless taking care of by you. You know that my way of thinking and working is in bursts of energy, often fitful. I cannot do it any other way. This demands quiet, thoughtful listening and drawing me out . . .

I am not of the generation of you, your friends, your brother and sisters. Yet you began loving me in spite of this. Therefore, I must be taken thus. What I feel for you is not at all the cinematic cliché of an Old Man's possession, but instead the desire for uninterruptedly being together that comes from a lonely person of any age having found, at long last, the Ideal Love and Companion . . .

Can you accept a whole man . . . accept him as your adoring

love and support and, as needs be, your leader (as the male must lightly, gently and firmly lead in the dance or in bed) without needing to assert your own qualities by needling, taunting?

Can you accept the pattern by being supremely female in trying to please, to charm, to shed your own special wisdom on me . . . ?

I want, I really want, to delegate to you our home, its decoration, the shape of our social life . . . I want to draw you out, to me and to the world . . .

I promise to make our life as much as possible a mutual one, and I promise to be faithful to you as I know you will tell me you will be to me . . .

It was a letter of eighteen handwritten pages, and I read it with a sigh, for like all his communications it was a fountain of protestations and yearnings, summonings, haunts and urgencies, in which, in my deafness, as he'd foretold that evening in Venice, I couldn't hear his necessary human plea: love me as I am.

To tell the truth, it wasn't such a fraught involvement he really wanted. He once wrote me he wanted us to have "something like that wonderful comradeliness of the unspoken that comes from the perfect harmony of two spirits, viz., the Brownings, the Curies, Bernard and Mary Berenson. What is required from me for that is more quiet and calm. But will you too try to come out to me from those secrets inside yourself, as actively and directly as ever you can . . . ?" It was a natural request, but one I couldn't often grant. For I was always either learning from or challenging him, then turning away to brood on what he said or I intended.

And then just two weeks before the wedding day, an extraordinary change overtook me, as if a hand had reached over the waters and quieted them. So I moved down the last days with a feeling of single-minded peace I hadn't felt in a

long time, maybe since the time when my mother had raised the question of Alfred's age, and I'd said, "I'd rather be married to him for five years than to someone else for a lifetime."

Still the ceremony itself filled me with solemn horror. As I garbed my feet and legs, my body and head with new finery— white slippers crusted with little seashells, a pink dress, a green tulle cap—as I laid out a red suit for leavetaking, I seemed to be decorating someone not myself for a rite so ancient and not of this world I could hardly take myself to it.

But after the words, not vows—for they were not promises but fearful hopes—my family came around with pageantry, binding Alfred and me together with pink ribbon in some Philippine custom. Then something happened that hit me hard. My father lifted a glass and proposed a toast to the husband of "our beloved Eleanor." For that one moment, I saw him objectively, as the world might, gentle, supportive, compassionate. Suddenly my long anger leading up even to this act of marrying a man unreasonable for me in ways seemed a fantastic error. In that one flashing second, the possibility of a whole other life I might have had opened in my mind—one easier, more "normal"—then closed. And my father was continuing his toast, now describing Alfred as a man of wide and mature knowledge of the world and "best of all, a kind and thoughtful character. May the gods bless your decision!" I thought I understood the emotions beneath his words, both of us knowing he was unable to protest anymore because he had hoisted himself on his own petard by praising Alfred's mind before he knew of our involvement.

We flew to Paris for our honeymoon and there, after a

single week, I wrote in my notebook my first married information:

I enfold the most extraordinary news. I am pregnant.

A doctor had sent me to a laboratory and a few days later I phoned for the results. It was the day we were to leave for a honeymoon drive through Burgundy. Our shared life lay before us utterly open and empty. It would be impossible to measure how much hung on the words the nurse would speak.

"*C'est positif,*" she said.

"What?" I asked.

"*Oui, madame,*" she repeated. "*C'est nettement positif.*"

My face told Alfred the answer. At once, as if a city fell down and all the stones lay around in heaps, the shape of my life changed forever. I put down the phone and we both began to laugh hilariously, as we had that August long before. "*Nettement positif*" would be forever our term for something so inescapably *here* that there could be no doubt about it.

We made our trip, but my bride's body now recoiled not with psychic but physical distress. Through Fontainebleau and Barbizon, down the gentle slopes of Burgundy to Avallon, from fairy-tale Gothic town to town, I traveled as a grey-faced mute while at each lunch and dinner the great Burgundian dishes were brought out under glistening dark-purple sauces to make me shudder. Coming home, we spent an hour in Geneva walking up and down before a building where abortions could be had. Alfred already had a grown daughter, and here was a clear-cut alternative. But neither of us would do that. If destiny was what I had taken on, and destiny took this form, I would not say no.

There was something else. Though this new life would change ours in ways I couldn't tell, I had the absolute conviction the child to come was the embodiment of my wish for an end to division.

It seemed extraordinary to me then, and so it still seems today, even as much a miracle as our unbelieving time can accept, that a wish for healing can become so strong it can affect the body, release the required hormones, and bring forth a child.

KEROPHON'S
WIFE

The question of whether our marriage "worked" is irrelevant to what we lived through. Alfred survived only five years, and in that time, child-bearing and social responsibilities were my work, to which I gave myself with the willing submission he'd hoped I'd learn vis-à-vis himself but which I failed to achieve there as a general rule. However, the marriage conveyed us each to a further point in our destined trajectories. Also it conveyed our two sons into the world and in that way sustained the miracle I spoke of.

Webster defines "miracle" as an event explainable by reference to the supernatural. But I needn't lean on God in appreciating the wonder of my having received just then, unplanned, the pregnancy which, during years of skirting it dangerously, I'd never experienced. Therefore I call the miracle my own and natural: the first sign from within myself that I was ready to live fruitfully instead of between small deaths. And there was this religious aspect to the event: I had with such zeal and devotion (Webster uses these words, too) sought my way to this incarnate wholeness that it raises in me now, looking back, the question of whether it wouldn't have been the Madonna who first thought of bringing Christ into the world, since in her heart, she hungered so for reunion? Indeed, my obstetrician, a Roman Catholic, as moved by the solemnity of what he was doing as a priest, gravely lifted up the newborn boy like a wafer and laid him on my belly, and I folded around him arms that would never again, however long I lived, be arms that hadn't held their child.

In the first weeks of motherhood I grew wings. I was in dominion at last over a new landscape of myself. My senses and mind reached out in long tandem explorations back and forth between tactile physical tasks—lifting, stroking, smoothing, wiping, oiling, powdering and so on—and ex-

panding ruminations. For a while, I felt still joined organically with this other being: the hormonal source of ecstacy. My nostrils were full of his scent and blood-warmth. The piercing and drawing of his nursing, providing voluptuous echoes in other parts of my anatomy, called to mind the love pangs of the saints. My obstetrician erred one day and called me "Mary." For Alfred, I was at last his *"Virgine Madre, figlia del tuo figlio . . ."*

Yet too soon the world began to intrude between us. By the ticking of the clock, each tick painful as the needle in the feet of Hans Christian Andersen's mermaid, I felt us being cut apart. I watched the baby flutter up on his hands, lifting his shoulders and head, craning around to look, amazing visitors by mouthing bleats of an unknown but seemingly articulated language to a little red music box Alfred set on the mattress right by his eyes, with a plastic dancer who held out her arms and twirled on a toe while the music unspun. And stopped.

It was that. I felt so acutely the minutes slipping away. My helplessness before time now seemed but the latest form of bondage I'd felt so long, only not just particular to me. It was helplessness before loss. There even came into my mind a country I called Land of the Lost when I joked about it with the children later. Into it would fly many things and also people, arrows shot over a hedge, never to be found. There was a little black truck from a London toy store someone carried to bed each night. That went out and never came back. There was a single shoe, and a green shell, and even a telescope. All these went flying out of hands into that country where they lay in the grass, waiting for the one who lost them to come looking. And they kept such a permanence in the mind, those things and people in the grass, in the Land of the Lost!

There was another state of mind that possessed me. Though I'd long been interested in Oriental religions, I was no mystic. But I now began to reflect, for the first time but not the last, on other modes of human awareness than the ordinary one, inspired by this person who, though not yet able to sit upright, still by those urgent vocalizations, penetrating gaze and arcane gestures seemed to be a traveler from another land. There was only one poet I could read in those days. Exactly as Wordsworth described, a clarity in the baby's eyes seemed to be fading daily and his present being moving away from what the poet, for want of other words, called Heaven. I watched that clarity fade into common day, though, again as the poet promised, the memory of it stayed with me and, in some way, may have with him—an intimation of natural mysteries on which we both, years later and in different ways, might base our writings.

If my first child separated me from Alfred to private thoughts, my second son returned me to him, widened my capacity for love where the first had focused it. This time, for instance, it seemed not a perversion of grace but comical to go out to dinner with gauze pads atop each nipple that still couldn't prevent them, by coffee time, from leaking enough milk to sweeten the world.

And from such sensual closeness that one could call it bliss, and such pain of separation that one could call it anguish, came a third state of mind: foreboding. I'd look into the baby's eyes still full of clouds and see the same face, aged, lined, with bitterness in its lips above a stubble of beard. I feared that what I had learned from my grandfather, my father and Alfred could be still true, that the old and younger wound one another in ways that make it impossible for love to be returned in the same pure way it is first bestowed. After a year or so, for example, it seemed to me the first child I held

in my arms with so ardent a wish to save him from pain took to wanting to hear, uncomfortably often, one story about a woman selfish and vindictive.

"What story tonight, my love, my precious lamb?"

"Snow White!"

"What, again?"

"Snow White . . ." and the wicked stepmother, I added in my mind. Never so single-minded a love had I felt for anyone, yet it seemed to me my son already saw in me someone to be reckoned with, even feared. Then I feared my fear—that it would breed the same in him—for in that way, my father whom I loved had became my enemy, and my mother, no savior. And later, after Alfred's death began to work on all our minds, I'd hear the ancient tragedies playing themselves in my mind—myself, Cassandra, foreseeing the old king's death, the children's cry for revenge, and the end of my own brief reign of unity and peace.

As well as fear for my children's future, that is, I felt it for myself. For I was now called to an identity I would have to fight for and sustain against myself: against the burden of my past and the heavy human pull to repeat it. Nothing *new* in my life had attached me hitherto. Moored like a boat to my origins, I'd been swept back and forth between false departures. But with my children, my future was born. Whatever else might happen to me, like my mother at my own birth, I'd never not be *mother,* charged to raise up lives out of but free of the past. My mother had let the charge lapse sometimes, but remembering her as she'd been in the early days, and finding her again later, I'd gradually found my way. Could I now be faithful to the power-of-life in me?

So I wondered off and on during my early years of motherhood, when I sat in an old blue bathrobe left over from my bachelor days, in a blue rocking chair with one or both

of the boys on my lap, facing forward toward the window as if I were a ship and they cabin boys on my prow.

Since my first book appeared shortly after the first baby was born, and I continued to write occasional pieces and think of myself as a writer temporarily stopped, Alfred gave me an eighteenth-century French *écritoire* inlaid with a bird on a spray of flowers. It had pigeonholes for love notes and a hole for a quill pen, but my typewriter would have crushed it, so I set up the typewriter in a closet. I bought file cabinets for my notebooks and manuscripts but there was no space in the closet so I suggested the bedroom. "Bedroom!" shouted Alfred. "File cabinets in my bedroom?" So I moved them into the bathroom.

It was his intellectual life that counted in our house. I'd been trained to respect the distant, faint sound of a writing man's typewriter and mimicked my mother in considering his work supreme. In fact, he had hopes. In addition to expanding the magazine, he wanted at last to write books. One would trace the Classical Ideal from antiquity, showing the persistence in art of the Good, the Whole and the Beautiful. Another would be a study of images in which existential contradictions are forced together: Watteau's *Harlequin*, who laughs while he weeps; the children in Breughel's *Crucifixion*, who play while tragedy unfolds; the dance melodies that wreathe the somber theme in *Don Giovanni*. The central image in that book would be Rembrandt's *Sacrifice of Isaac*. A reproduction of this frightening work hung in his room when he was a boy and taught him much, he often said, about the nature of fatherly love.

Such works were Alfred's touchstones, and I thought about them at his side, at exhibitions of art, at the theater and opera, as, I was beginning to be aware, I'd also

glimpsed them in the lives of my parents, and also my grandfather, old Shuffle Shoon, who believed in the spirit immortal.

In the upper stratum of New York's art world in the early 1960s, I myself walked in contradiction. I was determined to let my fragile newborn self shine through while also forcing it to the manners of worldly society. As a result, my behavior was unbalanced and I suppose sometimes a little mad.

Alfred's friends, clients, colleagues, the rich, acquisitive and powerful, lived awash in things, the very *matière* of high world art, in which money, the hemoglobin of our world, flowed not on or back, healed none of the low-world's anemias, but lay coagulated. Such collections, inherited or made by elderly Parisian and American tycoons, bore resemblance to those of the noble past, not the fashionable displays-for-media-prestige of today. In them, masterpieces of historic and modern art, destined to hang in museums a decade or so hence, were displayed in accurate but homey eighteenth-century French or English settings, surrounded by the paraphernalia of a bygone life-of-the-mind, from Renaissance bronzes to rare drawings and bits of Greek and Gothic carvings.

There was an Oriental degree of luxury to some of these salons dark as tents, glowing with candles in green jars, where one walked on thick flowery carpets and reclined in clouds of cushions. My eyes grew drunk as well on salons white as paradise, with mirrored walls and tables giddy with pink- and blue-figured porcelains—cups, pitchers, pill boxes, plume holders, *pots-de-crème,* and vases full of wide-open roses and anemones. There was a certain dark red room in which I sat speechless before a mantel on which stood two tulip-shaped Meissen flower vases, filled with yet more tulips bending streaked heads to the streaked marble sill. I even forgot the

grotesque manners of art dealer X when I lunched in his country house in a tiny dark-green-paneled room across whose fruitwood chairbacks danced golden reflections from the fireplace, as if we were picnicking in a Courbet glen.

When my hostess in one of these residences would appear, a satin swath reflecting light in sheets, with dyed chestnut hair in outswept billows like ormolu scrolls, to greet me with "Hello, darling!" I'd sink into complicity, the houri of my moist old longings at last. Back in the 1960s, such power-women still wore Modernistic clothes that signaled their astronomical distance from base or ethnic origins, dresses of pure shining geometry like the Seagram building. Since rigidity was the aim, the cloth was hooked by inner tabs and struts until it stood out from the body like a billboard. Only Alfred and I knew how we laughingly shopped in a Parisian Left Bank boutique for such models, which, set off by one of his wonderfully chosen Roman, Rococo or Edwardian pins, passed for an original. To the same end of armoring myself against my own awkwardness, I taught a Lexington Avenue hairdresser to build me a coif architechtonic as Nefertiti's headdress.

So set, I met the heroes of Alfred's early tales. "In this world," he warned me, "it's essential to be climbing but fatal to appear so." I was born and bred a Highlander, but among these friends of his, I felt myself too high up, awed by the view, elated by where I'd got to but uncertain which way was north, or down. Therefore I made all the missteps of ambitious country cousins, now over-bold, now crumpled by paranoia, now babbling, now dumb. At dinner, I'd lecture experts on their fields, chiding them for errors till they'd smile, treat my tirades as a joke, finally throw glances down the table at the hostess, whereafter my eye recorded every shade of their distress while my mouth kept blabbering nonsense I stored on Edisonian rolls in my brain.

Done with the men, I'd turn to the women and flog myself to say not deep but ingratiating things to them. My head whirling with vodka or champagne, my heart pounding with the Dexamil I took to keep me awake through so much food and wine, I'd burst on the consciousness of one of these caryatids who seemed to carry the sky on their heads. "Jane! What a beautiful dress! You look like a stuffed bird!" I once cried to a dazzling if desiccated heiress with hair in plumes to match her pink net dress all aruff with bits of ostrich. In my reeling mind, I saw a museum cabinet with fabled birds on ivory stands, green, bronze, golden, scarlet, trailing feathers, lifting plumes, spreading flashing wings. Jane, however, must have imagined some sleazy remnant of an old hunt, spewing sawdust, its button eyes and mouldering feathers gathering dust in an attic.

"Stuffed . . . ?" she asked in her lilting but congealing voice, "Stuffed . . . ?" peering down into my wildly staring eyes to make sure she heard me correctly.

"Yes, stuffed!" I cried, lifting my champagne glass as she moved off into the crowd, shoulders, boas, bow ties, mandibles all flicking and shining in the periphery of my vision, as I began to ask myself why she failed to accept my compliment.

That sort of thing.

I speak like a provincial, and so, lamentably, I felt myself to be. I went to every last grand party with Alfred like a beggar wanting to lift the skirts of the world and see the *mons de Vénus* of paradise. When we went to the Kennedy White House for a dinner in honor of André Malraux, I drank such a bolt of lightning before leaving the hotel that I took one look at the salon, crowded with the great, the bejeweled and the confident and burst into tears on the arm of the steward who escorted me over the threshold. That some members of the

Rabinowitz Society were also riven by confusion about their status only rarely lightened my way with humor. One of them was the Russian émigré man-about-town George Schlee, who said to me, as we sat in his wife Valentina's living room awaiting the arrival of his great love Greta Garbo, "The trouble with my friends Alfred and John [he meant Gunther, another Rabinowitz] is that they both married nobodies, so they'll be forgotten, while I have married one famous woman and been loved by another, so my reputation is enormous."

Among Alfred's papers I found minutes of a Rabinowitz Society meeting before I came on the scene. Every member contributed a maxim for the New Year. The distinguished lawyer Eustace Seligman contributed, "Go before God with justice and before the judge with money." Mary Lasker, patron of medicine, provided, "He is a fool who makes his physician his heir." Valentina, forever jealous, noted, "A wife is not a slipper, a glove or a girdle you can remove when you like." Diffident Garbo allowed, "It is a nuisance to go alone, even to be drowned." And Alfred, the connoisseur, adviser both to those who sold and those who bought, said, "For rotten goods, a blind buyer."

Was he blind when he bought me? Some might say yes, others no. He himself said both, as I did, too, from time to time. Perhaps not strangely, I felt most at ease with his English and European friends, like the old Baroness Germaine de Rothschild, wed at sixteen to the much older Baron, thereafter mistress of immense Parisian and country establishments. She had the simplicity and refinement of heart to receive visitors from all over the world, some with the flimsiest of introductions, and then mix them, so her table was a crossroads of world-famous bankers and artists, decayed nobility and poor relations from Milwaukee. Many a provincial cut his or her eyeteeth on the presentations at her table. A

dessert would be served topped by what, on tapping with the spoon, seemed a crust hard as malachite. One would feel alone in the world, testing the crust, judging how the cream below swayed under pressure, calculating the precise angle of blow that would crack the top without jettisoning the cream. I was bested by one platter, a pyramid of lobsters. I tapped with the server. The shells were hard as stone and coated with what appeared to be a ceramic glaze. I bowed to fate and asked the butler for help.

When our first son David was two, we took him to the Rothschild house in Chantilly for lunch. He played on the vast lawn, then was set on a Sèvres chamberpot and led to the dining room. We peered through a keyhole and saw him seated on a number of books at a full-size table set with linen and one service of silver and crystal, gravely watching the butler hand down a spoonful of soufflé. He sat to the manner born, awed but not awkward, fitting both the expression on his face and his posture to the occasion. If only, I often wished, I were so innocent!

We drove one time from London down to Sussex to visit an art historian and his wife, once a famous beauty but by then somewhat faded and withdrawn. We lunched in the historic castle our host inherited when he was given a title. I was enthralled as I always was listening to Alfred in his element, exchanging ideas with another scholar-esthete. Then I felt a genuine enjoyment at his side, among wise and humane people with whom not only he but I shared values. If I spoke little on these occasions, it wasn't that I felt inhibited so much as in a state of pleasurable suspended animation.

After lunch, we toured the castle. I was charmed by the old stone stairways and the combination of antiquity and modern luxury in the rooms. Our hostess's bathroom, for instance, was tucked into a corner between cold stone walls, but in it

was a marble tub with gilded lions' heads for fixtures. A tiny gilt mirror hung on a gold chain, and on the dressing table, covered with green velvet, lay a golden brush and comb.

Yet I began to have a feeling of spiritual death somewhere. The feeling came not from the two vivid men, nor from the storied and cared-for old stones.

After our tour, I sat for a while on the terrace with our hostess. She lay back in her chair and shut her eyes. A red flush showed through her powder.

"Are you happy, darling?" she asked me in her husky voice without opening her eyes.

I said I loved sitting in the sun when it came out between the clouds, as it had just then. Lunch was delicious.

Was she happy being her husband's wife? I wondered. Like me, she sat silently in his presence, wrapped in her thoughts, waiting . . . or not waiting. Alfred had told me that when she was young, she'd had a gift for the piano and was ambitious. But whatever it was she wanted to achieve, she had not. Then disappointment may have led to depression. Or else inertia led to disappointment. Who could tell? She may have seen it one way; others, another.

"Tell me a true story," she said suddenly, leaning forward and holding her hands together, elbows on her knees. "Tell me something you've learned in this world you're discovering."

"Oh," I laughed, turning in my chair. It always took me time to sort out my thoughts: what I really meant from the half-lies of habit or politeness. "Alfred tells me," I said finally, turning the question back to her, "that when you first were introduced to I Tatti, you were so beautiful you charmed them all."

"No," she said, leaning back and closing her eyes again. "I'd rather hear from you . . ."

My mind shrank. What was I to say?

In the nature of things, Alfred would probably die before me, and I didn't know whether I would be desolate or set free.

We turned our chairs to follow the sun. The terrace was bordered by roses, come to the end of their season. They dropped their heads, showing edges of brown along the rims of the petals. It was then late summer of a year we'd also gone to Istanbul. In Hagia Sophia, I'd wandered through the dank tomb of space that smelled of roots and whitewash, under blackened chandeliers that hung from the dome on tremendous wires, like wilting flowers. The stone floor underfoot was pressured by the settling of the earth below.

In light that sank through alabaster portholes, I climbed into the soot-crusted galleries where the Byzantine women, banished to seclusion, stood to follow rites enacted below by the men. There was a marble rail which still bore the imprint of hands laid down over many centuries. Standing there, I laid my own hand in a softened hollow, and, without my thinking, the other hand came over to lie upon it in an attitude of resignation, and then my body, too, inclined in a certain way, and I found myself leaning over the rail, looking down into the gulf of silence.

When I'd traveled the coast of Big Sur alone, I'd felt the power of the earth turning in space to move me to its will. In Istanbul, I felt again the power of a massive form, outside of me both in space and time, to force me to its will.

Our hostess shifted in her chair. I looked around at the rose gardens and idly, with one hand, made the gesture of strewing petals. I watched myself doing so, turning my hand till my palm was open to the sky. At some certain time to come, Kerophon's shield would lose its protective power, and this drama that held me would be over. Then all this world of conversation and castle towers, of ancient stones and gold brushes would be gone for me. And I wondered what I would have saved up from these rich days, except my sons, who,

though not with me that day, alone of all the people I could think of, at that moment seemed real. Would I only be able to say that these days had been, and then were gone? Would that be all I would know how to say?

And for me, which was the real and which the illusion? The days when Alfred and I first groped toward each other out of needs that then imprisoned us, or these days of marriage? Or another life beyond both of these shared ones, when the principal force acting on me so far—my father—would have ceased to hold me?

LOSING

When we married, the art world where Alfred had reigned high for two decades had already begun to change. Under his direction, *Art News* had been a catapult lifting the Abstract Expressionists to fame. In the advance guard of that movement, where poets, theater people, dealers and publishers mingled, Alfred, with his sidekick, spiritual son and genial tormentor, Tom Hess, had played a major role, nurturing a new mode of criticism to bring the new art to the public.

He didn't initiate me into the workings of this world, I think, because he didn't want to have to justify the sort of machinations that went on, then as now, and to have admitted certain things would have meant also admitting certain others—that he needed money, that like most people, he feared failure, anonymity and isolation.

He never lied in print, as I knew him. He attacked and praised where his conscience led. Only it often happened that, like B.B., he was led to praise where profit was to be made in terms of influence. Social mobility meant life to him. Lunch in Paris with a Rothschild, in Venice with Count Cini, in London with a Sitwell were the transcendent joys for him, for with them he expanded in ebullient self-confidence to become his wittiest, most vivid self. Why then should he have diminished himself in the eyes of O'Groats? Better to keep Norina interested and amused.

His secrecy disturbed me, however. Around the edges of our life threatening figures appeared. Though I knew few details, I was aware that gargantuan ambitions were stirred over these matters of buying and selling art. X, a dealer, was the most malevolent. In his company, Alfred seemed to shrink in size, not with fear but rather as if next to this grossly inesthetic man he became a younger, more vulnerable image

of himself. It may have been a revival of his old craven hate-love for his father, this wish for approval from a man he knew might turn on him anytime. Y was a critic who had failed to co-opt the magazine for his own promotional uses and so determined to sabotage it. Z was a man whose corrupt legal influence had penetrated many parts of the art world in the late 1960s. He would strike a blow at the end.

In fact, the beginning of Alfred's slip from power coincided with the end of the heroic phase of post-war art, indeed, the very end of the historic movement of Modernism. Was there ever in cultural history so wrenching a transit from thesis to antithesis as from Abstract Expressionism to Pop—from Modernist philosophical density to the culture of *kitsch*? Alfred's loathing for this vulgarization of the historic character of art was boundless. And promoting Pop came a new raft of characters onto the scene, bent on wresting power and money from the old guard.

Nor had Alfred been cautious. In an editorial, he baited a most dangerous adversary. A campaign of smear and innuendo followed that stirred widespread, buried resentments against him. He had always claimed a critic ought to be remembered for his enemies, not his friends. But when the art world turned into a battlefield, few of his glitter crowd of sycophants lent a hand.

And if personal attacks weakened him, the deaths of those who mattered to Alfred took a different toll. Jackson Pollock, who called himself "nature," died in a car crash in 1956. Others followed yearly. Also the old tribe of maverick condottieres, connoisseurs like Berenson, was drawing to a close. In 1963, Marlborough Incorporated, a suave combine of international dealerships, opened its New York branch, luring artists from other galleries by blandishments both aboveboard and questionable. In the next years, as sculptor George Segal later

observed, "moral sense was suspended." I don't say a moral sense in the pure abstract was operative in the old days either, but then the challenges and victories had been seen in the light of principles that ranked art and the authentic creative initiative over other things. By the new standards, Big Money counted most, and Alfred, who in his last editorials was questioning the legal basis of Marlborough's setup and advocating reform of tax laws as they applied to art collectors, was an obstruction.

In these years, he aged rapidly. Though he had sung the praises of his octogenarian aunts, he hadn't so often reminded himself that both parents died early of vascular disease. There were warnings. We spent a summer in what had been a medieval hunting lodge by the sea outside Rome. The house itself was an enormous terra-cotta block built around a dirt-floored space into which mounted huntsmen once rode to toss carcasses of their prey right at the kitchen door. Every other facility of the lodge—the kitchen now ruled over by a malevolent and superstitious Sardinian peasant woman, the bedrooms, the reception room with its flaking Baroque frescoes, the steps and fireplaces infested with scorpions—was squeezed back to allow for this gloomy theater at the center.

Alfred and I drove into Rome most days, peeling the city by layers, beginning with the Etruscan age and arriving, by summer's end, at the apotheosis of Roman grandeur: the Baroque. Or else Alfred would be writing in his room, and the baby and I would idle around in the ruins of orchards and rose gardens, whose root systems must have spread like tentacles underground. More than once, the villa's plumbing broke down and workmen came to excavate and scour the ancient root-clotted pipes.

Often that summer I felt we were moving into unfamiliar depths in our marriage. As a charm, I bought a reproduction

of Piero della Francesca's *Madonna della Misericordia,* sheltering a host of little people under her mantle. I pinned it over the baby's crib, and when I went to him at night, I'd stand with one hand on his chest and look at the painting close and long.

In fact, I was noticing the first signs of Alfred's illness, and what was then a vague unspoken worry later would become a desperate consciousness: If I know of his illness and fail to save him, am I not lending myself to his death? The source of that fear lay back in the early days of our affair. Now I'd take back the bargain I'd made then, or simply wipe it out as a past evil illusion. But the matter remained between us. Such thoughts came to me most often when I was sitting with the baby on the lawn that was only a ragged field. For then I'd have an almost physical sensation of movement beneath me, an expansive shudder of the root systems underground. I'd tighten my hold on the baby, feeling the approach of things I was helpless to control or stop.

Yet in another sense, the heart of our marriage was our next summer, in Salzburg, where I wrestled with Alfred's native German and we heard music to our fill. We had friends with whom we felt easy, musicians, art dealers, some hoydenish rich with whom we laughed. The glacial Salzach was in its summer stasis. No more did it blindly rush away as it had that evening when I'd stood on a balcony and heard it speak. In quiet waters we fished for our second child. He was born the following May, and we planned to spend the first summer of his life in a rented house in Connecticut.

But the winter had taken its toll. Alfred moved around his old terrain with uncertainty. He traveled restlessly, shuttling between continents and coasts visiting galleries and dealers, inspecting paintings for evidences of repaint or fakery, bump-

ing into old friends. But his letters were nostalgic, as if his professional world held diminishing reassurance for him.

> Even Venice, for me till now always the loveliest place, seems unreal to me, as if it were paper I could put my finger through. Today while I was in the exhibition, it became a little more real, but then it again became an illusory stage set, and I felt unreal in my whole self, so far from you and now the little boys whom I adore. Truly, there are no *places*, as I used to think, but only happiness in oneself and one's family.
>
> How much I have learned in these few years, and how much I owe you, my love, for showing it to me . . .

The summer began calmly enough. But in his illness—which I little understood, nor would his doctor until years later when the side effects of certain blood-pressure drugs were known— Alfred wouldn't let the calm continue. The country was a torture for him. Blue flies and hornets abounded. He was fiercely allergic to their stings and twice had to be put to bed with witch-hazel compresses. He was logy with retained fluids and couldn't concentrate on his work. In steamy August, my own hormones swung out of kilter as I nursed and weaned. In the heavy heat, we began arguing again. Buried resentments surged back in my mind, and my opposition stirred old authoritarian manners in Alfred. We brooded solitarily and fought when we met, saying things that were or were not meant but left their wounds.

"Why did you marry me?" I finally cried at the end of one long harangue. "To bring me out here and torture me?"

"Because you loved me," he said, struggling for a truth that would quiet us both. "That must have been the reason."

"That's a lie," I shouted. "I never did . . ."

"But you must have," he said heavily, turning to stare into my face. "You said you did . . . All those letters . . ."

"The letters lied. You should have read my notebooks . . . they told the truth . . . ," I cried.

He paused and stopped speaking, though the blood pressure still kept him trembling. "Then there's been a terrible mistake," he said slowly. "A terrible mistake."

Later on, of course, we came back together again as we always did, for nothing said in the heat of battle is either true or false but part of each. Yet something between us may have changed, for I recognized that a single truth, if such there was, was so buried in contradiction there could only be one test of it. If he died, my feelings afterward would tell the truth. If I suffered, I would have loved. And then I would be saved. For if I hadn't loved, all these years were lies, and I would create my own damnation for myself.

Or if I felt liberated by his death, in my guilt I'd find a way to destroy myself.

It was my Cartesian argument: I have loved, therefore I exist. Or, I have not loved, and therefore I don't exist. I annihilate myself.

Philip Graham blew his brains out that summer. He had bought *Art News* not long before. His visionary enthusiasm matched Alfred's, and he'd committed himself to underwriting the magazine's future. That disaster meant the end of Alfred's dream. By then the mischief makers had worked well, and Graham's survivor was not a friend. For a man of hungry ego, it would be unbearable to work for an unenthusiastic patron. The discouragement that settled on him in the next months was bleak.

In November, President Kennedy was assassinated. I refused to face the horror of it. I could not accept to be crushed by another death.

In the spring of 1964, I sat up in bed while Alfred slept, shut the book I had just finished and knew it had changed

my life. I was one of thousands who felt that way about *The Feminine Mystique.* In one breath, that angry, lucid, deeply researched work swept away ideas I'd inherited from my mother who mouthed but didn't believe them either. As if I took off wrong glasses, blurred things looked clear and clear ones were gone to shadow forever. I was wasting my life again, as surely as when I'd lingered in the sloughs.

I determined to rehone my writing tools, to write no more idle notes, unfinished effusions. I'd choose a form in which I could finish a piece every day. Because I couldn't write at my eighteenth-century desk, I put my typewriter on a card table and set myself to stay until a finished poem was on a clean sheet of paper. I wrote my sonnets, odes and villanelles, my iambs and anapests and spondees. But my mind was heavy with unexplored thoughts, and the poems were surfacy or opaque. I didn't want to expose my feeble efforts to Alfred, who would judge them in reference to Dante and Yeats. And so in secret—as how many women!—I began to work my field.

That summer we spent in a villa in the south of France, with a tiny shallow pool in which the boys could play. Alfred had aged greatly. Though he was only fifty-eight, his hair was nearly white and he couldn't lose the weight that burdened him. He tried to write but accomplished little. Sometimes he would sing German children's songs and talk about his love for the boys and how proud he'd be when they graduated from school and so forth. One day, a nest fell out of a tree and strewed four birdlings on the walk. I fed them sugar water, but one by one they died. They hadn't even opened their eyes. They squirmed in my hand, stretched out their necks, opened their mouths and clenched their tiny wings. For what, since they couldn't see? For whom, since they didn't know they were born? Some things came and went too fast, with catastrophe cutting them short.

* * *

When we returned to New York, I went back to my writing. Now at night I read over my morning's work with excitement, feeling I was beginning to move. At all costs I must protect the new life I was harboring.

That winter, George Schlee died. Alfred read a poem of Pushkin's at the funeral: "I have raised a monument to myself, one not built by hands. . . . It lifts its head higher than the Alexander column." It was no valedictory for amiable, drifting Schlee but for someone Alfred knew much better.

That January, Winston Churchill, Alfred's monumental hero, who, by an occasional nod in the direction of recognition had built his ego higher than the Alexander column, died. Alfred and I, with the two boys on our laps, watched on television the funeral barge floating down the Thames past a line of loading cranes that, one by one, lowered their heads like ancient reptiles.

I went on writing in secret, the boys were growing and Alfred was like a lost man, overwhelmed by sadness. His wonderful conversation swung off its axis. He would talk nonstop for an hour or more and would have gone on all night, it seemed, if I didn't stop him.

I, on the other hand, felt a strengthening determination that was rekindled each morning when I sat down to my typewriter, and intensified all day until the evening, when I reread in secret what I'd written.

Often Alfred grew angry with me, shouting that by my refusal to listen to his chaotic outpouring of misery I was driving him crazy. He stood in our bedroom one evening shouting, "Listen . . . I beg you to listen . . . you are driving me crazy. I am going crazy. Can't I make you listen . . . ?" As he stood there shouting, his face flushed, his eyes inflamed, his fists pounding the air, I didn't immediately remember—but somewhere in my memory there may have

come into near-recall—earlier scenes of which this was a transparency dreadfully reversed. Back then, it had been I who cried to my father for relief. Now I was the one who stood back, not moving to calm him.

In bed, he read aloud the poems he loved, only now it was forever Yeats and the center that wouldn't hold. I grew impatient and told him to stop being morbid. He took the book and hurled it across the room. Or he read *The Tempest* again and again, the ending of the revels, and shed tears, and my own defenses would crack and I would be pulled down by his sorrow.

Violence was in the air. The student rebellion was spreading. Like many of his contemporaries, like my father, Alfred had a horror of the collapse of social forms. We were riding in a taxi and stopped at a red light. A so-called flower couple crossed the street before us. The girl wore a flowing challis dress with puffed sleeves. Her long hair hung down her back. The boy's hair was long, too, and his face, young and mild. I was thinking how lovely they looked, when the light changed and the taxi began to move. It moved a trifle too fast and brushed—not hit but brushed—the boy's sleeve. He wheeled, stalked to the car window and spat in the driver's face. The driver, a friendly Puerto Rican who'd been telling us about his children, recoiled. A knife flashed from his pocket. Nothing more happened. But I came home with a sense of sick horror.

We went to Florida, always the place of reunion for me. There was a saying Schlee and Alfred had often laughed about. It dated back to old Russia, where George, according to one story, had found the waif Valentina on a train platform and brought her to New York. Later when they were often bitterly estranged, one or the other would sometimes feel remorse and have only to say, entreatingly, "Old friend from

Sebastopol . . ." for both of them to remember what they'd
meant to each other. Alfred and I said it now and, from time
to time, remembered.

Our son David began to shun his father with a child's
instinct about illness. "Your eyes are so red," he'd say, draw-
ing back, or "You're so old. . . ." But I told Alfred he must
claim the boy, so one day he insisted they go for a walk, and
it turned out the child, in his shyness, had taken along a little
book as a kind of icebreaker. Alfred was charmed. They came
back friends, and I felt I'd done something good in the way
of Piero's *Madonna,* drawing fathers and sons together under
her cape.

Alfred preceded me back to New York. After he left, I
gathered, washed and arranged some fifty tiny shells in a box,
glued them down and mounted it under glass. Then I bought
a star chart and at night lay on the sand studying the constel-
lations. To find, to fix, to know: sometimes one is impelled to
do these things.

We were planning a research trip to the Near East. We were
to be gone over a month. We would stop in Paris, then fly to
Jerusalem where Alfred was to give the inaugural speech at
the Israel Museum. Then we would push on to Teheran,
Isfahan, Shiraz, Persepolis, Baghdad, Aman, Petra, Damas-
cus, Palmyra, Aleppo, then by car over the mountains by
Baalbek, Byblos and the Cedars of Lebanon. We'd end in
Beirut and travel home via Venice, Vienna and London. Each
day a new site, an arduous walk. A hard trip, even for a
youngster.

Alfred flew briefly to California and there finished his
speech. He had worked harder on it than on anything he'd
tackled in a long time. "If I weren't so sadly alone," he wrote,
"I'd open a bottle of Dom Perignon. Love, love, love, love,

love (and if the paper were 100 times bigger there wouldn't
be enough space).''

He also wrote an editorial for the magazine, leading with
a rush of memories about the old days in Europe, such a flood
of memories, he wrote, he had to make an effort to stop their
flow.

When he returned we packed for the journey. After these
years of rehearsal, I was at last the chic wife he'd wanted. I
packed my short black chiffon dress, my black travel suit and
cottons for the treks. I was very thin and had gone to great
pains to have the costumes properly fitted.

The eve of our departure, Alfred moved around the apart-
ment as if he were pushing his way through thick oil. He
would lift his arm and slowly, slowly make the gesture he
intended. That slowness filled me with monolithic fear. When
I found him folding his dinner jacket and protested that he
needn't drag along such a heavy weight, he said darkly, ''I
don't need to travel . . . like a pariah.'' The words fell into
my mind like a stone dropped into a well, which fell and fell
and never reached bottom.

Paris in May was unearthly beautiful. The chestnut trees were
in bloom, and we saw an exhibition of medieval religious art
at the Louvre, where Alfred scrawled his catalogue full of
notes for an article. We lunched with the beloved Baroness
and there I failed the challenge of the lobster. She hugged us
as we left and told us to hurry back with the boys. We said
we surely would.

Alfred was moved to send some little presents home, a toy
squirrel for Alexy, a bear for David, a handkerchief for my
mother. For me, he bought a black-and-white cashmere
shawl. ''You can wear it to my funeral,'' he said, watching me
open the package and hold it to my cheek, and I flung it down

and told him not to talk that way. That evening, we walked arm in arm in streaked yellow twilight by the Luxembourg Gardens, and he talked of old days in Paris. "It must be terribly lonely to outlive all one's friends," he said, and I agreed, yes, it must be, not hearing he was talking about himself.

Our last night in Paris, we made love, and I had the extraordinary sensation of being knifed and having the knife slowly withdrawn so that I actually cried out in pain. That night, I dreamed I was taking our sons to meet my grandfather Munro. We were traveling a dirt road through fields, and all along the road were small piles of stones to mark the way.

All his life, Alfred had put off going to Jerusalem. It had to do with the conflict between his German and Jewish sides. He would make some bitterly anti-Semitic joke and then say, "I'm afraid to go to Jerusalem. I'm afraid I won't ever come home."

When we arrived and were driving from the airport toward our hotel, I looked out the car window and saw, all along the way, small piles of stones to mark the miles.

I went alone to the museum, for Alfred felt too out of himself to do more than work over his speech in our room. When I returned for lunch, he met me downstairs, cleanshaven and immaculately dressed, and I felt a wild happiness, thinking that the terrible gloom had lifted and he was well and young again. But by the time we went into the garden, he was shuffling and sucking at his unlit pipe and we began to bicker. He said he was glad to be in Jerusalem at last, that the Jews were the most intelligent people on earth, and I said, "Oh, I don't know . . . ," and then he jokingly called himself an old Jew coming home, and I said I wouldn't have married such a one even though I'd criticized the Germanic husband,

and he laughed, and we went walking on through the garden, our talk flowing loose and free, then into traps where there were nets and spikes and then into the clear again, until we began to climb a little hill and I saw he was breathing hard and trying to light the damned pipe. So we went indoors, and he went to bed.

I was supposed to go to a dinner, but as I was dressing, he reached up a hand and said, "I wish you'd stay with me tonight," and I said of course and picked up the phone, canceled the dinner and had supper on a tray by his bed.

Then I, too, got into bed and was reading the Old Testament, as I had since we began preparing the trip. I was reading Isaiah, feeling the weight of male suffering so thick in the room it bore down on me.

Then into my consciousness there flowed as I read a curious impression, or sensation, I can only say, as if there were a welling of *red* into my mind, so that without really being aware of it, my brain seemed to be experiencing a darkening haze. The book grew heavy in my hands. I laid it down on the covers to try to understand the ancient, eternal heaviness of the words I'd been reading. It was at that time I saw Alfred, on the other side of the bed, shift, reach out and begin to struggle as if he wished to get up. I rose and ran around to his side and tried to help him, but he began making waving gestures with his arm, and from his lips came a series of unintelligible vibrating sounds, five notes over and over, "*Vuhvuhvuhvuhvuh. . . .*"

He had always been a stuporous sleeper because of the drugs, so I slapped his face, thinking this might be the same thing, and cried, "Can you hear me?" With his last effort, he shook his head and said irritably, "Of course I can hear you." But he was falling slowly back, and his eyes were closing. I rushed here and there, calling a maid, then

the manager, then a doctor. Then I began to get dressed, very slowly and methodically. I knew it was the end. It was the end we were born for and to which we had been coming from the beginning, when I said to him, "How handsome you are. . . ."

We buried him with simplicity as Jewish law makes it easy to do. Though he himself might have preferred a Mass in a cathedral with Baroque music pouring from the galleries, or a funeral like the one a friend arranged for his mother in Venice, with black-draped gondolas gliding out to the Isle of the Dead, where he lies is the place of places I would have chosen for him. It is a small, walled-in field with ragged pines and poppies sown through uncut grass. At the time, it seemed to me a place oddly my own, though I didn't understand why. I only knew the privacy and sweet fragrance, the common colors and grey stone of a few leaning markers made a scene I remembered with a sense of fitness. Later, of course, I realized the image of the meadow served me to bind him at the end into the form of my life instead of my being displaced into his, which had been the usual style of our life together.

It was an irony that he died in Jerusalem, but there was a greater irony. He had told me his mother was Lutheran— even taken me to "her church" for the Easter services he loved—so by law he was buried in the non-Jewish cemetery. When I came home, a number of people asked why I'd done that. When I explained, they pulled their mouths down at one corner and said, How like Alfred, and told me his mother had been Jewish as Ruth or Naomi. So by his own confabulation, he lies in Jerusalem among the Protestants and Catholics, outlander among outlanders.

In any case, my standing over him in the Christian ceme-

tery was only the last of those tumultuous alternations between us that afforded first him, then me, then him, then me again the illusion of being free to leave the field in which we were joined.

I hadn't known what his loss would mean for me. But the form of my illusion showed me what the truth had been. He seemed to watch me while I lost him and drew his last relief from the knowledge that also gave it to me: suffering, I had loved him.

It was as if a presence, massive and central to my being as a tree, but also dwindling off like its branches and root system into my farthest fingertips, slowly was drawn out of my body. Inch by inch I let go my hold on the presence that had lived in my every atom. Then slowly, over weeks, new roots of my own grew down into the earth until they gripped him where he lay. Only then did I feel an alleviation and could say to him, Rest.

I dreamed of him for many years, that he was coming back after a trip. I couldn't imagine where he had been and how he survived, and I awoke with the same heavy sense I had before we married: that if he were to come, I would go to him. I simply would.

One of the discoveries one may make after a writer's death is how, in the last works, imagination understood what the conscious mind hadn't and set to work on its terminal formulation: to join the end to the beginning, closing the circle of life.

For his speech for the Israel Museum, to have been made the day after he died, Alfred surveyed the Old Testament sources for Christian art. He dwelt on touchstones: Michelangelo's *Moses*, Donatello's *David*, the *Sacrifice of Isaac*. His

hat the Mosaic prohibition against images hadn't
Judeo-Christian visual imagination. As evidence,
two passages:

His hands are as gold rings set with the beryl; his belly is as
bright ivory overlaid with sapphires. His legs are as pillars
of marble, set upon sockets of fine gold . . .

. . . And he dreamed, and behold a ladder set up on the
earth . . . and the angels of God ascending and descending
on it . . .

Reading these lines, I asked myself whether Alfred's need
throughout his life, to which I'd been no more than an out-
sider, perhaps even a hindrance, wasn't to forge again the
bond with his father. For the ladder is a sign of continuity
between child and ancestor, living and dead, and also a visual
metaphor for both memory and art, through which that conti-
nuity is made lasting.

Then Alfred was gone, and with him my life so wholly drawn
from him as well as from my father's heritage. I moved into
a smaller apartment, took over the running of three lives and
began to write short articles for publication. Yet much as I
tried, I couldn't yet answer the questions I laid on myself:
How had I got into Alfred's life and pulled him into mine?
Was I a good person or wicked? What of my appetite for
experience, for flinging back the door of the bathroom and
joining the gods in the showerbath under the light of the
washbowl bulb . . . for reaching out and asking, "May I touch
that?" and hearing a gentle voice say, "Yes . . ."

Were such desires proof of my grasping nature, having
brought me to such trouble, in which I caused pain to others
as well as myself?

Also, how could my father have acted as he did if he

loved me and if, as I believed, he was basically a kind man? How can the good cause havoc, the loving, pain? Is there a means of retribution when it has to be made too late? Such questions were, of course, but shadows of questions people would be asking for years to come regarding the historic decades past.

I wanted to begin exploring my life in writing and would soon write sketches of the more understandable ones in my family, Shuffle Shoon and Amber Locks. But I couldn't think how to confront the two Jehovahs who hung in the skies of my imagination, their white hair flowing east and west upon the wind.

My confusion was reinforced in the late 1960s by the feeling I and many others had of a world falling into disorder. The summer of 1969 I took the boys to Cape Cod. Our house was in the pine woods, lovely by day, with a view down to the dunes. But at night the place was aflame with my own anxieties breaking out. Mark Rothko was a friend that summer, or as much of one as he could be, entering his own outer dark of drugs supposed to help but killing him instead. Once, weaving on his feet, his eyes filled with tears and fog, he tried to tell me the difference between then and now: "In the old days, people would come to your studio with a look in their eye . . . looking for *experience*! Then buying and selling a picture was a real *trans-action*. But now who cares?"

So much seemed to be slipping through one's fingers then, children growing, slipping through and running . . . old people retreating, holding out their arms, sighing . . . marriages breaking up, kids going on drugs, singles in haphazard beddings . . . and then gone, the knowledge of who one had been in the beginning, and an understanding of why one had left that person behind . . . all gone, along with memory of those few extraordinary moments that, at the time, had

seemed to give all the others their meaning: *experiences* . . . what the artist called *trans-action*s . . . what I in my old-fashioned evangelical daughter's daydreams had called *love.*

The summer I spent in the woods, the Cleveland household was sold. My parents were ready to move to smaller quarters. Dad had wanted for a long time to sell and live shallow. Anything would suit him, he said, a shack for his books, his records and typewriter. Mother was worn out by physical labor. Therefore on a weekend in May, we four offspring joined our parents for a final distribution of possessions.

Like my mother I'd been unable to believe I could survive the dismemberment. But this time, the old house didn't fill me with sadness and guilt. It was just an old house, much of it in disrepair. Paint was peeling from the porch. Grass grew thick against the foundation. Daffodils shot up unplanned from piles of leaves. The old neighborhood atop Cedar Hill, lovely as it still might look from the outside, was no longer secure on its highland crest. The houses had been designed for more stable times, with unbarred cellar windows, French doors letting onto gardens, thick hedges crowding the front entries. Their upper stories still rose over the trees like castle turrets, and their windows still caught the setting sun. But now, when the wind blew at night, the sound of branches scraping glass raised fears of burglars.

Sometimes, sleeping in New York, I saw those houses in my dreams. But I saw them drained of their onetime golden light. I stood not on their level but down below as if on the plain, looking up to see them abandoned, ruined and hollow, in woods that had grown up the slopes of the hill to engulf them.

For long years I'd been bound in my father's attitudes, drawing them onto myself, reading his will, his anger and

depression in reference to my own struggle for independence. But along the course of my life with Alfred, I'd left off trying to disentangle myself. And now there were my children whose very names were in-binding: the Judeo-Christian David and the Hellenic-Scottish Alexander. So that once I was in the old house and faced with leaving it forever, the conflicted middle years fell away and memories of what we had been came back to me. There was a form that bound us. That form was of my father's projecting, he who so lived for the idea of family. The form had infused the house. Now the house was failing, but the form, I felt, would endure.

It rained those first few days, a thick Ohio rain that slid off the gutters in sheets. There'd been cold springs when the tulips came up hard, like knots of color, not opening, just sending up, tilting over and dying. This year the earth was wet and warm. There would be blooming.

The week of packing was chaotic. House plants sprawled out of their pots, scattering leaves over the African statues. Torrents of books were pulled off shelves and packed or given away. On the dining room table stood chinaware and glasses for the antique dealer: cut-glass sherry glasses, burgundy-red water glasses, blue Mexican glasses, glasses painted with daisies for summer suppers. The rough Japanese pottery un-packed from huge wood cases when I was a girl stood next to Spode service plates with dark blue rims. There were brass candlesticks and the Russian samovar. Things were coming apart under our very eyes.

Up in the attic, under the eaves, where in other days the rain battered and I had looked up to hear Pearl Harbor was bombed, the shelves were bare. The amethyst crystal was gone, the paleolithic stone tool. Gone was my grandfather's Indian skull, brought from Nebraska, that rattled when we picked it up to peer into its eye sockets and the wormholes

of its sinuses. Gone were the records of jungle drums and jitterbug tunes, gone the cedar chest with a white pussy-willow silk wedding dress, its hem sewn in awkward scallops.

I found myself continually reaching out for things: my grandfather's pocket knife; a leather Bible; an *Encyclopedia of Religious Knowledge*, 1837, with lists of Christian missions around the world, including China. "You are the most taking person," my mother said, and I looked quickly to see if she was angry, but she was understanding. It was my own letters home I was gathering up just then. Was I unreasonable to take them? My sisters seemed to let theirs go lightly.

The last afternoon, it became a compulsion of Mother's to terminate the garden. We worked as if for a single season. We tied up the daisies, the phlox, then cut off their heads to force a second blooming. We cut off the pods of the columbine. We trimmed the rhododendron, the hawthorne, the Rose of Sharon with its blue flowers like wrapped paper, the deep blue-purple monkshood, the nicotiana, sweet at twilight. We watered the carpet of forget-me-nots, the red and white petunias. Roses were pushing forth, shell-pink and purplish. Aphids rained from the elm tree.

At the day's end, exhausted, Mother lowered herself into a chair, leaned her head back and closed her eyes. Then she opened them, leaned forward and clasped her hands on her knees. "I wish I were starting life all over again," she said. She bowed her head. Tears filled our eyes.

That last evening we sat on the floor and opened a suitcase of letters handed down through our father's families. We sorted through them in no order, not knowing name from name. There was an older Alexander, an older Thomas and one with the name Americus Vespucius Spaulding. We read and caught the scent of puritanism, goading the conscience, lifting the sights, but at a price. We caught a drift of themes: people traveling west, struggling with loneliness, succumb-

ing, punishing themselves, pressing on. In their simplicity, the writers dwelt on physical details such as the manners of deaths by falling into snowdrifts or over rocking chairs. The starkness of their diction had the effect of displacing our ancestors into some region vast and emotionless, as if among the stars. Only once did I feel the distance spanned by a feeling familiar to me. A young girl had died, Flora by name. "She was the darling of my heart . . . ," wrote her father.

As we sat there reading, suddenly my youngest sister asked about our other family, our mother's relatives, who we had known for some time now were both Catholic and Jewish. That knowledge shared among us siblings, though never talked of with our parents, had lost its sting but the fact of the long lie still saddened us. There were no mementos of Mother's family in our house save a few photographs.

As we prepared to leave I kept waiting for an epiphany, a moment or word that would signal the end of the house and illuminate all it had been for me. But there was none. Each of us bowed a head, turned aside and let the others go. The only sign of finality I carried away with me was this: When I walked in the garden for the last time in the morning under a light drizzle, the parrot tulips streaked red and white had stretched back their petals. The blooms hung there finished, relaxed, spent. A spasm that had taken the whole long turn of years since the end of my childhood to finish had at last caught the garden, distributed the seeds and laid it to rest.

Our parents moved into a little house by a tidal canal in Florida. There they settled with the piano, the books, the works of art that remained, and the professorial desk with its boxes of paper, magnifying glasses, eyeglass-holders, scissors, pencils, pens, penknives, rubber stamps, stamps, rubber bands, paper clips of various sizes: a Darwinian counterpoint

of equipment laid out in descending orders. Here my father
set out to complete his oeuvre.

His formidable and still influential *Evolution in the Arts and
Other Theories of Culture History* had appeared in 1963, dedi-
cated at last to the memory of his father, who "introduced me
at an early age to the wonders of evolution, and later to the
Spencerian philosophy." Here he argued that the arts, like
plants, animals and human social relationships, evolve
through ascending and descending historical sequences, most
often—though not always—in the direction of greater hetero-
geneity of form. He described these processes in Darwinian
categories: "descent of styles and traditions," "complication
and simplification," "adaptive modification," "catastrophic
regressions . . . and destructive types of devolution." In
accord with this principle, he referred to the arts—not with-
out a touch of self-mockery—as "psycho-social technics."
Indeed, an honorable effort at perfect objectivity permeated
the work, in which he made an indirect plea, through the
many-sidedness of his argument, for it to be read with like
objectivity.

But the argument into which he had stepped so many
years before in writing *Scientific Method in Aesthetics* was
too deep for genteel scholarly exchange. Throughout this
century, fanatic anti-scientism has run side by side with
Modernist naturalism. As far back as 1914, the British art
critic and Formalist Clive Bell fulminated, "to criticise a
work of art historically is to play the science-besotted fool.
No more disastrous theory ever issued from the brain
of a charlatan than that of evolution in art." Now certain
philosopher-estheticians my father most respected seemed
not to have read the book they put down on the very
grounds he had sought to build defense against: that by
"evolution" in the material aspects of the arts, he meant
inevitable and continuous increase of esthetic value.

Standing against the back of a chair in his Florida house, the scientific materialist in his seventies returned to an old theme.

"The only important thing," he said, "is to decide whether ultimate reality is mind or matter. You have to take a position." The statement was loaded. He detested and refused to engage in any discussion of disembodied spirit or mind.

"But," I stammered, "the new physics . . . some people think . . . matter and energy . . . interchangeable . . ."

"Logical impossibility," he said, holding himself rigid. His boyish face with the clear wide brow was drawn into a mask. "Are you trying to tell me all physicists are Transcendentalists?"

"No," I muttered, my brain filled with white light which at such times made it impossible to think. "But philosophy today, as I understand it . . . not concerned with issues so vast . . . instead, epistemology, political forms . . ."

"Philosophy is in a state of decay," he said gloomily, ending the conversation. "Sickness. Caused by all this talk of politics and war. I belong to an older generation. We wouldn't let ourselves be distracted from the deep issues by trivial concerns."

I told myself he should have lived among the Encyclopedists or in the England of Darwin or Macaulay or Leslie Stephen; that he'd been misborn into an uncongenial time and his mixup was due to this. For he was always encouraging us children, urging us to get busy along lines he understood. He sensed the Women's Movement coming and urged me to write about women, but then laid out the inevitable categories: "Courtesans and queens. And philosophers."

Just as in our youth, he was forever pointing with his cane. Get going. Move west. Don't waver, drift or hesitate. Life is wasted or used, evil or good. There is one path to the promised land. And to tell the truth, in the end he brought

us with him. My brother became a respected professor of Chinese philosophy and my two sisters, a family psychologist and a sculptor respectively, while the bonds between us, and between each of us and our own close families, have held. Under the generational and cultural turmoil of our lives together, there'd been a routine, day-by-day faith in us we grew strong on.

However, to work on while the universal audience he'd hoped to reach decade by decade disappeared to follow other movements: such was our father's fate as he set himself to complete *Form and Style in the Arts*, then begin his culminating work, on value, which he would leave in unfinished drafts. For how could a Pragmatist end a book on value? It would have meant balancing the equation that dogged him all his adult life and still does the world: between individual values and ideal forms of society, art and the creative life.

Such a paradox he was even as he wrote on his beloved *Form*, this precisely reasoning, intellectually concentrated man in his seventies! For the structural outline by which he ordered his material was but a sort of mesh behind which was backed up a whole Gulf of Mexico of impassioned knowledge of his subject that came pouring forth in thousands upon thousands of words of analysis purified—by self-imposed rule—of the least taint of subjective commentary. Yet wasn't "art" the field in which his deepest bonds (with his mother, the friends of his youth, my mother) were memorialized? He'd spent his life discovering the connective themes in it. To live in contemplation of it was, it seems to me, to hold in existence all he feared to lose.

Now, as the flow of his meditations widened and thinned, moving ever farther from its source—perhaps those little cut-paper Indian forms he'd labored over with his mother—it devolved into such general ruminations as

No cultural synthesis can be fixed or final while life remains dynamic. All are unstable and contain the seeds of their own partial disintegration as life expands and outgrows them. But modern Western civilization understands and accepts this fact, whereas previous civilizations tended to hope for a final perfection . . . or at least, an escape from endless striving.

and finally cast up a premonitory vision of a mode of art that would in fact come into being in the decade after he died:

Works of art more complex than any yet achieved . . . produced by designing large, inhabited regions containing many cities, into unified spatial forms. . . . The limits are not inherent in the nature of the design, but in the tastes and desires of human beings.

So engaged, for a while he seemed serene. Twice a day the tide turned in the canal. The wind blew against the flow, and the surface was ruffled and opaque. The wind shifted, and the water lay open, transparent as glass. The palms rustled and on the high wires, cardinals and mockingbirds sang. He trained a cardinal to eat from his table where he scattered grain each morning. It was a mild behaviorist enjoyment. The cardinal had no argument to make, so the teacher withheld no grain.

When I came to visit, I'd think of golden and red late afternoons of antiquity in the Roman campagna. The early years of the 1970s were passing and my parents were like the old Romans in their umber villas, living out the decades while elsewhere was insurrection, history moving toward a hinge. So, too, our family in Cleveland had been absorbed in its own life of the mind, while holocaust had swept the world beyond.

One of the last things he wrote during this time that admakers call the Golden Age was a study of medieval esthetics. After

his death, I read this curious piece with its tentative probes into subjects long anathema to him, with the same pain with which I'd read Alfred on the Old Testament.

In it he fought through the old argument between spirit and matter that was the basis for Jewish and Puritan rejection of the visual arts. He traced Byzantine and Gothic styles and lingered over voluptuary descriptions of mosaics, gold and silver, rare woods and ivory, and marbles.

Then he went into the old principle of hierarchy, symbolized by the Tree of Jesse and, in social practice, by medieval tables of consanguinity, which determined who might marry whom and by whom inherit land and title. As the tables suggested, "one should obediently accept the status into which one was born. Any attempt to rise out of it or to change the hierarchy was sinful." I took that thought to mean that, despite his break with his parents and his early progressiveness—maybe even despite his marriage and his children's existence—my father's basic loyalty had been to the principle of blood continuity among the generations.

Finally he quoted Abbot Suger on the spiritual function of Christian art: "The dull mind rises to truth through that which is material, and in seeing this light is resurrected,"— and ended with Dante:

> Forth from the last corporeal arc we come
> Into the Heaven that is unbodied light,
> Light intellectual, replete with love,
> Love of true happiness, replete with joy . . .

Beyond these visions explicit and implicit, I wondered when I read that essay, with its talk of radiant gems and celestial fires, whether my father knew that from the same sea of symbolism, his Celtic ancestors took the idea that when a clan chief approaches his end, yellow, red and orange lights may be seen in the sky.

* * *

For it was death he now had continually on his mind. His atheism—or the fractured geometry of the imagination his atheism was a feature of—began to engender in him a mortal fear. Once, speaking of Alfred's death, I remarked to him that there was one thing I'd drawn from it all. I now was not afraid to die. My father was standing with his back to me but whirled, looked straight into my eyes and asked, "You're not? You're really not?"

He would hold on to everything, the paper clips and pencils, eyeglasses and rubber bands. The books. He had Mother on her knees beside the bookshelves for days, making lists to be checked when a visiting child wanted to borrow a volume. Sometimes I'd be irritated by this holding on to possessions. "I think," I said to Mother one day, "that whatever a person really wants, he should have." From behind me where I didn't know he was standing, sepulchral, came his voice: "I wish you'd tell that to the powers-that-be in the universe."

Death began to stalk him. There were times he'd fall into a silence of stone and not break it even when my children came running up and asked him to tell them stories. He'd sit mute with his arms close to his sides as if they might divert him from his single aim of keeping calm in the face of onrushing disaster. Other times there came from him a near unbearable sense of regret for hurts exchanged, so that no amount of loyalty we protested seemed to lift his spirits.

Sometimes when I visited Florida those days I'd put a typewriter on my knees and take notes as he talked about his life. It was a mutual service. I was gathering material I'd use one day and also letting him walk forgotten paths. He looked back over the years and forgave his father the failure that had weighed on the family, because he'd been very poor in his

youth and had to work hard, without encouragement. He recalled early friendships. "Having got so solemn in my old age, it's hard to believe we had such good times," he said. He spoke again about friendship, the "friendly exchange," "friends talking," and seeing him so vulnerable, my last anger was washed away.

For he was by then the loneliest man I ever knew. Save for these evoked reminiscences, he had shut the door on his past, seemed unable to find solace in his grandchildren, and whatever agency of a free imagination might have provided him structures of existential relief—real or illusory, what difference would it have made?—had been for fifty years forbidden to stir.

We walked on the beach. He had lost the power of easy communication and had to have a topic given him. So I chose a "topic of our walk" each day, each day another philosophy of one school or another. I didn't need to discourse myself, nor could I have. It was enough to prod him.

"Contemporary philosophers," he said, "don't treat the perennial questions. They think my ideas are blurred. They look for sharp, small answers to small questions. I have devoted my life to the wide, unfocused ones."

What does it matter, I thought at the time. Now there was only one question that weighed in the air:

Where do the dead go?

Yet he was a human being. Therefore there must have come a day when his empiricism seemed insufficient to his longing for a form of extended existence. And then he revealed himself in what I took as a breathtaking reversal of point of view.

We walked on the beach in a season of red tide. The sea that day was a charnel house. Even the spray carried invisible infection. A wave broke and released a gas. We sneezed, and our eyes burned, but we walked on, through heaps of

rotting sheepsheads, cowfish, eels, sea snakes. To my left under the waves, minnows dashed by. I lifted my hand in the sun, cast my shadow over the water and—flick!—they disappeared.

A grey wind, harbinger of storm, blew against us. We turned and walked back by a stretch of tangled beach grass interwoven with dark red flowers.

This time while we walked, gingerly, almost shyly, speaking with great simplicity, he advanced an idea. Would I find it ridiculous? was the question he meant to ask. Would I find his talking this way scandalous?

"Many of the great ones talked about the immortal soul . . ." He looked at me quickly, looked away. "Epicurus believed . . . he and Lucretius . . ." He walked slowly now, prodding the sand with his cane, clearing his throat, coughing. "They had a conception of the gods, somewhat like those worshipped by Homer. But different . . . not immortal . . . they *could* die but arranged their lives so they lived on indefinitely . . .

"They lived in far-off regions between the worlds. They were made of matter, not spirit, for spirit does not exist.

"Their lives were long and devoid of anxiety. There were none of the evils for them, not war or oppression, cruelty, poverty, robbery, anger, envy, disease or pain . . .

"Neither heaven nor hell existed for them. They felt no compassion, because none among them needed or desired it.

"Somewhere off in their corner of the universe, between the stars, they live, the gods. Huge beings, yes, made of atoms, enjoying themselves, not interested in us . . . So thought Epicurus, and Lucretius, who dedicated his book to him."

That conversation cast a light across my later life. For I began to awake to an extraordinary recognition, which I little

understood at the time though took in as I walked, so moved I couldn't speak, not knowing whether I was feeling pity or relief. For I felt a will beneath his words and asked myself continually thereafter: What did that shift to a meditation on the gods, by one on the edge of dying, mean?

For a while, he retained his memory. Like his father in old age, he recited poems. One day walking with Mother, he began *The Rubáiyát* and went on through many verses, now walking a bit faster, even swinging his cane as he used to, walking and reciting the lines that were a remembrance of youth for him, until he came to the ones that spoke of the philosophers—

> With them the seed of Wisdom did I sow,
> And with mine own hand wrought to make it grow,
> And this was all the Harvest that I reap'd—
> "I came like Water, and like Wind I go."

—when he stopped, took account of where he was, and turned to her with his face wet with tears.

Or he'd talk in aphorisms and parables, hard for us to follow, as if he couldn't express his thoughts directly but had to work around them. He spoke of slavery as he often had, defending the system as it existed in the ancient world as an alternative to execution. "Slavery was not wholly to be denied . . . ," he said gropingly, trying to frame a thought he knew I'd reject at face value. Yet I pondered what he meant and later felt I understood: no one can escape slavery to blood or conditioning. He had never escaped his. I understood. How I understood slavery! I'd spent half a lifetime in devotion to the state of mind he opened me to when I was a child.

If I would have been strengthened by breaking with him long before, it was not the road I took. So be it, I thought.

I am my road and have to find my meaning in its turning. All who love the past are its slaves to a degree.

And then there was the fact that he was dying, slave to the body corruptible.

His suffering increased. There came before long a period of organic disintegration. His mind eroded, the higher faculties he most prized going first. And as these went, ancient forest fears and visions became real to him.

He'd shored himself on his assurance, following Locke and Hume, that gods and demons had no existence since the senses afforded no evidence of them. Now his mind released visions of a kind our ancestors may also have "seen." There were faces in the trees, figures in the window. It wasn't, as Yeats wrote and Alfred felt, that the center didn't hold. My father's center held. He was, he saw. But what he saw was not what others saw.

Wasn't there some dreadful revenge being exacted here, I asked myself, by the primitive against the hyper-conscious man who all his life denied the existence of the unseen?

He became death-in-life, the very crossroads. Now he lay open to self-examination, performing an autopsy on himself. Stripped of the repressions of a lifetime, he began exposing buried attitudes that had sucked at his roots and destroyed his peace.

"Whom shall I marry?" he asked me, not knowing who I was. His face, tense, still without lines of age, leaned close to me. His eyes, watery, fearful, peered into mine.

In anguish, scandalized by my criminality, I was led to follow the thread for a minute.

"What about Lucile?" I asked, my voice shaking with remorse for deceiving him. Like Noah's child, I could die for this crime.

"Well, for one thing her beauty is of an unusual kind . . .

she isn't like others . . . Would it be a terrible mismatch?"
he asked me, his voice nearly breaking with apprehension.

"*Why?*" I asked, frozen to salt.

". . . someone of that *national group* . . . ," he whispered.
"Our *daughter* . . . she'd inherit the qualities good and bad . . .
Would you, for instance," peering into my face as if of a
stranger, as if his life depended on my answer, "would
you have us to your house? Would you take us in as
friends?"

In a rage, I turned away, wanting to cry out to Mother,
"Throw him away! He's worthless!" But I turned back, driven
to ask one more question, the question on which suddenly
everything seemed to hang, that if answered one way would
explain the mystery of why they were together, or if answered
another way would explain why Mother too lost her way and
he and I had had such conflicts: "Did you love her, love
Lucile?"

He stiffened and said, "Love . . . O love. That's a big
word." And those veils closed forever.

He had a final loss of control and was taken to the hospital.
There I came to sit with Mother for several days. Much of the
time he slept, waking to drifting confusion that seemed now
to be his full knowledge of the outer world.

"I've lost the thread," he whispered in a voice wavering
between anxiety and resignation. "What is the meaning of
this?

"Strange that all this should happen on your only visit."

"But I've been here many times," I said hesitantly, holding
back at last from opposing one truth to another.

"None so strange as this," he said.

In a hospital, one waits. Waits for birth, for healing, for
death. Time passes. Nothing moves. Sometimes it seemed

nothing would ever move except time. And when time was up, he would die.

Then, to my eternal relief, he rose above his fear.

What is the meaning of this? I asked myself, sitting in his curtained room watching his wasted frame on the bed. For two days, he had refused all food.

There at the last beach, he exercised his final control, even over our mother, who, knowing there was no hope, still kept on trying, out of heartsick momentum, to feed him. But his uplifted hand, Byzantine, palm out, fingers slightly bent toward the palm, moved away the proffered spoon. By that solemn gesture, he assumed before my eyes an existential dignity.

That refusal was his benediction on us all. Valorous, still reasoning, he accepted the necessity of death, and left with me forever the memory of him as teacher of the way to go.

PROCEDURES
OF THE
IMAGINATION

In New York, as I said before, I received the phone call reporting my father's death on Easter Sunday. We'd planned a child's birthday meal for that evening. There was no possibility of my going to Florida at once, and Mother was well cared-for, so, though my heart was heavy and the children were silent and stayed close to me, it seemed unreasonable to put the gathering off. Therefore around seven in the evening, our close family was in our dining room.

I should say I've always had in the back of my mind the crazy notion that the dying can send a message to those they love as they breathe their last or else after the spirit has left the body. Therefore all day, after the morning phone call, I'd been half-waiting.

Vaguely, I thought that since my father's intelligence had been so disturbed when he died, he wouldn't be able to send the message right away, but that he would regain that power after some time, however long *it*, whatever *it* might be, would take. From Dante I now take the figure: his evaporation from the corporeal into unbodied light.

I should say, too, that we're a book-loving family and our apartment is filled, floor to ceiling, with books in orderly shelves, the accumulated libraries of various ancestors. In all my life, though I've heard of its happening, I've never seen the following thing happen in my, or any, house, to my or anyone's books.

The lights in the dining room were dimmed for the birthday cake to be brought in, when suddenly a book shot out of a shelf. When I say shot, I mean just that. From a shelf near the top, a book wedged tightly in between a row of others shot out a good foot and a half, plunged in an arc through the air and landed with a crash in an empty wine cooler at a distance.

We all cried out, pushed back our chairs and leapt up, and

my elder son, who was acquainted with such matters, cried out, "Poltergeist!" I grabbed the book and looked to see what it was.

It was *The Darkening Green: Message from a Vanishing Generation.*

I held the book tight. I was certain it embodied a message. But what?

Then I was struck by a wave of purest relief. I had the absolute conviction the suffering individual my father had become in his last years had simply blown off like a shell, and that from somewhere, released, capable now of precisely this antic gesture, he had flung me an arrow across space/time and the border of life and death.

No one at the table said more about the event. I'm sure it was forgotten by them, and I was embarrassed to announce what I'd thought. Indeed I accepted that my interpretation had been forced out of my imagination by the power of my need to claim my patrimony: my father's appointment of me to get him right.

I had conjured him back, bent him out of the trajectory of his flight, to say to me, What I preached was not true. In some way, I still live. Therefore, from other things I preached to you, you are also set free.

In the past, he used the power of the love he fostered in me to bend me toward what he wanted me to be. Now I could go my own way. What might I become?

Soon after his death, we moved to Cape Cod for the summer. I'd by then been remarried for several years, to E. J. Kahn, Jr., the peripatetic writer, dedicated family man and entrenched summertime Cape Codder. We'd met in that place by arrangement of friends, and our meeting soon led to a resettling of both our lives. Each night of that first August, we'd placed candles in bottles around a rug on the floor,

stepped into the ring of fire and made love in the middle. On our wedding day a year later, my father, looking like the Ancient Mariner, had moved to bind me back into the structures of his own life by saying, when I asked for his blessing, "Yes . . . well . . . never mind . . . *it's destiny,*" but I rejected the claim. Jack is unconflicted about his heritage and takes an open pleasure in people and the world that enhances my own. So my very young boys became part of an extended family, gaining a father who had already, with their mother, well-raised three older sons, and we moved into the productive years of a shared life. We joined hands with the generations. And save in one respect, Jack has never imposed his mentality on mine: he has never let us not come back to Cape Cod for the summer.

That summer of my father's death, therefore, I set up my usual work place in the Truro pines and unpacked my notes on the missionaries. But this time, my mind kept turning elsewhere. I looked out my window and saw new growth everywhere, branches coming knobbing out of the stumps of trees I'd cut down the year before, grass pushing forth in waves across the dunes. At first, I took little comfort from these signs, for my father had been hungrier for life even than the grass, and I couldn't say to that vast impersonal tumult, Stop, while I get it into my head what it means to be without being. Nor, since he'd taught us to eschew wishful thinking, could I say to myself, yes, assuredly we'll all meet together one day on the heavenly mountains. Still, some change of mind was coming.

I reflected that a parent grounded in outmoded ideology is like a Stonehenge in a field that wants to go back to nature. Though my father was gone, the ruins of his philosophy were with me still. Though I disbelieved in the literal applicability of the vision to the present world, I knew I was bent by its geometry. I had struggled in its apertures and closures, now

apostle, now apostate. As a writer I craved to give formal order to my thought and experience, believing with the Modernists that content reveals its meaning through the grammar of form. So had my father believed. But he'd gone at the job backward, I now considered. The problem isn't to impose an ideal form on things but to find and express the form in them. A different, stranger form is in the actuality. *Sapere aude*, again.

Now cautiously, I moved away from the old place. I felt my mind ready to lead me to unexpected meetings. It was as if my imagination were a snake and my self an egg it held in its mouth to carry to a new location. Or as if it were the point of an arrow or a bird's beak drawing the rest of me, the feathers, behind it.

At first, imagination drew me into what felt like my father's very space in air. I felt his pain at leaving us and what might be his astonishment in coming back. I looked through his eyes at the ocean, at clouds like fishes' bones, at my sons playing in the surf. Circle after circle of the natural world seemed permeated with his personality. A mocking bird somersaulted on a tower as if in salutation, a cardinal spoke from the housetop, a pheasant with a red comb stalked my door. I heard my father's voice in these carnival birdsongs. Despite myself, a mystic sense stirred in me. I listened and saw, not believing yet believing, and cheered.

And why, I asked myself, had I to stop that motion of the mind and call it "superstition"? Pantheistic thinking, a self-indulgence my father guarded himself against and would have trained me out of, seemed instrumental in reorienting my mind after the event of his death. To personify nature, I considered, could be a natural inclination even hinting at bonds not yet understood between the natural background

and ourselves. I heard my grandfather's voice in the creaking house and glimpsed my absent mother in the green pine tree, in the boughs of which I heard a chicker of birds even as I wrote my notes. The house had windows that filled up with tears, the sky grew an eye that shone on me in bed. When real eyes close, I said to myself, the world's eyes may open.

As I was ruminating that way, my mother in Florida made a decision to bury Dad's ashes at the foot of an orange tree they'd planted in their yard, which faithfully had put forth abundant white blossoms and fruit. A couple of us offspring agreed, a couple were indifferent, but one day we four flew down, our brother brought out from the cupboard a tin box, we folded back the grass and each of us in turn took the trowel and shook our father's ego and vision, his passion and melancholy into the ground and covered them up with the turf.

> (And this reviving Herb whose tender Green
> Fledges the River-Lip on which we lean—
> Ah! lean upon it lightly! For who knows . . .)

Then we flew back to our own homes, waiting for the elixir that seemed to have drained out of the world to come rising back into it. But our mother was immobilized, cut off from her root in their shared life.

Eventually she decided to come north and boarded a plane. It took off and climbed till it reached cruising altitude in the blue that rings the world around. There it leveled off. She then leaned against the window and for the first time began to cry.

Then suddenly she had a vision. It was so sharp and brought with it such a swelling of sensation that the plane seemed filled with perfume. The vision was simply of the dogwood tree back in the Catskill mountains under whose

leaves she had been married nearly fifty years earlier in the presence of their joined families and in whose shade her own young family had later played at being in Paradise.

When she told me that, I realized the return of the ashes from under the orange tree to their place under the tree of memory was something she couldn't live without, so imagination provided it for her, as imagination at last returned my father through his voluminous readings to the gods between the stars, and imagination returned my father to me.

I would watch others go through like procedures. My son Alexander has an artist's nature, as his brother David has a philosopher's. One of Lexy's earliest works, made when he was only five, was a painting he called *Ancient Relics.* On a canvas board, he laid down first a monolithic shape, then rubbed it off with turpentine—all the while impelled by his own fierce intention—leaving on the surface only a skein of rosy light, upon which then coalesced many radiant globules of pure pigment squeezed from the tube. Then he, whose father died before he knew him, gave the work its title and so took permanent possession of that form-in-the-mind.

Also I'd watch David—the one in whose infancy I could only read Wordsworth and who as a boy read aloud, by his own choice as we drove through Scotland, "Tintern Abbey" and "Ode on Intimations of Immortality"—seated in the grass before a paint pot and a slat of plywood composing a motto to stand in his vegetable garden. When I looked to see what words he'd chosen, I saw they were the very ones his grandfather had stopped over that day walking with Mother and wept: *"With them the seed of Wisdom did I sow."*

In these instances, too, imagination (foraging backward to fulfill itself forward) had been at work giving structure to the life (in these cases the life-to-come) and drawing it into the flow of common experience.

When the procedure is completed and the form in the memory is joined end to origin, then that coil of association takes on a stability, call it even a subjective immortality, which may outlast the ruptures of actual life. It was that will-to-form that drove my mother to the piano all the days she was able, daily to restore her bond with a girl on a piano bench in Alabama dreaming of flight and eventual happiness. An artist herself, she nourished herself on such forms-of-return to survive, alone of her generation, into old age, when she grew expressive, soft, and original, and I gathered in her wisdom as if I were taking, at last, the full blossoms off the tree.

I began to remember times in my own past which, returned to, acquired that expansive power, as when I stood at my father's knee on the High Rocks, or drifted at night on a line of gold light under the bathroom door, or watched widening circles of waterlight move across a Venetian ceiling, or lay in a ring of candle-fire. The astonishment and beatific tranquillity that follows on such moments fixes them in the mind as moorings to return to in times of turmoil or fear. Such are the glints of forms that are *in* the life, germane and particular to each individual because truly *of* the life.

At the end of that summer, I returned to New York and sat down at my typewriter. Then it seemed that in my very arrival at that place, seated with my hands on keys, there was visible a corner of a design whose totality wasn't yet clear to me.

At first, as I said earlier, my writer's ambition swelled, and I envisioned a universal history in the manner of Proust and Joyce. Then I scuffed resentfully in Gosse's shoes for a time and finally picked up Willa Cather, who confessed that "mental excitement was apt to send me with a rush back to my own naked land and the figures scattered upon it . . ."

It was a clue. I began to look to my ancestors. I followed their linked courses west across seas and continents. Gradually, I began to see them clear, as if I were a child again shouting, "Daddy, watch me fly!"

I parted the clouds over Nebraska on a tempestuous day in March of 1876. I saw wind sweeping a sea of mud and a little family of homesteaders struggling to pull their wagon over a swollen stream. I saw a bearded man, muscular, not young, lose control of his team. The horses slipped, the wagon lurched, and icy rain lashed the interior, drenching his little daughter, dying of a mastoid infection. When the wagon jounced, the pain in her ear was like a knife being turned in bone. Then the rain, and the creaking of the wheels and harnesses, and the shouts of her father, couldn't drown out her shrieks.

When she died a month later in the family's new homestead across the Platte River, her father took her to a cemetery just staked out two miles west of William, in Montgomery County. Since the place was too new to be marked on maps, he wrote the directions with a stub of pencil in his notebook.

"I did this," he wrote, "so she would not be lost in the new country."

She was not lost to me.

I could save her from being lost forever, and I knew the exercise pertained also to my father and mother, my brother and sisters, my children and other loved ones, and me.

I was coming closer to the generative source of my own life, from which, if I conceived my arrival there rightly—it must be done with love—I could begin my real work.

I began to imagine things forbidden me to see.

I saw a mountainside and a house halfway up its slope. I saw a young man open the screen door on a June day and come walking out. His forehead was high and his blue eyes

shone with the light of clear intelligence. He swung his alpine stick, ready to be off.

I saw a woman with strong shoulders and legs and a cloud of red hair. I understood her will to cut her own path though it lay beside his.

I saw them walk away from the house along the path that led to the meadow. Through sunlight they walked, over springs of mint and wintergreen, on into the shadows and rush of firs.

From the distance as they climbed, a wood thrush called and called again, now to the left, nearer, now ahead, as if leading them as they climbed.

They stopped. He rapped a tree with his stick. In a hollow at its foot, they lay down. He pressed her hair into the leaves.

Now I could see her face. A green light passed across her brow. Her grey eyes closed.

I began to write.

FOR THE BEST IN PAPERBACKS, LOOK FOR THE

In every corner of the world, on every subject under the sun, Penguin represents quality and variety—the very best in publishing today.

For complete information about books available from Penguin—including Pelicans, Puffins, Peregrines, and Penguin Classics—and how to order them, write to us at the appropriate address below. Please note that for copyright reasons the selection of books varies from country to country.

In the United Kingdom: For a complete list of books available from Penguin in the U.K., please write to *Dept E.P., Penguin Books Ltd, Harmondsworth, Middlesex, UB7 0DA.*

In the United States: For a complete list of books available from Penguin in the U.S., please write to *Dept BA, Penguin*, Box 999, Bergenfield, New Jersey 07621-0999.

In Canada: For a complete list of books available from Penguin in Canada, please write to *Penguin Books Canada Ltd, 2801 John Street, Markham, Ontario L3R 1B4.*

In Australia: For a complete list of books available from Penguin in Australia, please write to the *Marketing Department, Penguin Books Australia Ltd, P.O. Box 257, Ringwood, Victoria 3134.*

In New Zealand: For a complete list of books available from Penguin in New Zealand, please write to the *Marketing Department, Penguin Books (NZ) Ltd, Private Bag, Takapuna, Auckland 9.*

In India: For a complete list of books available from Penguin, please write to *Penguin Overseas Ltd, 706 Eros Apartments, 56 Nehru Place, New Delhi, 110019.*

In Holland: For a complete list of books available from Penguin in Holland, please write to *Penguin Books Nederland B.V., Postbus 195, NL–1380AD Weesp, Netherlands.*

In Germany: For a complete list of books available from Penguin, please write to *Penguin Books Ltd, Friedrichstrasse 10–12, D–6000 Frankfurt Main 1, Federal Republic of Germany.*

In Spain: For a complete list of books available from Penguin in Spain, please write to *Longman Penguin España, Calle San Nicolas 15, E–28013 Madrid, Spain.*

In Japan: For a complete list of books available from Penguin in Japan, please write to *Longman Penguin Japan Co Ltd, Yamaguchi Building, 2-12-9 Kanda Jimbocho, Chiyoda-Ku, Tokyo 101, Japan.*